MW00787997

# THE OFFICIAL

# HALO

# COOKBOOK

## RECIPES FROM ACROSS THE GALAXY

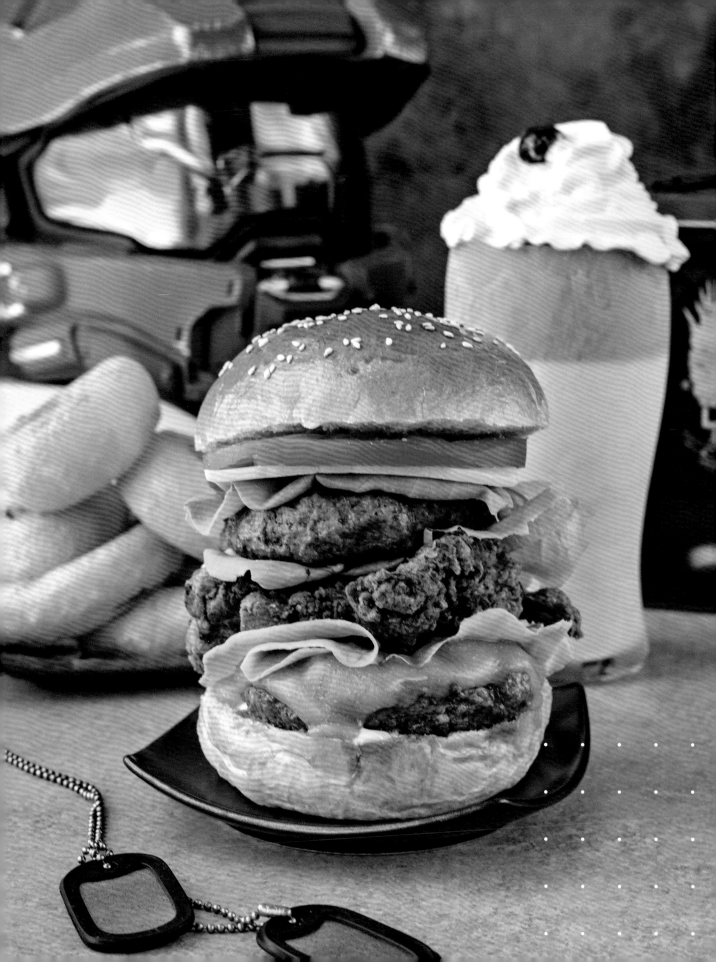

# THE OFFICIAL
# HALO®
# COOKBOOK

## RECIPES FROM ACROSS THE GALAXY

Victoria Rosenthal

INSIGHT
EDITIONS

SAN RAFAEL · LOS ANGELES · LONDON

# CONTENTS

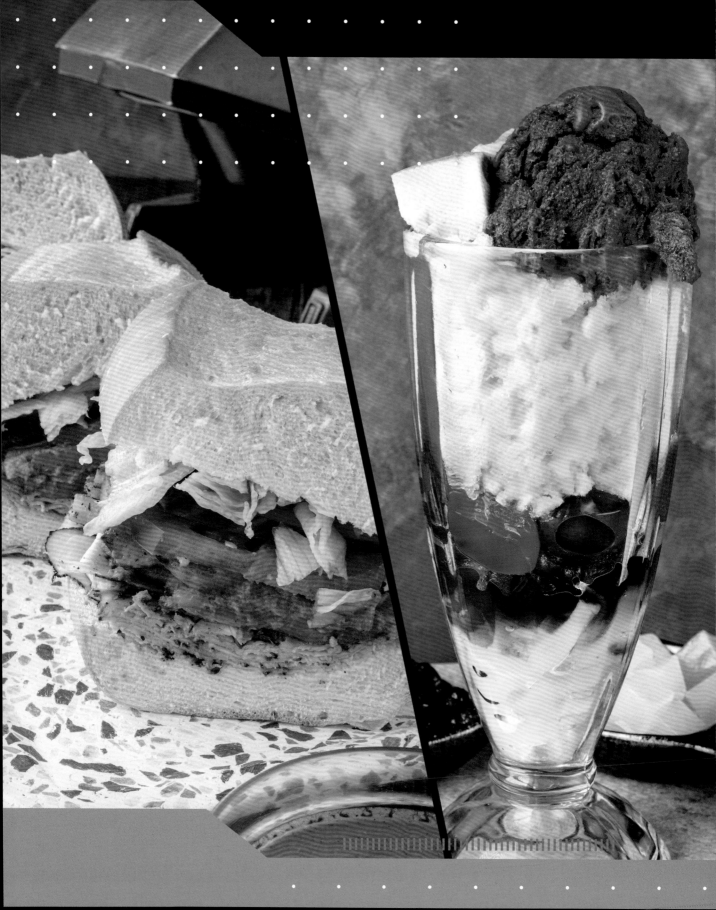

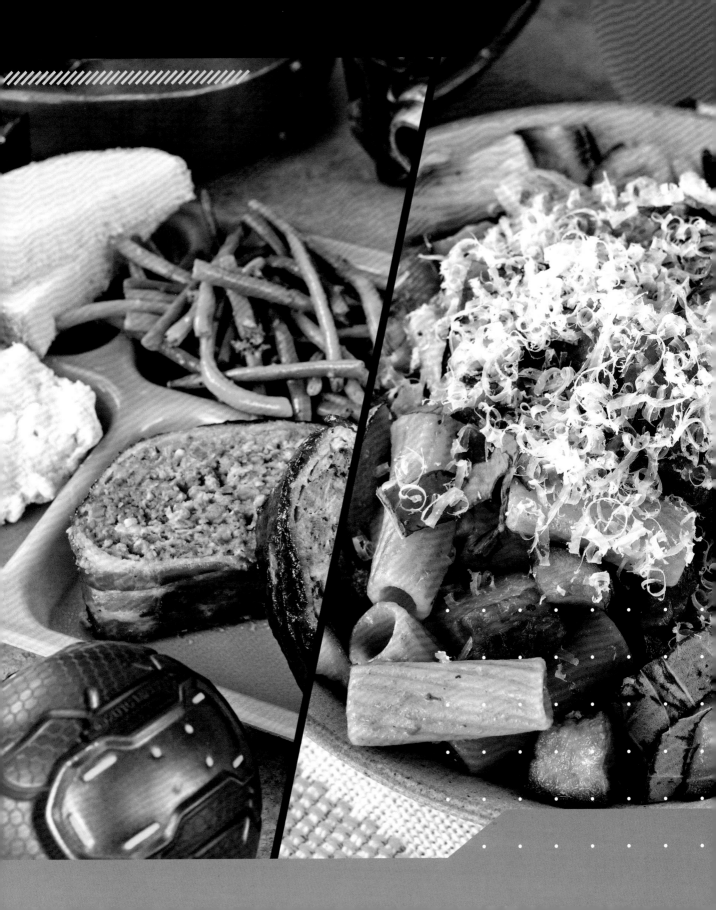

# INTRODUCTION

Space. The big unknown. Massive, cold, and empty. And for most of human history, a merciless vacuum that kept us watching and wondering. But humanity saw to end that mystery and take to the stars, thanks to some genius pioneers in space travel some time ago. Instead of strapping a metal casket to a bomb and detonating enough liquid and gas to push us outward, we now have the Shaw-Fujikawa Translight Engine to let us rip holes in the fabric of space itself and conquer what felt so impossible before.

And what did us humans do with these new boundaries? Why, we reached out into the void with the violence and anger that has always come so naturally to us. I'm not suggesting there was only peace before we got here, but we brought the same selfish attitudes that had plagued our own empires for centuries. But when there's exploration to be had, money to be made, and conflict to be waged, what could we do except spread our influence?

There's an awful, hollow feeling being stuck on a freighter for a month or assigned to coordinate with some United Nations Space Command capital ships without being on natural soil for the whole assignment. It's sterile and terrible. One of the few things that makes it bearable is food. It's thanks to the real heroes of the space fleets—the line cooks, the chefs, and even the vending machine maintenance crew that keep something tasty waiting for us, reminding us of our roots and our home.

If you're stuck on a ship and you're lucky, there's an artist in the kitchen, bringing along their family recipes, putting their culture and history on a plate. And if your only choice is the chef's special in the mess hall? Well, at least it isn't Covenant cuisine. Don't get me wrong—they've got some Sangheili gourmets making some grub that is out of this world. But for every decent meal I've ventured, another ten put me in the infirmary, so I'd suggest sticking to human food.

And who am I to share all this with you, you may ask? The name's Arturo Bustamante, and I had one of those life-draining upper-middle-management jobs that no one writes, much less reads, a book about. My time managing contracts and arrangements with Yaka Frutas let me see just how far humanity has expanded in the universe and what each settlement and station and outpost does to keep their stomachs and hearts full. But I'm more than happy to leave that behind and keep my feet on soil for the rest of whatever time I have left. I don't miss any of the work, but something in me felt incomplete after my retirement.

After much contemplation, I decided that a compilation of all my favorite meals from my time cruising the stars would be a great project to keep myself busy. If you're planetbound, like I am now, consider this an opportunity to see a sliver of what you may be missing without the perils of space travel. And trust me, you're not missing too much. Space is, after all, vast and full of danger.

# INGREDIENTS LIST

**Amchur powder,** used in Indian cuisine, is made from unripe mangos dried in the sun and ground into a powder. It has a tangy and sour taste to it—very similar to dehydrated mango—and can be stored in the pantry in an airtight container for about a year.

**Ancho chile,** a dried poblano pepper, has a Scoville scale of 1,000–2,500 SHU. This can be replaced with another dried chile of your choice with a similar heat level, but keep in mind that the flavor will be slightly different. Ancho chiles can be stored in a cool pantry.

**Bolilo,** a crusty bread made in Central America, is typically used for sandwiches.

**Bonito flakes (katsuobushi),** dried tuna shavings, are a key ingredient in Japanese cuisine and one of the major components in dashi. Bonito flakes, which can be stored in a cool pantry, enhance the flavors of stocks and are used as a garnish.

**Castelvetrano olives,** bright green olives grown in Sicily, have a firm texture and a rich, buttery flavor. These olives can be substituted with another firm green olive.

**Chinkiang vinegar,** also known as black vinegar, is a dark, fermented vinegar made from glutinous rice. It has an acidic, yet slightly sweet, flavor. You can substitute Chinkiang vinegar, which can be stored in a cool pantry, with another rice vinegar.

**Condensed milk,** an extremely thick, caramelized, sweetened canned milk, has been gently heated, has had about 60 percent of the water removed from it, and has been mixed with sugar. It can be stored in a pantry for about a year, but once opened, it must be refrigerated and used within two weeks.

**Crema Mexicana,** a creamy and mildly sour condiment, is slightly thicker than heavy cream. This item, which can be substituted with crème fraîche (its French equivalent) or heavy cream with a teaspoon of lemon juice for every cup, should be stored in a refrigerator.

**Dashi stock,** a basic fish stock used in Japanese cuisine, is made by combining kombu and bonito flakes with water. Dashi stock, which must be stored in the refrigerator once cooked, can be stored for up to five days.

**Evaporated milk** has been gently heated and has had about 60 percent of the water removed to make a dense, creamy milk. It is found in cans that can be stored in a pantry for about six months. Once opened, it must be refrigerated and used within five days. (The difference between evaporated and condensed milk is that sugar is added to condensed milk.)

**Fish sauce** is a sweet and salty, pungent liquid made from fermented anchovies and salt. The salt content in this product can be used as a salt substitute to add an extra layer of umami, but be careful to not add too much because it can easily overpower a dish. Fish sauce can be stored in the pantry for two to three years.

**Galangal,** a large root used primarily in Southeast Asian cuisine, has an earthy, citrusy, and piney flavor. Fresh galangal should be stored in the refrigerator for up to one week.

**Guajillo chile,** a dried mirasol chile, has a Scoville rating of 2,500–5,000 SHU. It can be replaced with another dried chile of your choice with a similar heat level, but keep in mind that the flavor will be slightly different. Guajillo chiles can be stored in a cool pantry.

**Harina de maíz,** a precooked cornmeal, comes in different varieties, but the one used for the recipes in this book is the blanco (white) cornmeal. Harina de maíz can be stored in an airtight container in a cool pantry.

**Hoisin sauce,** a sweet, thick sauce used in Chinese cuisine, especially barbecue, is made from fermented soybean and Chinese five-spice powder. The sauce, which can be used for cooking or as a dipping sauce. Can be stored in the pantry until opened. Once it is opened, however, store it in a refrigerator.

**Hua chai po wan,** a sweet, preserved radish used in Thai cuisine, can be found either as a whole preserved radish or already finely chopped. It can be stored in an airtight container in a cool pantry.

**Inari age** are thinly sliced, deep-fried, and seasoned tofu pockets used in Japanese cuisine.

**Kala namuk,** also known as black Himalayan salt, is a pungent sulfurous rock salt that is pale pink when ground. It can be stored in an airtight container in a cool pantry.

**Kamaboko,** a Japanese fish cake typically made from whitefish, comes in many shapes and colors. It should be stored in a freezer or refrigerator. If frozen, however, defrost it before cooking with it..

**Kashmiri chile powder,** made from dried and ground vibrant red Kashmiri chile, has a mild heat. Paprika or another mild chile powder is a good substitute.

**Kombu,** a type of dried kelp used in Japanese cuisine, can be used to enhance stock flavors. It can be stored in a cool pantry.

**Mirin,** a rice wine commonly used in Japanese cuisine, has more sugar and less alcohol when compared to sake. Mirin can be stored in a cool pantry. For the best quality, use within three months once opened.

**Nam prik pao,** a ground chile paste used in Thai cuisine, is made from roasted chile peppers and typically combined with dried shrimp, fish sauce, and palm sugar. It must be stored in the refrigerator once opened.

**Nata de coco,** a fermented, chewy coconut gel, comes in a large variety of flavors. It must be stored in the refrigerator once opened.

**Nori,** a dried, edible sheet of seaweed used in Japanese cuisine, is most commonly used to wrap sushi rolls. It can be stored in a cool pantry.

**Oyster sauce,** a thick sauce made from oysters and used in Chinese cuisine, is savory, with a hint of sweetness. The fishy flavor is mild, while the caramelized flavor stands out.

**Palm sugar,** a sweetener made from nectar of coconut or palm flowers, can be substituted with brown sugar.

**Pasilla chile,** a dried chilaca pepper with a Scoville rating of 1,000–4,000 SHU, can be replaced with another dried chile of your choice with a similar heat level, but keep in mind that the flavor will be slightly different. Pasilla chiles can be stored in a cool pantry.

**Poha,** parboiled and flattened rice, can be stored in a cool pantry.

# INGREDIENTS LIST

**Queso de mano,** a soft Venezuelan cheese, can be substituted with fresh mozzarella cheese. It should be stored in the refrigerator.

**Queso fresco,** a fresh, soft Mexican cheese that is salty and very mild, can be substituted with a mild feta cheese. It should be stored in the refrigerator..

**Sambal oelek,** a ground chile paste used in Southeast Asian cuisine, is made from chile peppers, garlic, and ginger. It can be substituted with another hot sauce. It must be stored in the refrigerator once opened.

**Shichimi togarashi,** a seven-flavor chile spice mix used in Japanese cuisine, can be stored in a pantry.

**Shaoxing wine,** a rice wine used in Chinese cuisine, can be stored in a cool pantry for about six months.

**Tahini,** a paste made from ground white sesame seeds and oil, can be stored in the pantry for up to six months.

**Tangzhong,** a paste of liquid and flour that is combined and heated to help develop gluten in the flour, helps create fluffy, soft breads.

**Thai basil,** an herb with purple stems and green leaves used in Southeast Asian cuisine, has a licorice-like and mildly spicy flavor. A slightly sturdier herb than Italian basil, it is more stable at higher cooking temperatures. Thai basil can be substituted with any type of basil, but it will have a different flavor profile.

**Tomatillo,** a tart-flavored Mexican fruit naturally wrapped in a papery husk, should not be confused with a green tomato. Tomatillos, with the husk still on, can be stored in the refrigerator for about two weeks.

**Tonkatsu sauce,** a thick, sweet sauce used in Japanese cuisine, can be stored in the pantry. Once opened, it can be stored in the refrigerator in an airtight container for about two months.

**Ube halaya,** a thick spread made from ube (purple yam), sweetened condensed milk, evaporated milk, and sugar, is sweeter than orange yam, with a flavor like vanilla. Once it is opened, it should be stored in the refrigerator.

**Wasabi,** the stem of Wasabia japonica, found in Japan, must be served immediately after grating to avoid loss of flavor and has a shelf life of one to two days at room temperature and one month in the refrigerator. More common is a wasabi substitute made of horseradish, mustard powder, and food coloring. This spicier and more pungent substitute can be stored in the refrigerator for up to twelve months.

**Za'atar,** an Arabic spice mixture, comes in many regional varieties, but common herbs include oregano, sesame seeds, sumac, and thyme. It can be stored in the pantry.

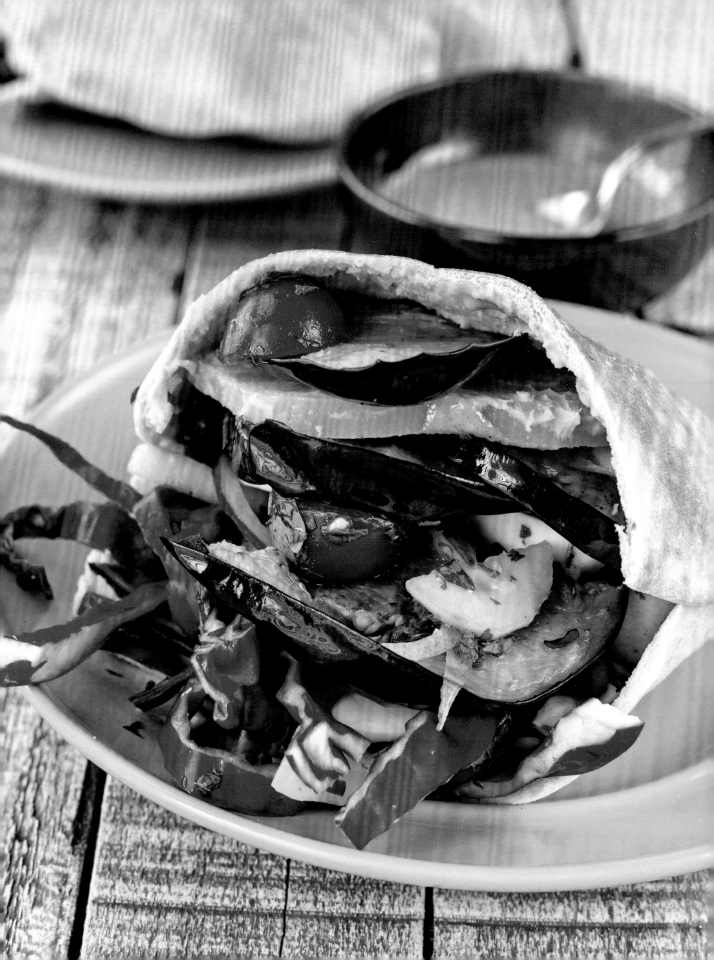

# ALLERGY NOTES

There's nothing better than the feeling of making your own delicious meals in your home kitchen. It's even better in the company of good friends and family. But good chefs always keeps in mind restrictions and accommodations for themselves and any guests, so remember that it's always fine to make adjustments to fit the recipes to your own needs.

## ADAPTING TO VEGETARIAN DIETS

Several recipes in this book are vegetarian or vegan friendly. Many other recipes can be adapted to dietary needs: Replace meat broths or stocks with vegetable ones; swap out proteins with your favorite grilled vegetable or meat substitute. This will affect the cooking times, however, so plan ahead.

## ADAPTING TO GLUTEN-FREE DIETS

For most recipes, you can use equal amounts of gluten substitute instead of flour, but be prepared to modify the quantity just in case the consistency seems off compared to how it is described in the recipes.

## ADAPTING TO LACTOSE-FREE DIETS

Feel free to replace milk and heavy cream with your favorite nondairy milk. Numerous butter alternatives are available, too. But be careful about using oil, which doesn't provide the same consistency needed for certain recipes and should be used in smaller quantities than butter.

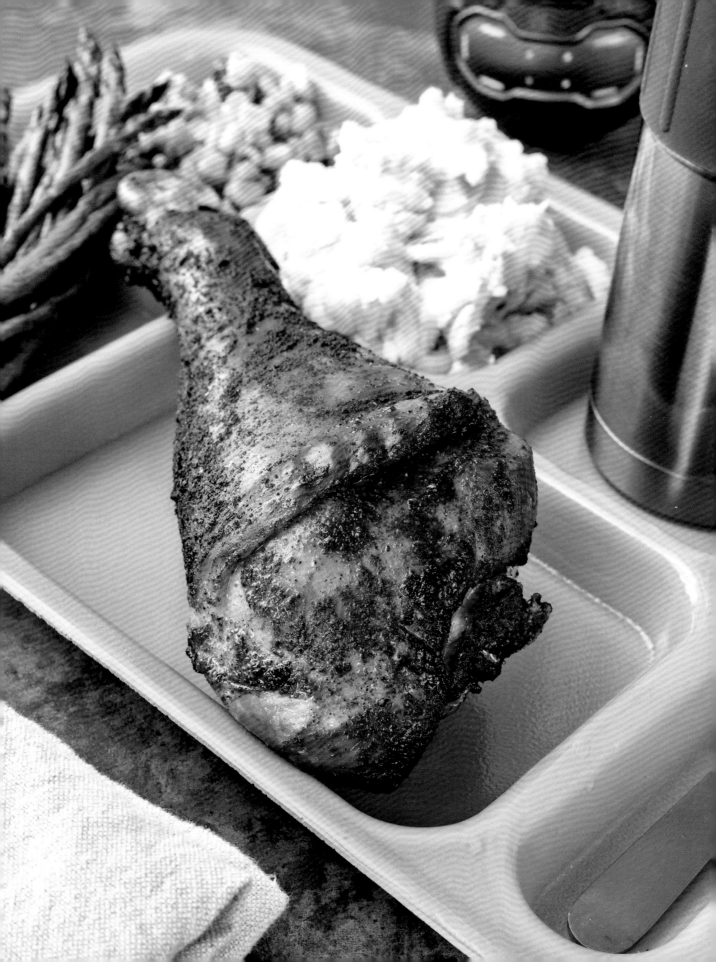

# WORLD CUISINE

It's a damn shame what happened to Reach. It was quite an impressive place. Always busy, always something new to see or do. You could get lost exploring the streets of Manassas. There was a night-club in New Alexandria I was quite fond of. Immerse yourself in enough of those little pleasures, and you could forget that you weren't on Earth at all. Of course, there was the unmistakable military presence everywhere you looked, what with the different UNSC bases and secret discoveries I'd hear whispers about. But Reach really felt like humanity's best attempt to make a home away from home, and I'll miss my trips there.

Yes, I found myself in Reach quite often, but only ever for business. One of the biggest players in the food scene on Reach was World Cuisine. A culinary wonderland, it found a way to marry two of humanity's greatest strengths: a rich, diverse offering of food from all corners of the globe abruptly smashed into fast-food portions and served for a busy person on the go. Every time I ordered something new, I always felt this deep regret that the inspired menu and talented cooks were being instructed to make such delicious fare quickly and cheaply. If only they had a nice sit-down location where you could relax and let the kitchen really do their thing, it would have been one of my favorite places to eat.

Ah, but you might be saying, "Arturo, why are you talking like that? There's a World Cuisine down the street from me!" To which I'd say, yes, there probably is, as World Cuisine managed to overcome catastrophe, unlike most of Reach. But the years have not been kind to my gut, and as much as I'd love to shovel more fast food into my mouth, my doctor has been pleading with me to cut back. I've got some delicious recipes from my favorite fare from World Cuisine, with a little more care in the kitchen to give the menu the highlight it deserves. You're welcome.

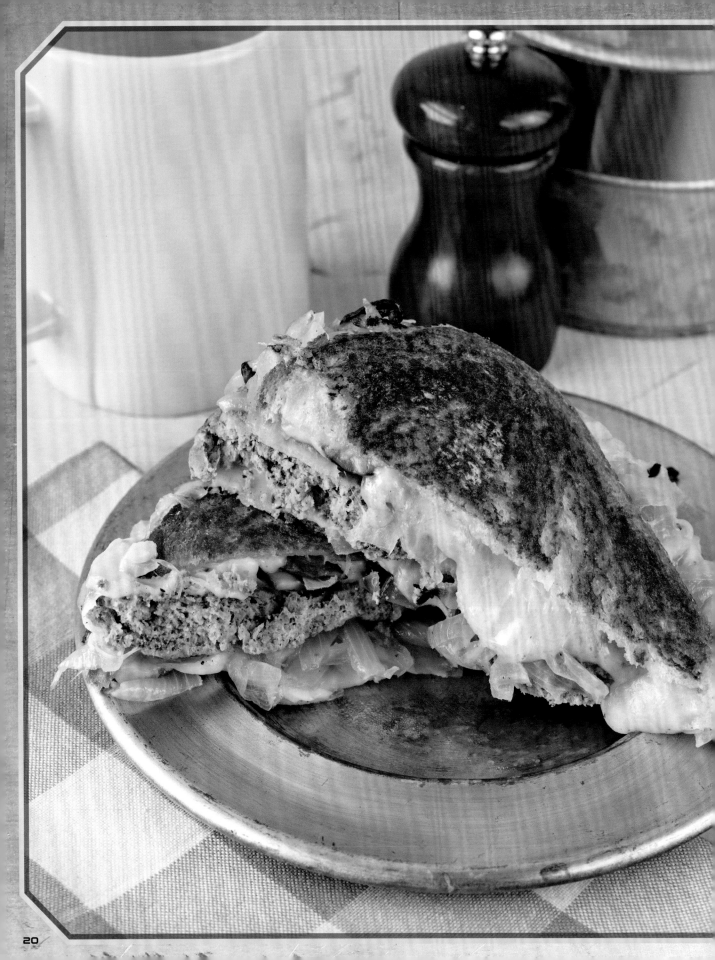

# PATTY MELT

**Difficulty**: Easy
**Prep Time**: 30 minutes
**Cook Time**: 1 hour
**Yield**: 4 patty melts
**Dietary Notes**: N/A

### CARAMELIZED ONIONS AND MUSHROOMS

2 tbsp. (30 ml) olive oil
2 large onions, sliced
1 lb. (454 g) mushrooms, stemmed and sliced
Salt

### BURGER

1 lb. (454 g) ground turkey
2 tsp. (2 g) rubbed sage
1 tsp. (1 g) dried thyme
½ tsp. (2½ ml) Worcestershire sauce
Salt
Ground black pepper
2 tsp. (10 ml) canola oil
8 thick slices sourdough bread
½ cup (114 g) butter
8 slices Swiss cheese

*This is a favorite guilt food of mine. Caramelized goodness? Check. Well-seasoned patty? Check. Smothered in butter and cheese? Check and check. It's everything you could have hoped for in a guilt food—all you have to do is make one.*

### CARAMELIZED ONIONS AND MUSHROOMS

1. Heat a medium frying pan with 1 tablespoon (15 ml) olive oil over medium heat. Add the onions, toss, and coat with the oil. Cook the onions until they turn translucent, about 2 minutes.

2. Add a pinch of salt, stir, and reduce the heat to medium low. Continue cooking and stirring occasionally until the onions become golden and caramelized, about 30 to 45 minutes. Remove from the heat, transfer the onions to a spare plate, and set aside to cool.

3. Place the same pan over medium heat. Add another tablespoon (15 ml) of olive oil. Add the mushrooms and cook until golden brown, about 10 minutes. Transfer to the plate with the onions and mix together. Set aside until you are ready to assemble.

### BURGER AND PATTY MELT ASSEMBLY

1. Combine the turkey, sage, thyme, and Worcestershire sauce in a large bowl. Mix together until the spices are blended with the meat, but do not overwork. Divide into 4 equal portions and shape into patties roughly the size and shape of the sourdough slices. Generously season the patties with salt and pepper.

2. Heat a large frying pan over medium-high heat. Pour 2 teaspoons (10 ml) of canola oil into the pan (or cover the bottom of the pan with nonstick spray). Place the patties in the pan and cook each side for 4 minutes, or until cooked through. Remove from the pan and set aside.

3. Prepare each of the slices of sourdough by spreading one side with butter, about 1 tablespoon (14 g) of butter per slice. Place 4 of the slices, butter side down, in a large nonstick frying pan (or two medium nonstick pans). Top each of those slices with 1 piece of Swiss cheese. Split the caramelized onion and mushroom between the 4 slices. Place a patty on each, followed by the remaining Swiss cheese slices. Top with the remaining sourdough slices, butter side up.

4. Place the pan over medium-high heat and cook for 4 to 5 minutes per side, until the bread is golden, and the cheese is melted.

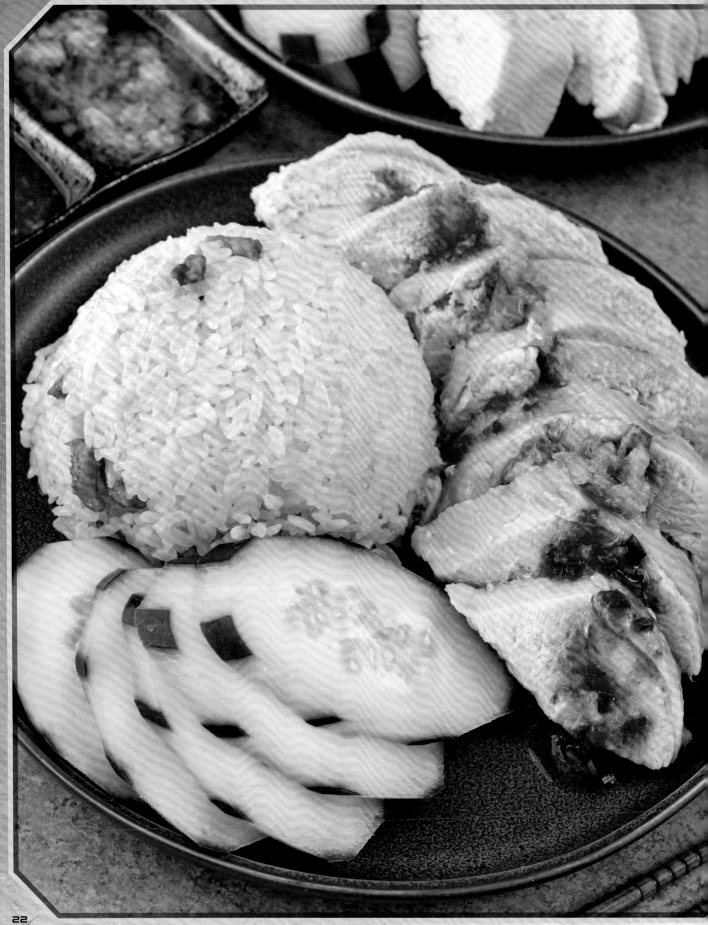

# HAINANESE CHICKEN

**Difficulty**: Medium
**Prep Time**: 45 minutes
**Cook Time**: 1½ hours
**Yield**: 4 servings
**Dietary Notes**: Dairy-free

*If chicken is a common occurrence at your dinner table, there's a good chance you've been doing poultry a disservice. Get yourself a high-quality bird from the grocery, healthy and humanely raised, and treat it even nicer in the kitchen, and you'll be surprised by how much you've been missing out. Or stop by World Cuisine and see how they do it.*

1 whole chicken
Salt
8 scallions
3-in. (7½ cm) piece of ginger, thickly sliced
4 garlic cloves, crushed
½ tsp. (2½ g) monosodium glutamate (optional)
Sesame oil for rubbing

### FOR SERVING

1 cucumber

### RICE

Excess chicken skin and fat from whole chicken
1 tsp. (5 ml) canola oil
3 garlic cloves, minced
2 tsp. (4 g) ginger, grated
2 cups (400 g) rice
2 pandan leaves (optional)
Reserved chicken broth from above (follow rice cooker's directions for amount need)

### GINGER SCALLION OIL

2 tbsp. (12 g) ginger, grated
1 scallion, minced
1 tsp. (4 g) salt
½ tsp. (3 g) sugar
5 tbsp. (75 ml) peanut oil
½ tsp. (2½ ml) sesame oil

### CHILI SAUCE

2 tbsp. (30 g) sambal oelek
1 tbsp. (20 g) palm sugar
2 tbsp. (30 ml) reserved chicken broth (from above)
4 garlic cloves, grated
2-in. (5 cm) piece of ginger, grated
Juice of 1 lime
1 tsp. (5 ml) rice vinegar

## CHICKEN

1. Place a stock pot, large enough to place the whole chicken in, filled with water over high heat.

2. While the water is coming to a boil, prepare the whole chicken by removing excess fat and skin. Set the excess fat and skin aside and reserve for the rice. Thoroughly wash the chicken. Transfer to a plate and pat completely dry. Rub the chicken with a lot of salt. Massage the salt onto all parts of the chicken, making sure to not tear the skin. Let sit for 2 minutes. Rinse off the salt completely and pat dry again.

3. Carefully place the chicken into the boiling pot. This will stop the water from boiling. Let sit in the water for about 1 minute before carefully lifting from the water to allow the water in the cavity to drain. Place back into the water and bring to a boil. Reduce the heat to medium low. The water should be gently simmering. Add the scallions, ginger, garlic, 1 tablespoon (14 g) salt, and monosodium glutamate. Cover and let simmer for 30 minutes.

4. Turn off the heat, remove from the burner, and keep covered. Allow the chicken to rest for another 30 minutes to cook through until it reaches an internal temperature of 165°F (74°C).

5. Fill a large bowl with water and 5 pieces of ice. Carefully transfer the chicken into the bowl and let it rest for 15 minutes. Keep the broth in the pot; you'll need this to make the rice. Remove the chicken from the ice water and pat dry. Rub the whole chicken with sesame oil and cover with aluminum foil until the rice is done cooking.

## RICE

1. Roughly chop the excess chicken skin and fat. Heat a medium stainless steel frying pan over medium heat. Pour in canola oil, then add the chicken skin and fat and cook until golden brown and the fat has rendered. Add the garlic and ginger and cook until softened, about 3 minutes. Add the rice, stirring often, to lightly cook the rice and cover in the fat. Cook for about 1 minute. Transfer to the bowl of a rice cooker. Place the pandan leaves on top of the rice.

2. Add the chicken broth and cook according to your rice cooker's instructions.

3. Before serving, remove the pandan leaves and fluff up the rice.

4. Once the rice is ready, carve the chicken and serve with slices of cucumber, the rice, and the sauces.

## GINGER SCALLION OIL

1. Combine the ginger, scallions, salt, and sugar in a heat-resistant medium metal bowl.

2. Pour the peanut oil into a small frying pan over medium-high heat. Heat the oil to about 350°F (177°C). Carefully pour into the metal bowl. It will sizzle very loudly. Mix together. Add the sesame oil and mix well.

## CHILI SAUCE

1. Combine everything together in a bowl just before serving.

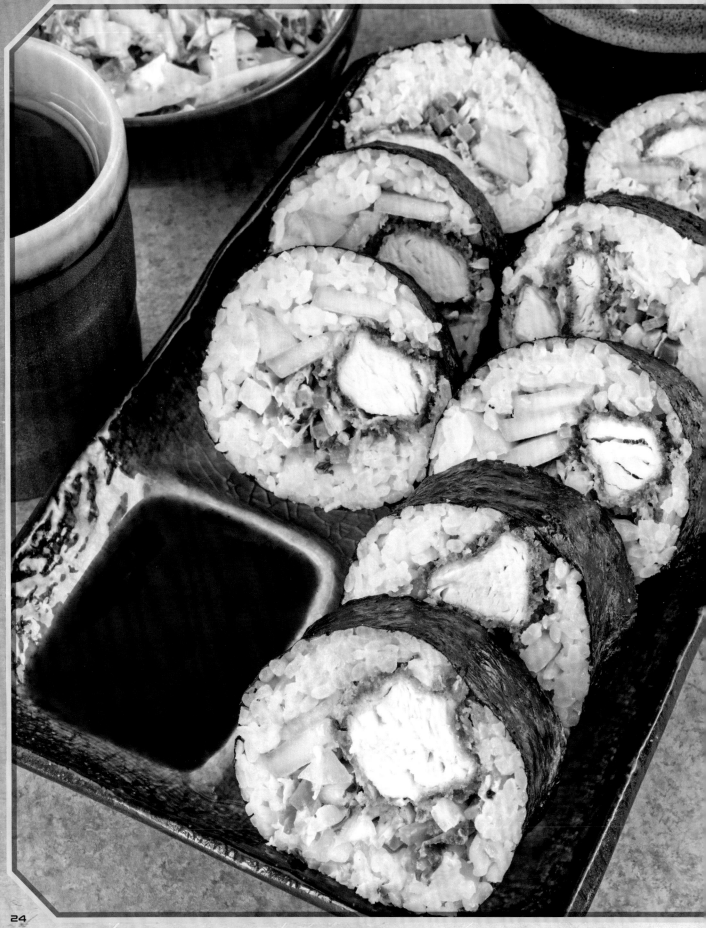

# SUSHI

**Difficulty**: Hard
**Prep Time**: 1½ hours
**Cook Time**: 2 to 3 minutes per batch of tenders
**Yield**: 6 rolls
**Dietary Notes**: Dairy-free

### SUSHI RICE
3 cups (600 g) sushi rice
2 dried shiitake
1 pandan leaf
Water (follow rice cooker's directions)
3 tbsp. (45 ml) rice vinegar
2 tbsp. (30 g) sugar
½ tsp. (2 g) salt

### SLAW
¼ cup (58 g) Japanese mayonnaise
2 tsp. (10 ml) rice vinegar
1 tsp. (7 g) wasabi
2 tsp. (3 g) shichimi togarashi
1 tsp. (5 g) sugar
¼ Napa cabbage, thinly sliced
1 carrot, peeled and julienned
Salt
Pepper

### CHICKEN KATSU
Peanut oil for deep-frying
Salt
Ground black pepper
½ cup (63 g) all-purpose flour
1 tsp. (5 g) garlic powder
1 tsp. (2 g) ginger powder
2 eggs
1 tsp. (4 g) tonkatsu sauce
1 cup (60 g) panko
1 lb. (454 g) chicken tenders

### ASSEMBLY
6 nori sheets
Prepared slaw
1 cucumber, peeled and cut into long strips
Cooked chicken katsu tenders
Prepared sushi rice

*I'm not really sure why World Cuisine insists on including sushi on its menu. It's a real pain in the rear to keep a consistent supply of sushi-grade raw fish moving to all their locations, so most of them resort to less traditional sushi. One place I went to had a chicken katsu sushi that actually worked quite well, so I included their unique take here.*

## SUSHI RICE

1. Put rice in a large bowl, fill it up with cold water, and rub the rice in a circular motion. Strain the water and fill the bowl with more water and repeat until the water is clear.

2. Place the cleaned rice, dried shiitake, pandan leaf, and the amount of water required into a rice cooker and allow the rice to cook.

3. When the rice is done cooking, remove it from the rice cooker and place it in a large nonmetallic bowl.

4. In a small bowl, combine the rice vinegar, sugar, and salt. Use a rice paddle to fold the rice vinegar mixture into the rice while the rice is still hot. Continue to fold and slice the rice until it has cooled down.

## SLAW

1. Whisk together the mayonnaise, rice vinegar, wasabi, shichimi togarashi, and sugar in a small bowl. Combine the cabbage and carrot in a large bowl. Toss in the dressing and fully coat the vegetables. Salt and pepper to taste. Cover and place in a refrigerator until you are ready to assemble the dish.

## CHICKEN KATSU

1. Fill a deep, heavy pot with 2 inches (5 cm) of peanut oil and heat to 365°F (185°C) over medium-high heat.

2. Set 3 stations up to bread the chicken. On the first plate, combine flour, garlic powder, and ginger powder. In a bowl, mix the eggs and tonkatsu. On another plate, place the panko.

3. Generously salt and pepper the chicken tenders. Cover the chicken tenders in the flour mixture first. Next, cover with the eggs. Finally, coat with the panko. Repeat until this is done with all the pieces.

4. When the peanut oil has reached the target temperature, carefully place the chicken tenders in the heated oil, but do not crowd the pot. Cook until the chicken has reached an internal temperature of 165°F (74°C), about 2 to 3 minutes. Transfer to a plate with paper towels to dry.

## ASSEMBLY

1. Place a sheet of nori on a sushi mat. Wet your hands and add a thin layer of rice onto the nori, leaving about ½ inch at the top of the sheet empty.

2. Starting from the bottom of the nori, place a generous portion of slaw, cucumbers, and 2 to 3 pieces of chicken tenders in a single layer. Carefully and tightly roll the sushi together using the sushi mat. Repeat this with the remaining ingredients. At this point, the rolls can be wrapped in plastic wrap and stored in the refrigerator for up to 3 days.

3. Cut the rolls in half using a sharp knife. In between each cut, wipe the knife blade with a wet kitchen towel. Cut each of the halves into 3 to 4 pieces.

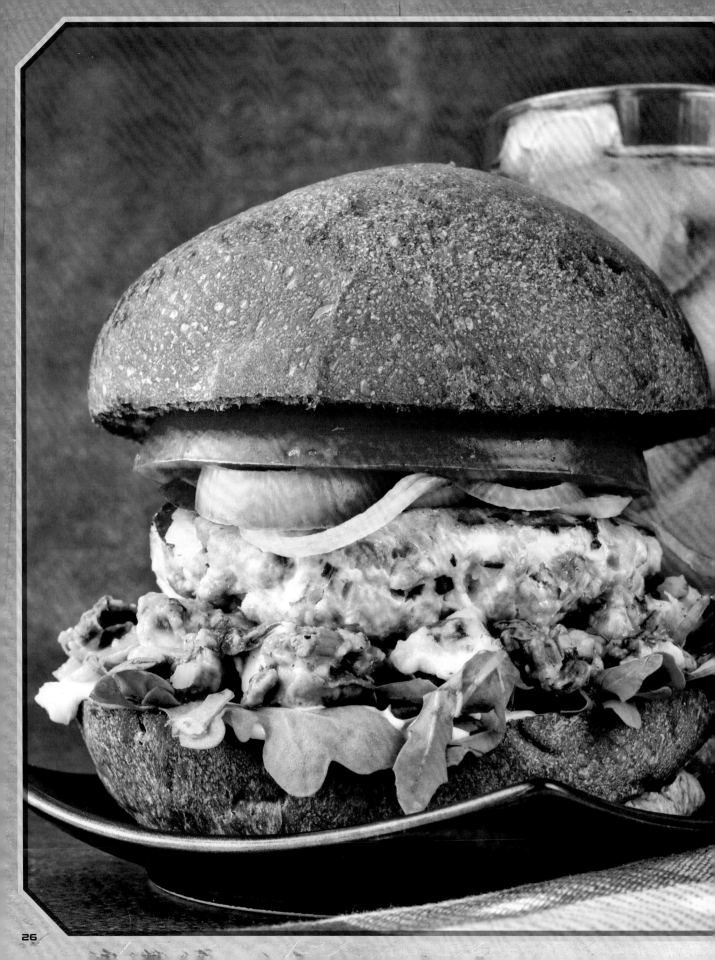

# SALMON BURGER

**Difficulty**: Medium
**Prep Time**: 30 minutes
**Cook Time**: 15 minutes
**Yield**: 3 burgers
**Dietary Notes**: Dairy-free

### AVOCADO SALSA

1 barely ripe large avocado, diced
3 tbsp. (12 g) cilantro, chopped
1 scallion, chopped
Juice of 1 lime
Salt
Ground black pepper

### SALMON PATTY

12½ oz. (354 g) skinless salmon, finely chopped
¼ cup plus 2 tbsp. (24 g) panko crumbs
1 tbsp. (4 g) cilantro, minced
2 tbsp. (5 g) chives
2 tbsp. (30 g) mayonnaise
1 tbsp. (15 g) Dijon mustard
Juice and zest of ½ lemon
1 tsp. (4 g) salt

### ASSEMBLY

3 burger buns
Mayonnaise
Arugula
¼ red onion, thinly sliced
3 tomato slices

*You can get a burger any place, but it wouldn't be a World Cuisine burger. They serve a burger with a real mouthwatering salmon patty and a crisp avocado salsa. Well, it isn't always salmon—they adapt the menu to the local fish in the area that are more easily farmable. But if you have access to salmon, it's my preferred protein.*

### AVOCADO SALSA

1. Combine all the ingredients in a medium bowl until the mixture just comes together. Season with salt and pepper. Set aside.

### SALMON PATTY

1. Combine all the ingredients in a medium bowl until well combined. Split into 3 portions and shape into patties roughly the size of your burger buns.

2. Heat a large nonstick grilling pan over medium heat. Place the patties and cook each side until golden brown, about 4 to 5 minutes per side.

### ASSEMBLY

1. To assemble a burger, spread a generous portion of mayonnaise on the bottom half of the bun. Top with arugula and a third of the avocado salsa. Next, place a patty with a few slices of red onion and a slice of tomato, and then top with the top half of the bun.

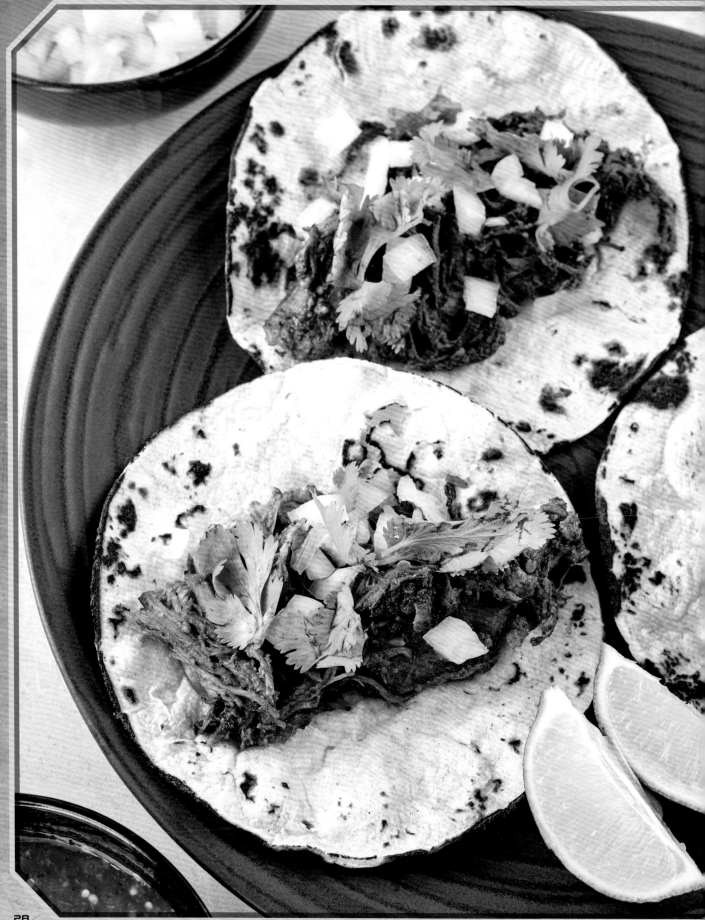

# BARBACOA TACOS

*The tacos from World Cuisine are incredible—they put some real effort into a tasty filling no matter what's available at the time. If you can find a location making these with lamb, you'll never look at tacos the same again. Or you could always just make them and see for yourself.*

**Difficulty**: Easy
**Prep Time**: 30 minutes
**Cook Time**: 5 hours
**Yield**: 6 to 8 servings
**Dietary Notes**: Dairy-free

## LAMB

4 lb. (1816 g) lamb shoulder
Salt
Ground black pepper
2 tbsp. (30 ml) canola oil

## SAUCE

3 cups (710 ml) beef stock
3 dried guajillo chiles, stemmed
2 dried ancho chiles, stemmed
1 dried pasilla chile, stemmed
1 large onion, sliced
7 garlic cloves, crushed
2 tsp. (3 g) dried Mexican oregano
1 tbsp. (9 g) cumin
¼ tsp. (½ g) ground cloves
½ tsp. (1 g) ground cinnamon
½ tsp. (1 g) ground black pepper
1½ tsp. (6 g) salt
2 tbsp. (30 ml) apple cider vinegar
2 chipotle chiles
3 tbsp. (45 ml) adobo sauce
3 bay leaves
1 cinnamon stick

## SERVING

Corn tortillas
1 large onion, chopped
½ bunch of cilantro, stemmed
4 limes, quartered
Salsa verde (see page 169)

> **NOTE** If you don't want this to be too spicy, remove the seeds from the dried chiles before rehydrating them. A lot of the heat from the peppers comes from those seeds.

1. Preheat the oven to 275°F (135°C). Heat the beef stock in a medium saucepan over medium-high heat. Once it comes to a simmer, remove from the heat, and add the dried guajillo, ancho, and pasilla chiles. Let rest for 15 minutes to rehydrate the chiles.

2. While the chiles are rehydrating, place a large Dutch oven over medium-high heat. Generously rub the lamb shoulder with salt and pepper. Pour 1 tablespoon (15 ml) of canola oil into the Dutch oven. Add the lamb and sear each side until browned, about 3 to 4 minutes per side. Transfer to a plate.

3. If the Dutch oven is dry, add another tablespoon (15 ml) of canola oil. Add the onion and garlic and cook until softened, about 6 to 8 minutes. Add the Mexican oregano, cumin, cloves, ground cinnamon, pepper, and salt. Mix in the onions and cook until fragrant, about 2 minutes. Add 1½ cups (355 ml) of beef stock from the saucepan with the dried chiles. Scrape off the bits at the bottom of the Dutch oven and bring the stock to a light simmer.

4. Turn off the heat and transfer the stock to a blender. Add the rehydrated chiles, the remaining beef stock, apple cider vinegar, chipotle chiles, and adobo sauce. Blend until smooth.

5. Place the lamb shoulder back into the cooled Dutch oven. Pour in the liquid and rub it into the lamb shoulder. Add the bay leaves and cinnamon stick. Cover and place in the oven. Cook until tender, about 4 hours, flipping the lamb a few times during the cook time.

6. Remove from the oven and transfer the lamb into a large bowl. Shred the lamb into large chunks. Place the Dutch oven over medium-high heat. Remove the bay leaves and cinnamon stick. Cook, stirring constantly, until the sauce reduces and thickens, about 5 to 8 minutes. Add as much sauce as you would like to the shredded lamb. Taste and season with additional salt and pepper.

7. Serve on corn tortillas with raw onion, cilantro, limes, and salsa verde.

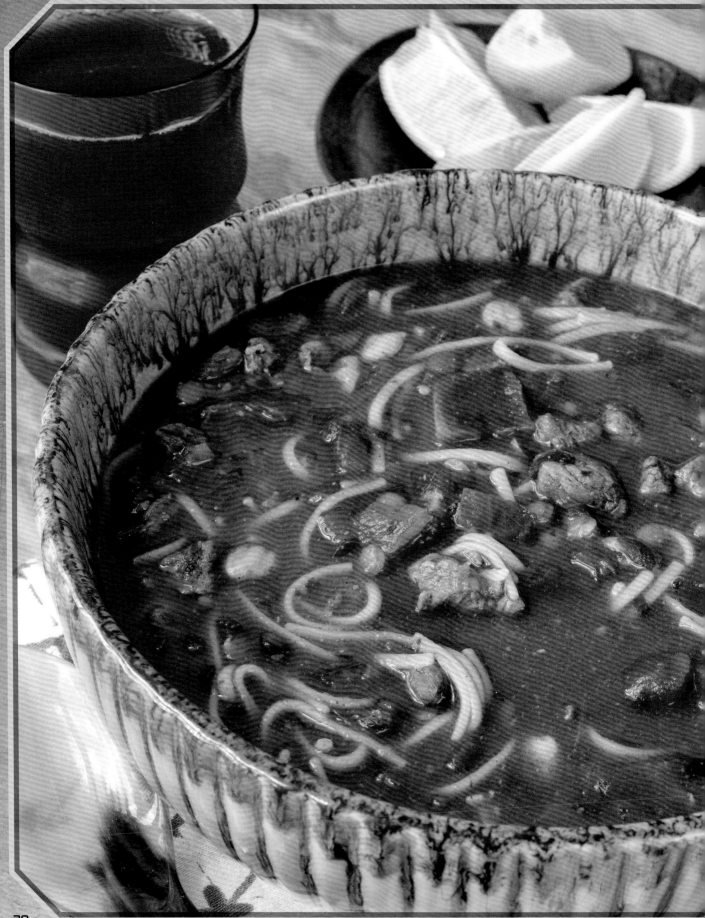

# HARIRA

**Difficulty**: Easy
**Prep Time**: 30 minutes
**Cook Time**: 1 hour
**Yield**: 6 to 8 servings
**Dietary Notes**: Dairy-free

*World Cuisine consistently surprises me with their worldly menu. I never expected such a hearty soup at a fast-food joint, much less a take on Moroccan harira. As hard as they try to provide a great dining experience, I have no doubt they cut a few corners on their recipes, and I clearly went a little overboard on this one. But I swear the effort is worth it.*

¼ cup (56 g) dried chickpeas
¼ cup (56 g) lentils
2 tbsp. (30 ml) olive oil
1 lb. (454 g) lamb shoulder, diced
1 large onion, chopped
3 oz. (85 g) tomato paste
2 tsp. (7 g) cumin
1 tsp. (3 g) paprika
1 tsp. (3 g) turmeric
½ tsp. (1 g) cayenne pepper
1 tsp. (2 g) ginger powder
2 tsp. (8 g) salt
1 tsp. (2 g) ground black pepper
28-oz. (794-g) can diced tomatoes
5 cups (1183 ml) water
3 tbsp. (4 g) celery leaves, chopped
1 cinnamon stick
2 bay leaves
3 tbsp. (23 g) all-purpose flour
3 oz. (85 g) vermicelli
¼ cup (4 g) cilantro, minced
¼ cup (4 g) parsley, minced
2 lemons, quartered

1. Place the dried chickpeas in a medium bowl. Cover with cold water and let sit, uncovered, overnight, until they double in size. The next day, rinse the chickpeas and the lentils. Peel the skin off each of the chickpeas.

2. Heat a large pot with the olive oil over medium-high heat. Add the lamb and cook until all sides are browned, about 5 to 8 minutes. Add the onion and cook until softened, about 5 minutes. Add the tomato paste, cumin, paprika, turmeric, cayenne pepper, ginger powder, salt, and pepper and mix together well. Let cook for 2 minutes.

3. Add the chickpeas, lentils, diced tomatoes, 4½ cups (1065 ml) of water, celery leaves, cinnamon stick, and bay leaves. Bring to a boil. Reduce the heat to low and allow to simmer, covered, for 45 minutes, until the chickpeas and lentils are cooked through.

4. Combine the remaining ½ cup (118 ml) of water and the flour in a small bowl. Once the chickpeas and lentils are cooked through, uncover, and add the water-and-flour slurry. Increase the heat to medium and mix together until the soup begins to thicken, about 2 minutes.

5. Add the vermicelli, cilantro, and parsley and cook until the vermicelli is cooked through, about 8 minutes, stirring so that the pasta doesn't stick to the bottom of the pot. Remove the bay leaves and serve each portion with 1 to 2 quarter slices of lemon.

# UNSC HIGH FLEET DINING

For all the big budgets that the UNSC gets for their military spaceships, it always saddens me how they skimp out on food for their crew. In my past life as a corporate food pusher, my task was always to get them to spend more—buy the fancier stuff. If you shove a bunch of moldy vegetables and low-grade meat in the cafeteria food dispenser, you're gonna get what you pay for, so to speak. But it didn't matter what I told the bigwigs with the checkbooks. They always ordered the cheapest they could and were rewarded for cutting the budget.

These recipes are not going to win any awards or be featured in any upscale restaurant, but the line cooks in the galley did the best they could with the supplies they were given. Given how relatively cold and depressing the inside of a battlecruiser can be, I might even say these meals are a bit charming, old classics, meant to lean on nostalgia and inspire a sort of longing of home. Sometimes, though, I had a bit too many hot dog dinners, and the only longing I had was for the head.

The good news for you reading this at home is that you don't need to go out to a military surplus store and buy your own UNSC food dispenser. You can make the staples of an interstellar cruiser all in the comfort of your own kitchen. I even made some changes to make these recipes a bit more palatable with some good ingredient choices—you know, the good stuff that I was supposed to be persuading the ones with the money to buy. Please don't make the same mistake they did. Find yourself some good ingredients to make these meals as special as they should be.

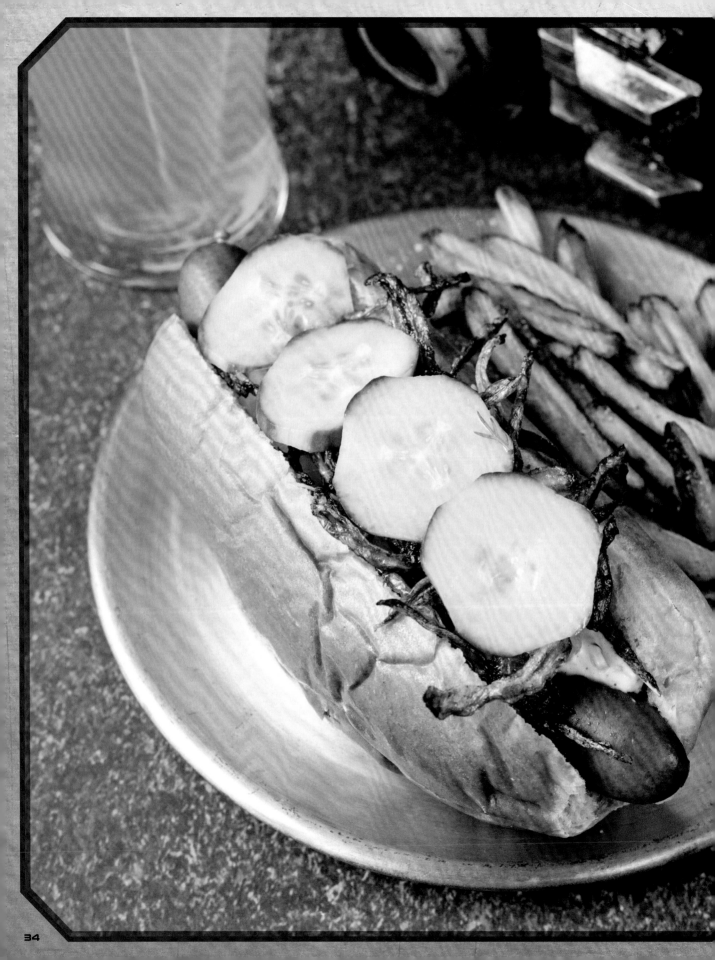

# HOT DOG DINNER

**Difficulty**: Easy
**Prep Time**: 30 minutes
**Rest Time**: 30 minutes
**Cook Time**: 15 minutes
**Yield**: 6 hot dogs
**Dietary Notes**: N/A

## PICKLED CUCUMBERS

½ cup (118 ml) white vinegar
½ cup (118 ml) water
⅓ cup (67 g) sugar
1 tsp. (5 g) mustard seeds
1 tsp. (5 g) black peppercorns
3 sprigs fresh dill
2 small cucumbers, thinly sliced

## RÉMOULADE

⅓ cup (75 g) mayonnaise
2 tbsp. (28 g) yogurt
1 tsp. (5 g) Dijon mustard
1 tbsp. (15 g) shallot, minced
1 tbsp. (13 g) capers, minced
2 tbsp. (28 g) pickled cucumbers, minced

## FRIED ONIONS

Oil for deep-frying
1½ onions, thinly sliced

## HOT DOGS

6 hot dogs, cooked
6 hot dog buns
Rémoulade
Spicy mustard
Fried onions
¼ onion, chopped
Pickled cucumbers

*Who doesn't like a good hot dog recipe? And this one, in particular, isn't your usual hot dog, either. This is a Danish-style, onions-on-onions, direct-to-your-taste-buds hot dog. You gotta mix things up and try it if you've never had one.*

## PICKLED CUCUMBERS

1. Combine the white vinegar, water, and sugar in a large airtight container. Add mustard seeds, black peppercorns, dill, and cucumber. Cover and place in the refrigerator for at least 30 minutes. (The pickled cucumbers can be stored in the refrigerator for about 1 week.)

## RÉMOULADE

1. Combine everything in a small airtight container. Cover and store until needed. (The rémoulade can be stored in the refrigerator for about 1 week.)

## FRIED ONIONS

1. Place about 1 inch (2½ cm) of oil in a deep pot and heat it to 300°F (149°C). In batches, add the onion slices and cook until golden brown and crispy, about 3 to 5 minutes. Remove and transfer to a plate with a paper towel. Repeat with the remaining onion slices.

## HOT DOGS

1. Place the hot dog in a hot dog bun. Top with the rémoulade and spicy mustard. Add the fried onions and raw onions. Top with the pickled cucumbers. Repeat for additional hot dogs.

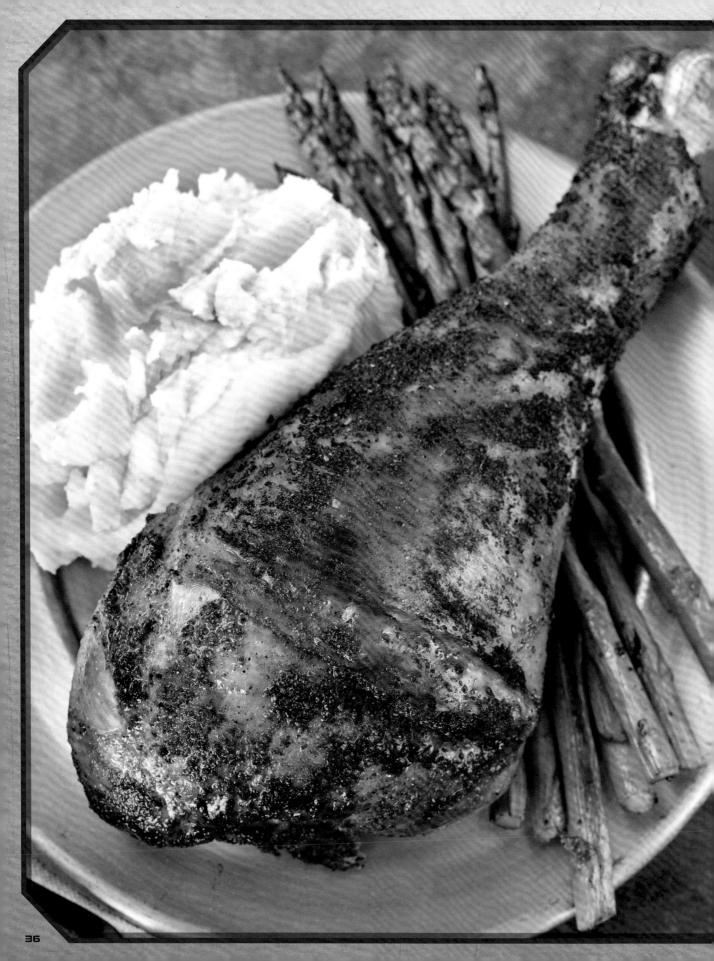

# TURKEY DINNER

*The turkey-dinner meal that came out of the food dispensers was always just a smidge short of being delicious, so I went a little extra on this recipe and put together something that puts the cafeteria food to shame. It's not a contest or anything. I'm here on solid ground, and they're making do with packaged supplies—but my version is still definitely better.*

**Difficulty**: Easy
**Prep Time**: 1 hour
**Rest Time**: 12 hours
**Cook Time**: 1½ hours
**Yield**: 4 servings
**Dietary Notes**: N/A

### BRINE

8 cups (1.9 L) water
½ cup (137 g) salt
¼ cup (50 g) sugar
¼ cup (55 g) light brown sugar
1 tsp. (2 g) ground black pepper
2 tbsp. (20 g) garlic powder
1 tbsp. (9 g) chile powder

### ROAST TURKEY LEG

4 turkey legs
2 bay leaves
2 carrots, cut into large chunks
3 celery stalks, cut into large chunks
5 garlic cloves, crushed
1 onion, quartered

### DRY RUB

2 tsp. (7 g) sweet paprika
1 tsp. (3 g) chile powder
½ tsp. (2 g) onion powder
½ tsp. (2 g) cumin
¼ tsp. (1 g) coriander
1 tbsp. (14 g) light brown sugar

### MASHED POTATOES

Canola oil for sautéing
1 onion, sliced
Salt
2 lb. (907 g) russet potatoes
½ cup (114 g) unsalted butter
8 oz. (226 g) cream cheese
¼ cup (56 g) sour cream
Pepper

## TURKEY

1. Combine the water, salt, sugar, brown sugar, pepper, garlic powder, and chile powder in a large pot and heat over medium-high heat until the salt dissolves. Allow to cool completely.

2. Split the turkey legs between two large, sealable storage bags, with 1 bay leaf in each. Once the spiced water has cooled, divide it between the two bags. Place in the refrigerator and allow to marinate for 12 hours.

3. Preheat the oven to 375°F (191°C). Prepare a large, deep baking dish by placing the carrots, celery, garlic, and onion on the bottom.

4. Combine all the ingredients for the dry rub in a small bowl. Remove the turkey from the brine, discard the brine, and pat dry. Generously rub the turkey with the dry-rub mix. Place the turkey legs on top of the vegetables in the baking dish. Bake for 20 minutes. Reduce heat to 350°F (177°C) and bake for another 20 minutes. Flip the turkey legs and bake for another 30 minutes, or until they reach an internal temperature of 165°F (74°C).

## MASHED POTATOES

1. Heat a large frying pan with canola oil over medium heat. Add the onion slices and toss to coat with the oil. Sauté the onion slices until they turn translucent, about 2 minutes.

2. Add salt, stir, and reduce the heat to medium low. Continue cooking and stirring occasionally until the onions become golden and caramelized, about 30 to 45 minutes. Remove from the heat and set aside to cool.

3. Place the potatoes in a large pot with just enough water to cover them, and 1 teaspoon (4 g) salt. Bring to a boil and then reduce the heat and simmer for 15 to 20 minutes, or until the potatoes are tender. Drain, and set the potatoes aside. Place the pot back on the stove and add the butter, cream cheese, and sour cream. Add the potatoes and mash until smooth. Add the caramelized onions and mix together. Season with salt and pepper.

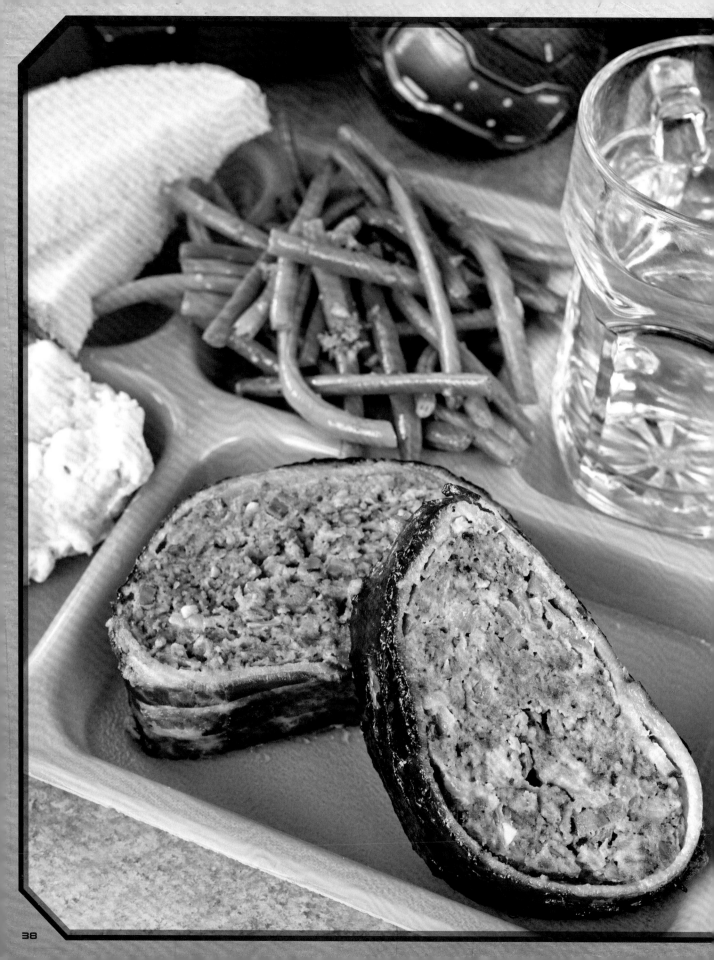

# CHEF'S SPECIAL

**Difficulty**: Medium
**Prep Time**: 45 minutes
**Cook Time**: 1 hour, 15 minutes
**Yield**: 6 to 8 servings
**Dietary Notes**: N/A

*Ah, the old chef's special. If you're in a frigate cafeteria and they're serving the chef's special, they are definitely trying to ditch whatever supplies they have left in a fancy-looking presentation. I usually would suggest caution when ordering it, but I've seen some creative chef's specials, leaning on things like bacon and other meat to pass it off as something special. This one is one of my favorite renditions.*

## MEAT LOAF

1 tbsp. (15 ml) olive oil
1 medium onion, diced
¼ medium red onion, diced
4 garlic cloves, minced
1 carrot, peeled and diced
1 lb. (454 g) ground beef
1 lb. (454 g) ground pork
¾ cup (90 g) breadcrumbs
¼ cup (59 ml) buttermilk
2 eggs
1 tbsp. (15 ml) Worcestershire sauce
1½ tbsp. (22 g) ketchup
1 tbsp. (15 g) Dijon mustard
2 tsp. (8 g) salt
½ tsp. (1 g) ground black pepper
¼ cup (15 g) parsley, chopped
10 to 12 strips bacon

## MEAT LOAF GLAZE

½ cup (76 g) ketchup
2 tbsp. (28 g) light brown sugar
2 tsp. (10 ml) hot sauce
1 tsp. (3 g) chile powder

## GREEN BEANS

2 lb. (907 g) green beans
2 tbsp. (30 ml) olive oil
6 garlic cloves, minced
2 tsp. (4 g) dried oregano

## MEAT LOAF

1. Heat a small frying pan over medium-high heat. Add olive oil and diced onions and cook until the diced onions have softened, about 5 minutes. Add the garlic carrots and cook until the carrots have softened, about 10 minutes. Remove from the heat, transfer to a large bowl, and allow to cool.

2. Preheat the oven to 350°F (177°C). Once the vegetables have cooled, add the ground beef, ground pork, breadcrumbs, buttermilk, eggs, Worcestershire sauce, ketchup, Dijon mustard, salt, pepper, and parsley. Mix until everything has come together. The mixture should be slightly sticky and moist—if it is too difficult to handle, add more breadcrumbs.

3. Prepare a large baking sheet with parchment paper. Transfer the meat mixture and shape it into a 10- to 12-inch (25 to 30 cm) loaf.

4. Whisk together all the ingredients for the glaze until smooth. Brush the shaped loaf with a thin layer of the glaze. Carefully wrap the loaf with slices of bacon, with each slice slightly overlapping.

5. Place in the oven and bake for 50 minutes. Take out and brush with the remaining glaze. Place back in the oven and bake for another 15 minutes, or until it reaches an internal temperature of 165°F (74°C).

6. Once cooked, allow the loaf to rest for 10 minutes before slicing to serve.

## GREEN BEANS

1. Bring a pot of large water to a boil. Place the green beans in the water and allow to cook for 2 minutes. Remove and transfer to a bowl with ice-cold water.

2. Heat a large nonstick frying pan with 2 tablespoons (30 ml) of olive oil over medium-high heat. Add the garlic and cook until it just browns, about 3 minutes. Drain the green beans and add to the pan. Toss until well coated. Add the oregano and toss once more to coat.

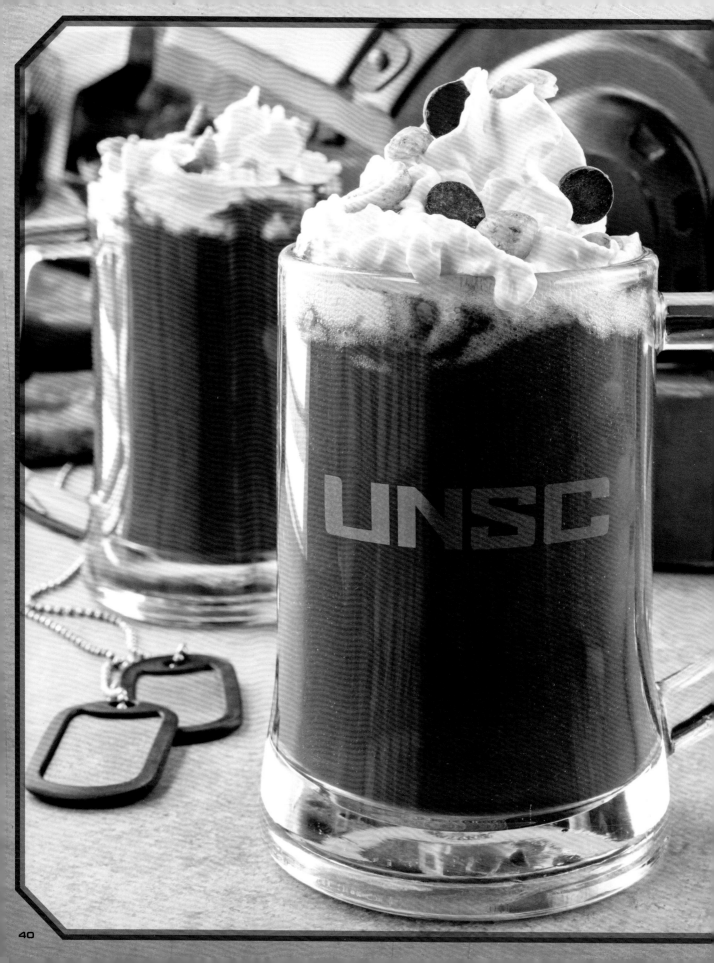

# HOT CHOCOLATE

**Difficulty**: Easy
**Prep Time**: 10 minutes
**Cook Time**: 15 minutes
**Yield**: 2 drinks
**Dietary Notes**: Vegetarian

2 cups (473 ml) oat milk
¼ cup (86 g) honey
⅓ cup (80 g) peanut butter
2 tbsp. (18 g) cocoa powder
Pinch of salt
1 oz. (28 g) dark chocolate, chopped
whipped cream

*Ah, the simple yet decadent hot chocolate. You know, I always hear space referred to as cold and empty. It's actually not cold in the traditional sense, but don't let that stop you from warming yourself up with a nice, warm drink. It is empty, though. Space, specifically—but also my mug shortly after I prepare one of these.*

1. Combine oat milk, honey, peanut butter, cocoa powder, and salt in a medium saucepan over medium heat. Whisk together, making sure the mixture doesn't burn on the bottom of the pan, until it comes to a simmer.

2. Add the chopped chocolate. Cook until the chocolate is melted.

3. Split between 2 cups. Serve with whipped cream.

**NOTE** As this drink cools, the peanut butter will fall to the bottom and make the drink thicker. Be sure to not let this completely cool before you finish enjoying it.

# PEACH ICED TEA

**Difficulty**: Easy
**Prep Time**: 15 minutes
**Rest Time**: 12 hours
**Cook Time**: 20 minutes
**Yield**: 6 to 8 cups
**Dietary Notes**: Vegan

### PEACH SYRUP

3 ripe yellow peaches, sliced
1 cinnamon stick
1 cup (200 g) sugar
1 cup (237 ml) water

### TEA

5 cups (1183 ml) water
3 white tea bags
1 green tea bag

## NOTE

You can use any peach variety, but I've found that yellow peaches give the strongest peach flavor and add a really nice color to the tea.

*There had to be a higher-up in UNSC logistics who loved peaches, because every ship always ordered way too many. The chefs in the kitchen had to get creative with the excess before they went bad, so this peach iced tea is a common beverage wherever you're traveling.*

### PEACH SYRUP

1. Combine the ingredients in a medium saucepan. Bring to a boil. Lower heat to low and allow to simmer for 10 minutes. Remove the cinnamon stick and lightly mash the peaches. Cover and remove from the heat. Let steep for 45 minutes. Strain in a mesh strainer into a large pitcher.

### TEA

1. Heat 5 cups (1183 ml) of water in a large pot over medium-high heat to 175°F (79°C). Add the white and green tea bags. Turn off the heat and steep for 5 minutes. Remove the tea bags, transfer to the pitcher with the peach syrup, and stir together.

2. Allow the combination to cool completely and then store in the refrigerator overnight before serving. Serve in a glass with ice and fresh slices of peaches.

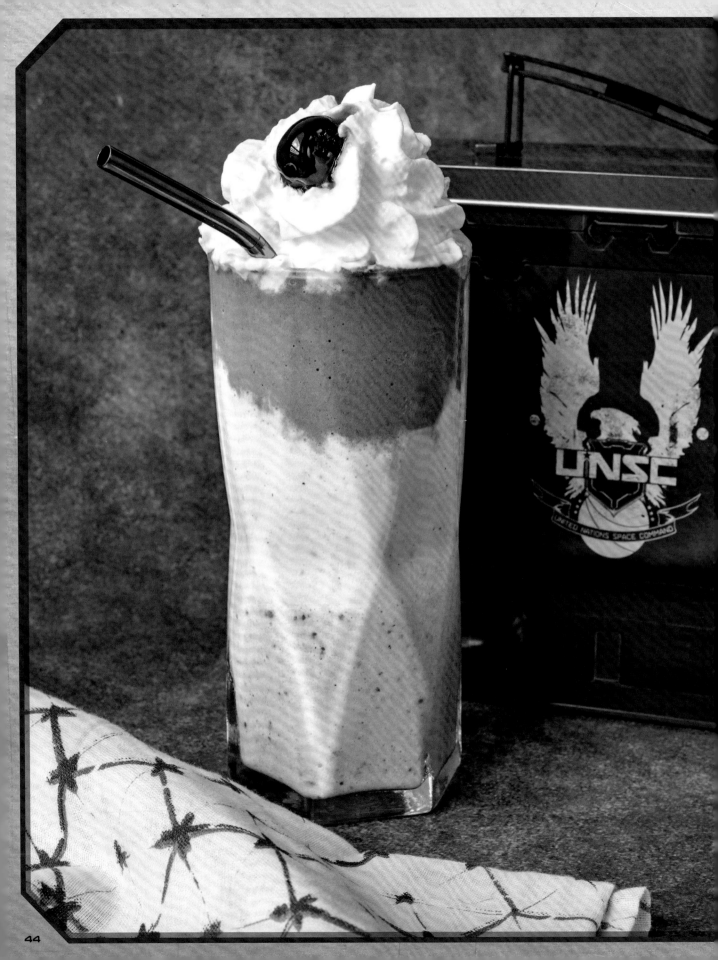

# COOKIE'S SURPRISE

*When new supplies arrive, the chefs on UNSC ships must use the fresh fruit before it starts to go bad. You can always tell when they bring out the "Cookie's Surprise" drink dispensers, a real treat among the usual fare. If you're stuck on a ship, try to get there before they run out.*

**Difficulty**: Easy
**Prep Time**: 30 minutes
**Yield**: 2 shakes
**Dietary Notes**: Vegetarian

### STRAWBERRY LAYER

5 oz. (125 g) strawberries, tops removed
⅔ cup (100 g) vanilla ice cream

### VANILLA-BANANA LAYER

3½ oz. (100 g) banana
¾ cup (112 g) vanilla ice cream

### CHOCOLATE-BANANA LAYER

1½ oz. (43 g) banana
1½ oz. (43 g) chocolate syrup
⅔ cup (100 g) vanilla ice cream

### ASSEMBLY

Whipped cream
2 maraschino cherries

1. Start with the strawberry layer. In a blender, add the strawberries and blend until smooth. Add the ice cream and blend until smooth. If the mixture is too thick, add a small amount of milk. Split the strawberry layer between two large glasses. Cover the glasses and place in the freezer until the next layer is made.

2. Next, the vanilla-banana layer. In a blender, add the banana and vanilla ice cream and blend until smooth. If the mixture is too thick, add a small amount of milk. Carefully, pour this on top of the strawberry layer in each glass. Cover the glasses and place in the freezer until the next layer is made.

3. Finally, the chocolate-banana layer. In a blender, add the banana, chocolate syrup, and vanilla ice cream and blend until smooth. If the mixture is too thick, add a small amount of milk. Carefully pour this layer on top of the vanilla layer in each glass.

4. Top each beverage with whipped cream and a maraschino cherry.

## NOTE

Try to get the good maraschino cherries, not the neon-red ones. Sure, they cost more, but the taste is worth that extra price. This drink is supposed to be special, after all!

# HAVADI GOODWAN

I, like many people, sometimes find myself bereft of inspiration. Looking at my computer screen too long, staring at a blank page with nothing but a vertical line blinking back mockingly at me—that's when I find that a little change of scenery goes a long way to getting the creative juices flowing. So I head on over to the closest Havadi Goodwan. You know the feeling when, as you walk into a neighborhood joint, the layout, the smell, even the people feel familiar? Going to a coffee shop lets me grab a nice drink and maybe a pastry or two and ground myself.

I'm sure you have plenty of coffee shops to pick from, but Havadi Goodwan is the only spot for me. Everything on the menu is special, from the famous custard pies down to their unique twist on coffee. Even the staff there is refreshing, greeting me with a warm smile every time I return and bidding me a good one when I leave. OK—hold on a second. Is this the first time I'm realizing this? Every location waves farewell, telling me to have a good one, and the place is called Havadi Goodwan. How has this not dawned on me until I read it back to myself? There's no way it's a coincidence, right? Once I'm done, I'm heading right over and getting some answers. Ooh, and maybe one of those chocolate chip scones too.

Havadi Goodwan

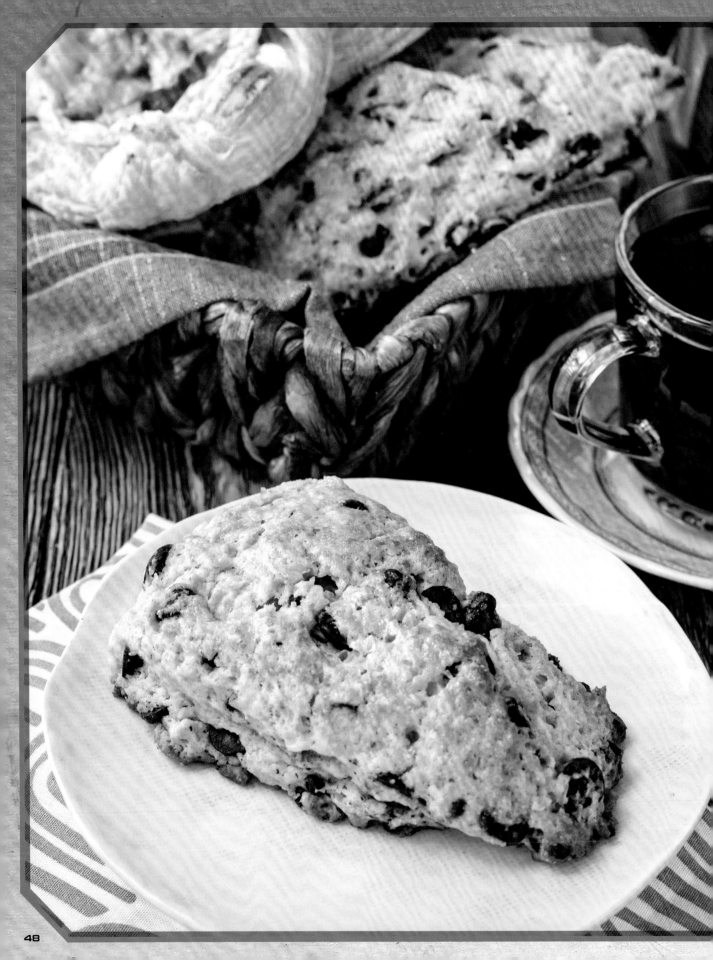

Havadi Goodwan

# CHOCOLATE CHIP SCONES

**Difficulty**: Easy
**Prep Time**: 20 minutes
**Cook Time**: 20 to 25 minutes
**Yield**: 8 scones
**Dietary Notes**: Vegetarian

2¼ cups (281 g) all-purpose flour
1 tbsp. (13 g) baking powder
1 tsp. (4 g) salt
½ tsp. (1 g) cinnamon
⅓ cup (67 g) sugar
2 tbsp. (28 g) light brown sugar
½ cup (114 g) unsalted butter, cubed and frozen
1½ cups (240 g) chocolate chips
1 cup (237 ml) buttermilk
1 tsp. (5 ml) vanilla extract
1 tbsp. (14 g) heavy cream, for brushing
Turbinado sugar, for topping

*I'm always a sucker for a good pastry. You can find scones at all the coffee shops across the galaxy, but the ones at Havadi Goodwan are just out of this world. Yes, I know that sounds corny, but it's my book, and I'm keeping it. Make them for yourself, then get back to me—you'll understand eventually.*

1. Preheat the oven to 375°F (191°C). Combine the flour, baking powder, salt, cinnamon, sugar, and light brown sugar in a large bowl.

2. Combine the butter with the flour mixture until it resembles coarse meal. Add the chocolate chips and toss to combine. Combine the buttermilk and vanilla extract in a small bowl. Add to the large bowl with the flour and mix together until just combined, but do not overwork.

3. Transfer the dough onto the countertop and form into an 8-inch (20 cm) disk. Cut into 8 portions. Prepare a baking sheet with parchment paper and nonstick spray. Place the scones on the baking sheet. Brush the top of the scones with heavy cream and sprinkle with turbinado sugar.

4. Bake for 25 to 30 minutes or until golden brown.

Havadi Goodwan

# CHEESE DANISH

**Difficulty**: Easy
**Prep Time**: 30 minutes
**Cook Time**: 20 minutes
**Yield**: 8 pastries
**Dietary Notes**: Vegetarian

8 oz. (226 g) cream cheese, room temperature
¼ cup (50 g) sugar
1 tbsp. (19 g) sweetened condensed milk
1 tsp. (5 ml) vanilla extract
1 egg yolk
½ tsp. (1½ g) ground cardamom
½ tsp. (2 g) salt
2 frozen puff pastry sheets, thawed

### EGG WASH
1 egg
1 tbsp. (15 ml) whole milk

*I can already hear the critics saying "Oh, Arturo, you use store-bought puff pastries? What would your mamá think?" I want these recipes to be approachable for everyone, so what's the harm if you cheat a little? Instead of spending all that time making perfect buttery layers, you get to cram these Danishes in your mouth that much faster.*

1. Whisk together the cream cheese, sugar, sweetened condensed milk, vanilla extract, egg yolk, cardamom, and salt in a medium bowl until smooth. Set aside.

2. Prepare your egg wash by whisking together the whole egg and milk in a small bowl. Prepare a large baking sheet by placing a sheet of parchment paper on it (or 2 medium baking sheets, each with a sheet of parchment paper).

3. Split each puff pastry sheet into 4 quarters, resulting in 8 pieces in total. Lightly roll out 1 of the portions, making it 25 percent larger. Brush the edges of the pastry with the egg wash. Fold the corners over toward the center about 1½ inches (3½ cm) and lightly press down. Transfer to the prepared baking sheet. Repeat this step with the remaining portions.

4. Preheat the oven to 375°F (191°C). Split the filling between the 8 portions by spooning some of the mixture in the center of the prepared puff pastry sheets. Transfer the baking sheet to the freezer and let rest for 5 minutes, or until your oven has preheated.

5. Take the baking sheet out of the freezer and brush the edges of the puff pastry with egg wash. Place in the oven and bake until the puff pastry is golden brown, about 18 minutes, rotating the sheet halfway through. Turn off the oven heat and let the pastries sit in there for another 2 minutes. Remove and allow to cool slightly before serving.

**NOTE** Please learn from my mistakes and let these cool before you eat them. As tempting as it may be, you don't want to ruin the experience by burning the roof of your mouth.

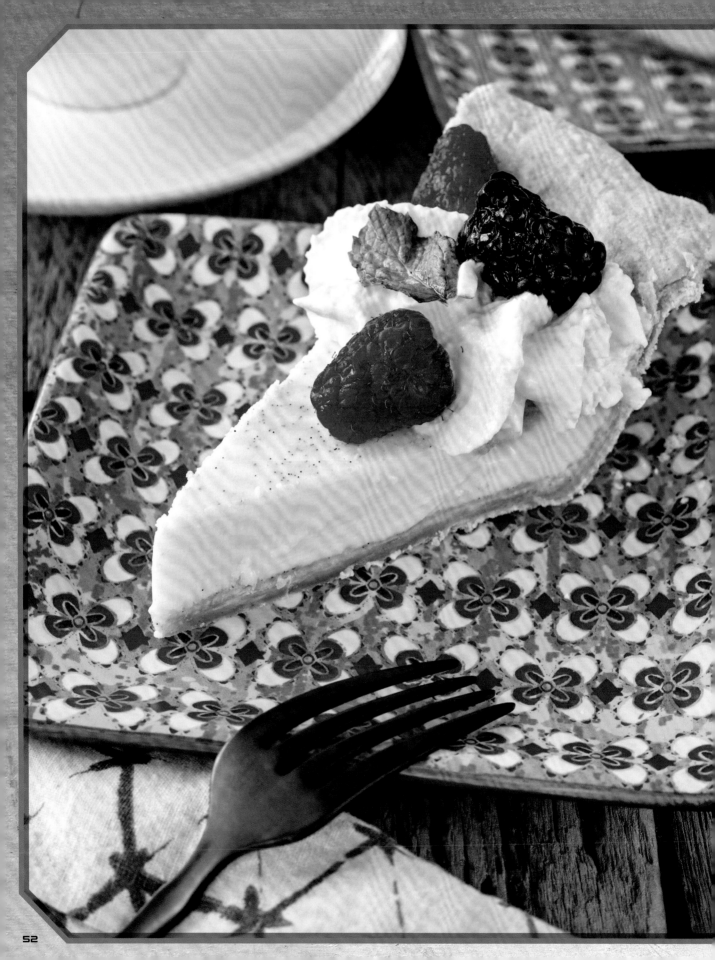

# CUSTARD PIE

**Difficulty**: Medium
**Prep Time**: 45 minutes
**Rest Time**: 2 hours
**Cook Time**: 1 hour
**Yield**: 1 pie
**Dietary Notes**: Vegetarian

### PIE CRUST

1½ cup (188 g) all-purpose flour
½ tsp. (1 g) cinnamon
½ tsp. (2 g) salt
½ tsp. (3 g) sugar
10 tbsp. (140 g) unsalted butter, cubed and cold
4 tbsp. (59 ml) ice water

### FILLING

4 eggs
½ cup (100 g) sugar
¾ cup (173 g) heavy cream
1¾ cup (414 ml) whole milk
¼ cup (57 ml) sweetened condensed milk
1 vanilla bean, scraped
½ tsp. (2 g) salt
1 tsp. (5 ml) vanilla extract

*Sometimes, when enjoying a nice cup of coffee at Havadi Goodwan, I get a craving for a simple dessert that won't take away from the deep bitterness of my drink. This pie is just that. It is what put Havadi Goodwan on everyone's must-stop-and-try list. It is simple and straightforward yet works so perfectly with the rest of their menu.*

1. Pulse the flour, cinnamon, salt, and sugar a few times in a food processor to combine. Add butter and pulse until it resembles a coarse meal. Add ice water slowly while the food processor runs until it just comes together. If the dough is too dry, add more water 1 teaspoon (5 ml) at a time. Remove the dough from the food processor and onto a lightly floured surface. Flatten to a disk and wrap in plastic wrap. Refrigerate for at least 2 hours and up to 24 hours.

2. Remove the dough from the plastic wrap and place on a floured surface. Use a rolling pin to roll the dough until it is ¼ inch (6 mm) thick and roughly 12 inches (30 cm) in diameter. Transfer the dough to a 9-inch (23 cm) pie pan. Press the dough into the dish and cut any excess dough off the edge of the dish. Cover with plastic wrap and place in the refrigerator.

3. Preheat the oven to 375°F (191°C). Once heated, remove the plastic wrap from the pie pan. Place a piece of parchment paper on top of the crust and dried beans (or pie weights) on top of that. Place in the oven and bake for 20 minutes.

**NOTE** Place the weights on the pie to keep the crust from expanding. Do not skip this step!

4. Remove the beans or weights and parchment paper and bake for another 10 minutes, until the bottom turns golden brown. Remove from the oven and reduce the heat to 300°F (149°C).

5. Combine the eggs and sugar in a large bowl. Set aside. Combine the heavy cream, whole milk, sweetened condensed milk, vanilla bean and seeds, and salt in a medium saucepan. Place over medium heat and heat until it begins to steam and right before it comes to a boil.

6. Remove from the heat and remove the vanilla bean pod. Slowly stream the heated milk into the large bowl while continuously whisking slowly. (You do not want to scramble the eggs.) Once all the milk is added, add the vanilla extract. Transfer the mixture, through a fine mesh strainer, into your prepared pie crust.

7. Cover the edges of the pie crust with aluminum foil to avoid overcooking it. Place in the oven and cook for 35 to 45 minutes, until it is set and reaches an internal temperature of 175°F (79°C).

8. Remove from the oven and let cool completely. Cover, place in the refrigerator, and let rest for at least 2 hours before serving. This pie can stay in the refrigerator for up to 3 days.

# FREYA'S TEA

**Difficulty**: Easy
**Prep Time**: 15 minutes
**Cook Time**: 30 minutes
**Yield**: 2 cups
**Dietary Notes**: Vegan

4 oz. (113 g) raspberries
4 oz. (113 g) blackberries
1 cup (200 g) sugar
7 cups (1656 ml) water, divided
2 mint sprigs
½ cup (118 ml) lemon juice
4 Earl Grey tea bags

*When it's a hot summer day and a cup of coffee just doesn't fit the bill, Freya's Tea is a great way to cool down. It's sweet, minty, and perfectly refreshing. This recipe makes a lot of tea, so show some restraint, and don't drink it all at once, alright?*

1. Combine the raspberries, blackberries, sugar, and 1 cup (237 ml) of water in a medium saucepan. Stir until the sugar has dissolved, then bring to a boil. Reduce the heat and simmer for 15 minutes. Remove from the heat, add mint, and let sit for 10 minutes. Strain through a fine mesh strainer into a pitcher. Add the lemon juice to the pitcher and mix well.

2. Heat the remaining 6 cups (1422 ml) of water in a large pot over medium-high heat until it comes to a boil. Add the tea bags and turn off the heat. Let steep for 6 to 8 minutes. Remove the tea bags, transfer to the pitcher, and stir together.

3. Allow the combination to cool completely, then store in the refrigerator overnight before serving. Serve in a glass with ice and fresh blackberries, raspberries, and lemon slices.

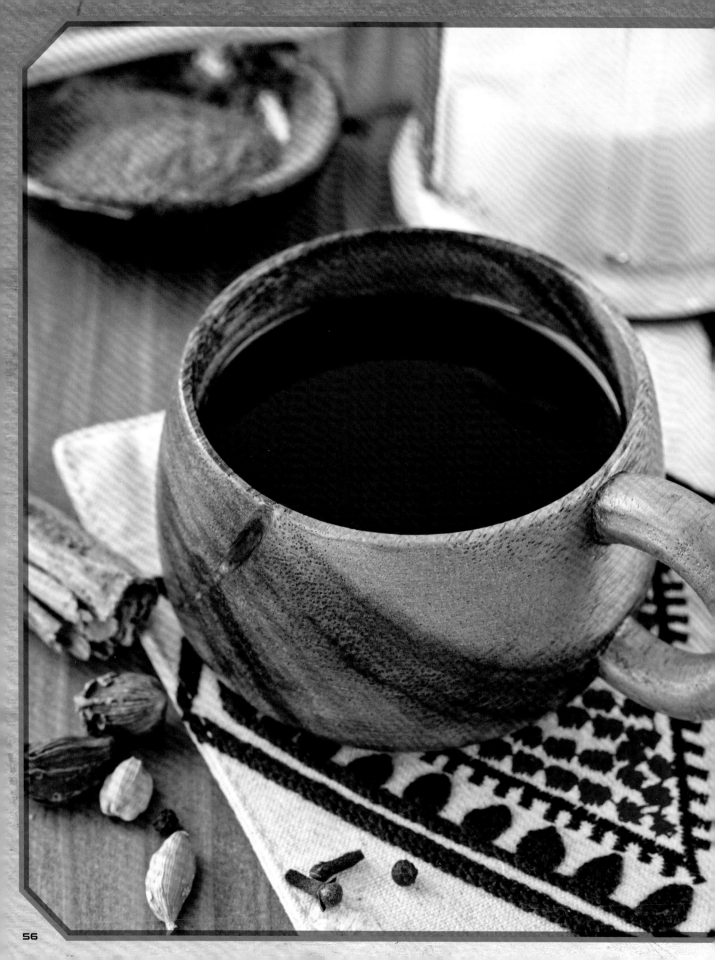

# SPICED COFFEE

**Difficulty**: Easy
**Prep Time**: 30 minutes
**Cook Time**: 10 minutes
**Spice Yield**: 4 to 6 coffee servings
**Dietary Notes**: Dairy-free, vegan

*Havadi Goodwan has this amazing, spiced coffee that makes the whole shop smell amazing. I tried figuring out my own method for brewing this spiced wonder, but I kept having issues with paper filters getting blocked up by the spices. I eventually realized using a French press gets around that issue, but not before I made a giant mess.*

## SPICE MIXTURE

1 cinnamon stick
10 green cardamom pods
1 black cardamom pod
4 cloves
10 black peppercorns
Pinch of ground nutmeg
1 tsp. (2 g) ground ginger

## PER DRINK

4 tbsp. (20 g) ground coffee, medium grind (preferably fresh ground)
½ tbsp. (2 g) spice mixture
¾ cup (177 ml) water, just off boiling

1. Heat a small stainless steel frying pan over medium heat. Add the cinnamon stick, cardamom pods, cloves, and black peppercorns. Allow to lightly toast for about 3 minutes. Set aside and allow to cool completely.

2. Transfer to a spice grinder and blend until the peppercorns have been ground. Transfer to an airtight container. Add the nutmeg and ginger. This mixture is enough for around 4 to 6 servings of coffee and can be stored in the airtight container for up to 1 month.

3. Combine the ground coffee and the spice mixture and pour them into a French press. Add water just off boiling, place the top of the French press on, and let rest for 4 minutes.

4. Remove the top and stir the top of the mixture, breaking up the grounds on top. Return the top of the French press and let sit for another 4 minutes. Push down on the French press filter and serve.

# FRONK'S

Fronk's first location, down in the Longshore district along the coast of Old Mombasa, was an institution. Right on the water, with access to all the bounty the ocean has to offer, they did fish better than any. Everyone knew of the commonly advertised formed-fish nuggets. I still dream about those sometimes. But the rest of their menu was a treat to explore. And if you happened to be in the area during a holiday, the owner changed up the standard menu with some pretty wild variations. You just had to be lucky enough to get there early before the holiday menu lines started running down the pier. I didn't have any sort of professional interaction with Fronk's; I was just a fan. And I went often.

But this original Fronk's location is no more. Yet another casualty of the constant struggle that humanity has found itself in since it dared to leave home. You know, I intended to make this cookbook a celebration of all the great things we've done as a people with our cuisine. But the more I look back at all my favorite places that met unfortunate ends, the more I'm starting to feel like an archivist—like I'm trying to gather all the good things we did as a people in the kitchen and put them all in one place before the knowledge is gone. I did not have those sorts of higher aspirations when I started collecting these recipes, but sometimes life sends you in a funny, formed-fish direction.

Fronk's
KEBABS







Fronk's

# KEBABS



**Difficulty**: Medium
**Prep Time**: 30 minutes
**Cook Time**: 15 minutes per batch
**Yield**: 4 kebabs
**Dietary Notes**: Dairy-free

Ingredients:

Canola oil for sautéing and deep-frying
½ medium onion, diced
1 shallot, diced
4 garlic cloves, minced
1 tbsp. (6 g) ginger paste
1 tbsp. (9 g) paprika
1 tsp. (3 g) ground cumin
½ tsp. (2 g) turmeric
1 lb. (454 g) ground beef
½ bunch cilantro, minced
½ cup (60 g) breadcrumbs
4 eggs
½ cup (63 g) all-purpose flour





61.

Fronk's

# KEBABS

*I used to get these great beef kebabs around Old Mombasa, but ever since the Covenant glassed that part of the city, I haven't been able to get in contact with the butcher that sold them. I was missing the kebabs, so I figured I'd make 'em myself, but I miss that kind butcher too. Hope he's doing OK.*

**Difficulty**: Medium
**Prep Time**: 30 minutes
**Cook Time**: 15 minutes per batch
**Yield**: 4 kebabs
**Dietary Notes**: Dairy-free

Canola oil for sautéing and deep-frying
½ medium onion, diced
1 shallot, diced
4 garlic cloves, minced
1 tbsp. (6 g) ginger paste
1 tbsp. (9 g) paprika
1 tsp. (3 g) ground cumin
½ tsp. (2 g) turmeric
1 lb. (454 g) ground beef
½ bunch cilantro, minced
½ cup (60 g) breadcrumbs
4 eggs
½ cup (63 g) all-purpose flour

1. Heat a large frying pan over medium-high heat with enough canola oil to sauté. Add the onion and shallot and cook until just softened. Add the garlic and cook for another 2 minutes. Add the ginger paste, paprika, cumin, and turmeric and mix until combined. Remove from the heat and place the vegetables on a plate with a paper towel to drain the excess oil. Allow to cool completely.

2. Transfer the cooled vegetables to a large bowl. Add the ground beef, cilantro, breadcrumbs, and 1 egg. Stir together until just combined. Split into 4 equal portions. Shape into 4-inch-long (10-cm-long) tubes.

3. Pour 2 inches (5 cm) of canola oil in a deep pot and heat to 365°F (185°C). Place the all-purpose flour on a plate. Whisk together the remaining 3 eggs in a bowl.

4. Once the oil has heated, coat the kebab in all-purpose flour. Dip the floured kebab in the egg and allow any excess egg to drip off. Place in the oil and deep-fry until all sides are golden brown, about 2 to 3 minutes. Remove the kebab from the oil and transfer to a paper towel to drain for about 1 minute.

5. Place the kebab in the egg mixture again and deep-fry until all sides are golden brown, about 2 to 3 minutes. Remove the kebab from the oil and transfer to a paper towel to drain for about 1 minute. Repeat this step 2 to 3 more times. At the end of this process, the ground meat should be cooked through.

6. Repeat steps 4 and 5 for the remaining kebabs.

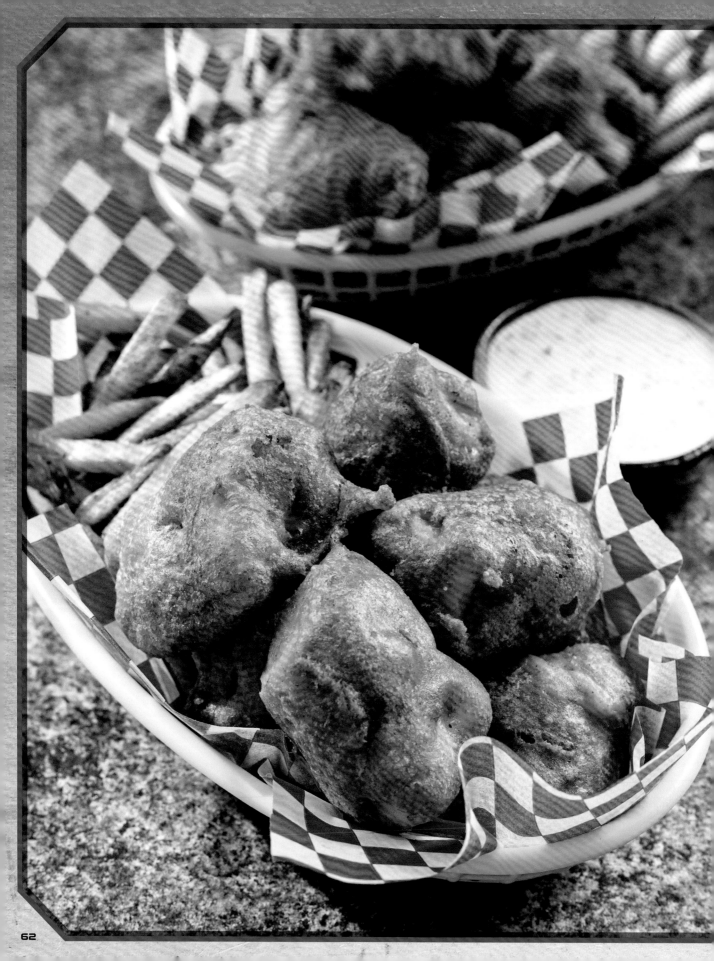

# FRONK'S FISH NUGGETS

**Difficulty**: Medium

**Prep Time**: 30 minutes

**Rest Time**: 1 hour

**Cook Time**: 3 to 5 minutes per batch

**Yield**: 8 servings

**Dietary Notes**: Dairy-free

### TARTAR SAUCE

¾ cup (180 g) mayonnaise

1 tsp. (5 g) Dijon mustard

¼ tsp. (1 ml) Worcestershire sauce

Zest and juice of 1 lemon

2 tsp. (4 g) fresh dill, minced

1 tsp. (3 g) parsley, minced

¼ cup (36 g) pickles, finely chopped

1 tbsp. (15 g) capers, finely chopped

1 shallot, finely chopped

### FISH NUGGETS

Peanut oil for deep-frying

1½ cups (188 g) all-purpose flour

1 tsp. (4 g) baking powder

1 tsp. (4 g) salt

1 tsp. (4 g) garlic powder

2 tsp. (8 g) onion powder

2 tsp. (6 g) paprika

12 oz. (340 ml) amber ale

2 lb. (907 g) cod, cut into 2-in. cubes

Salt

Pepper

*There's a reason Fronk's Fish Nuggets is the leading actor in a cast of delicious offerings. The fish is buttery, and crunchy, and fresh, and melts as soon as you bite into it. And when they're in these conveniently small nuggets, you very quickly can lose track of how many you've already eaten.*

### TARTAR SAUCE

1. Mix everything together and let rest for 1 hour before serving. Can be stored in a small airtight container in a refrigerator for up to 1 week.

### FISH NUGGETS

1. Fill a deep pot with 2 inches (5 cm) of peanut oil and heat over medium heat to 375°F (191°C).

2. Whisk together 1¼ cups (156 g) all-purpose flour, baking powder, salt, garlic powder, onion powder, paprika, and amber ale in a medium bowl. If the batter is too thick, add water to loosen it. Salt and pepper each of the fish pieces. Place the remaining flour on a plate. Cover each piece in flour. Set them aside until you are ready to start deep-frying.

3. Once the oil is at the right temperature, dunk each of the fish pieces in the batter, coating them completely. Place the fish in the oil and cook for 3 to 4 minutes. Flip the fish halfway through, or until the batter is golden brown and the fish is cooked through.

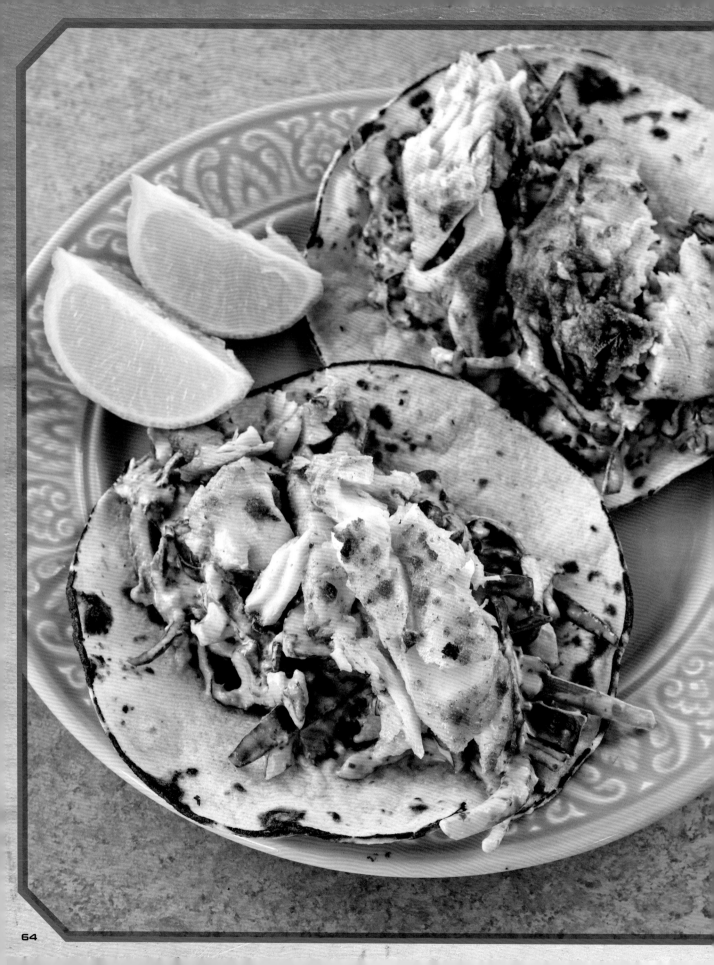

# FRONK'S FISHTACULAR TACOS

*Fronk's daily special might appear simple, like it's very unimaginative name, but the flavors are crisp and refreshing and well worth the effort. Try this recipe once, and you'll want it every day of the week too.*

**Difficulty**: Easy
**Prep Time**: 30 minutes
**Rest Time**: 15 minutes
**Cook Time**: 10 minutes
**Yield**: 8 servings
**Dietary Notes**: N/A

## AVOCADO AND SOUR CREAM SLAW

1 cup (226 g) sour cream
1 ripe avocado
1 jalapeño, chopped and seeded
2 garlic cloves, crushed
½ bunch cilantro
1 tbsp. (21 g) honey
Juice of 3 limes
½ red cabbage, cored and thinly sliced
¼ red onion, thinly sliced
Salt
Pepper

## BLACKENED TILAPIA

3 tbsp. (45 ml) olive oil
Juice of 1 lime
1 tsp. (3 g) smoked paprika
1 tsp. (3 g) garlic powder
2 tsp. (2 g) Mexican oregano
1 tsp. (3 g) onion powder
1 tsp. (2 g) ground cumin
1 tsp. (2 g) ground coriander
½ tsp. (2 g) salt
1 tsp. (5 g) brown sugar
¼ tsp. (½ g) cayenne pepper
3 tilapia fillets

## FOR SERVING

8 corn tortillas
2 limes, quartered

## AVOCADO AND SOUR CREAM SLAW

1. Place sour cream, avocado, jalapeño, garlic cloves, cilantro, honey, and lime in a food processor and blend until smooth. Add the mixture in a large airtight container with the cabbage and red onion and toss together. Season with salt and pepper. Place in the refrigerator until ready to serve.

## BLACKENED TILAPIA

1. Combine the olive oil, lime juice, smoked paprika, garlic powder, Mexican oregano, onion powder, cumin, coriander, salt, brown sugar, and cayenne pepper in a medium bowl. Add the tilapia fillets and mix until well combined. Allow to marinate at room temperature for 15 minutes.

2. Heat a large nonstick frying pan with nonstick spray over medium-high heat. Place the tilapia fillets in the pan and cook for 3 to 4 minutes per side, or until cooked through.

3. To assemble the tacos, simply warm some tortillas up and add some of the slaw and cooked fish.

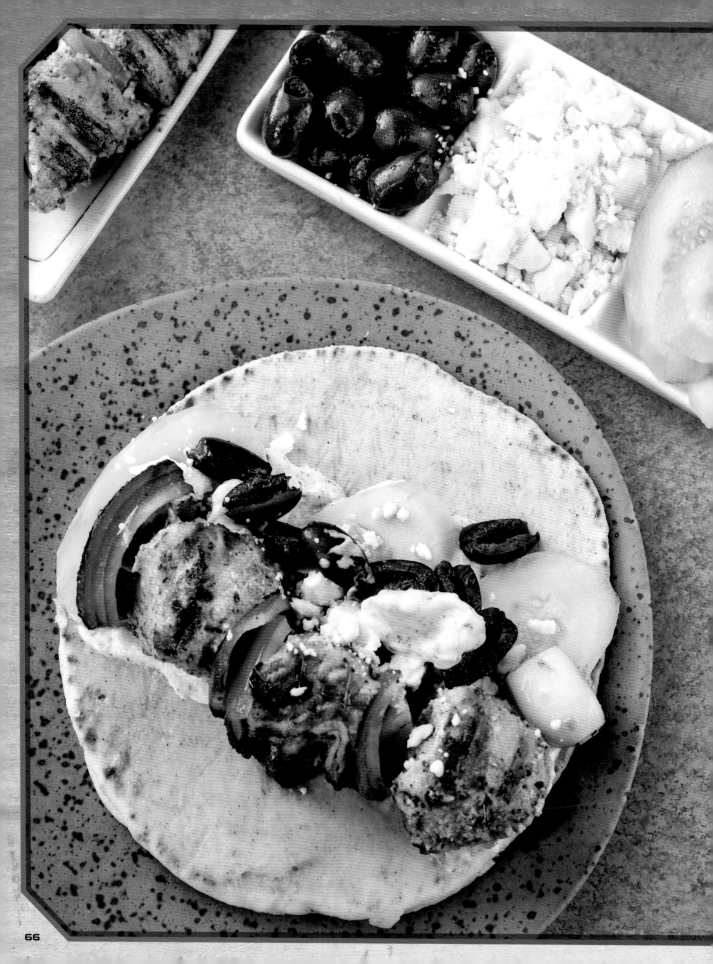

# TUNA GYROS

**Difficulty**: Easy
**Prep Time**: 30 minutes
**Rest Time**: 1 hour
**Cook Time**: 10 minutes
**Yield**: 4 Servings
**Dietary Notes**: N/A

*One time, I stopped by Fronk's and ordered these tuna gyros, I asked the owner if their logo was supposed to be a tuna. He just stared at me coldly, like I had betrayed him. "Uhhh, or is it a whale?" He snorted and handed me my gyros but went back to the kitchen without another word. So, which is it? Is a cold stare, or a snort, more of a confirmation?*

### TZATZIKI

1 cucumber, peeled and grated
3 garlic cloves, minced
1 cup (245 g) Greek yogurt
2 tbsp. (30 ml) olive oil
1½ tsp. (7½ ml) red wine vinegar
Zest and juice of 1 lemon
1 tbsp. (2 g) fresh dill, chopped
1 tbsp. (3 g) fresh mint, chopped
2 tsp. (2 g) dried oregano
½ tsp. (2 g) salt

### TUNA

¼ cup (59 ml) olive oil
1 tbsp. (15 ml) red wine vinegar
Zest and juice of 2 lemons
2 tsp. (7 g) garlic powder
2 tsp. (7 g) onion powder
2 tsp. (4 g) ginger powder
1 tbsp. (3 g) dried oregano
1 tsp. (5 g) sugar
1 tsp. (4 g) salt
½ tsp. (½ g) pepper
1 lb. (454 g) tuna, cut into cubes
½ red onion, cut into bite-size pieces

### PER GYRO

1 pita bread
Tzatziki
3 cucumber slices
Feta cheese
Kalamata olives

## TZATZIKI

1. Salt the cucumber and let sit for 10 minutes to help remove some liquid.

2. Mix in the garlic and yogurt until well combined in a medium bowl. Add the remaining ingredients. Mix until well combined.

3. After the cucumber has rested, squeeze out the extra liquid. Add to the bowl and mix. Can be stored in an airtight container in the refrigerator for a week.

## TUNA

1. Combine the olive oil, red wine vinegar, lemon zest and juice, garlic powder, onion powder, oregano, sugar, salt, and pepper in a large bowl. Whisk together until the sugar has dissolved. Add the tuna and toss until combined. Seal, place in the refrigerator, and let marinate for at least 30 minutes, up to 1 hour.

2. Allow the wooden skewers to soak in water for 30 minutes prior to grilling. Remove the tuna from the marinade. Place a piece of tuna on the skewer, followed by 2 pieces of red onion. Repeat until you have 3 pieces of tuna on the stick. Cook the skewered tuna and onion for 5 to 10 minutes on a preheated grill, flipping to crisp all sides. Remove the tuna and onion from the skewers before serving.

## ASSEMBLY

1. To make a gyro, warm up a pita. Top with tzatziki, cucumbers, tuna, red onion, feta cheese, and Kalamata olives.

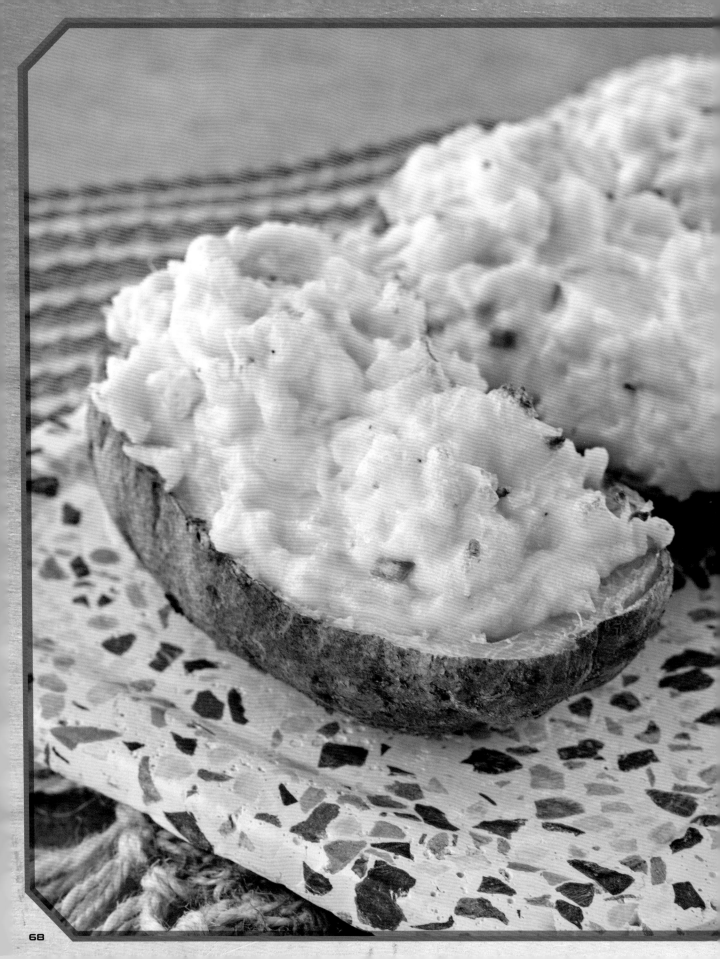

# LOBSTER-LOADED
# BAKED POTATO

*You can't go wrong with the topping you throw on a baked potato, but Fronk's definitely has it right. You need to try this lobster baked potato with all the amazing dairy you can fit.*

**Difficulty**: Medium
**Prep Time**: 30 minutes
**Cook Time**: 1½ hours
**Yield**: 4 servings
**Dietary Notes**: N/A

2 russet potatoes
Salt
2 lobster tails
5 tbsp. (70 g) unsalted butter, room temperature
2 garlic cloves, minced
¼ cup (56 g) cream cheese, room temperature
¼ cup (61 g) sour cream
2 scallions, chopped
¼ cup (59 g) cheddar cheese
Ground black pepper

1. Preheat the oven to 400°F (204°C). Wash the potatoes and then dry them. Stab several times with a fork and place on a baking sheet. Bake for 1 to 1½ hours or until tender. Remove from the oven and reduce the heat to 350°F (177°C). Allow to cool. When the potatoes are cool enough to handle, cut them in half lengthwise. Scoop out the inside into a bowl, leaving about a ¼-inch-thick (6-mm-thick) wall in the potato.

2. To prepare the lobster tails, bring a medium pot with water and salt to a boil. Place the lobster in and allow to boil for 3 to 4 minutes, until the lobster meat is cooked through. Remove meat, chop into large chunks, and place in a large bowl.

3. Heat a small frying pan over medium-high heat. Add 3 tablespoons (42 g) butter and let it melt. Add the garlic and toss. Cook until the garlic softens and browns slightly, about 2 minutes. Add to the bowl with the lobster and toss together well.

4. Add 2 tablespoons (28 g) butter, cream cheese, and sour cream in a medium bowl. Add the potatoes and mash until smooth. Add the scallions and cheddar cheese and season with salt and pepper. Fold in the garlic and lobster mixture to the mashed potatoes.

5. Add the mixed mashed potatoes in each of the potato skins. Bake for 15 minutes.

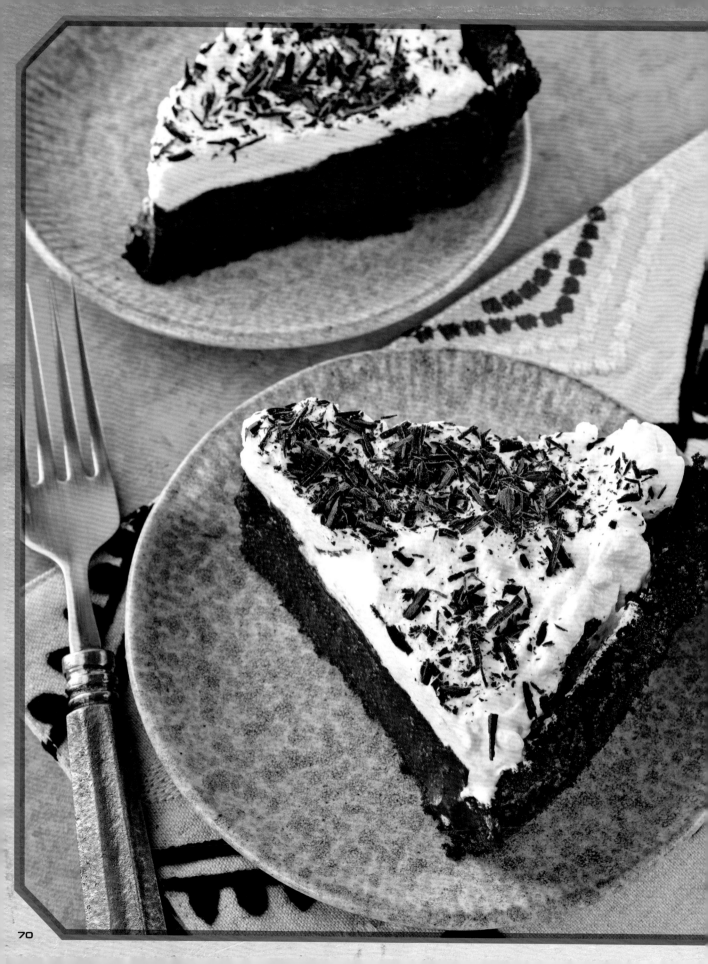

# CHOCOLATE CREAM PIE

*In a world full of peril and uncertainty, you could always count on Pie Day Friday. Bitter and chocolatey like a dream you don't want to wake up from. What? My dreams can be like that sometimes. Don't judge me until you try this dessert for yourself.*

**Difficulty**: Medium
**Prep Time**: 30 minutes
**Cook Time**: 30 minutes
**Rest Time**: 4 hours
**Yield**: 1 pie
**Dietary Notes**: Vegetarian

## CRUST

10 oz. (284 g) chocolate graham crackers
5½ tbsp. (77 g) unsalted butter
1 tsp. (4 g) salt

## CUSTARD FILLING

5 egg yolks
¼ cup (40 g) cornstarch
1½ cups (355 ml) milk
1¼ cups (289 g) heavy cream
¼ cup (57 g) sweetened condensed milk
½ cup (114 g) sugar
½ tsp. (2 g) salt
¼ tsp. (1 g) espresso powder
8 oz. (226 g) bittersweet chocolate, chopped
1 tbsp. (14 g) unsalted butter
2 tsp. (10 ml) vanilla extract

## WHIPPED CREAM

1 cup (231 g) heavy cream
1 tbsp. (11 g) confectioners' sugar
Pinch of salt

1. Preheat the oven to 350°F (177°C). Pulse the chocolate graham crackers into a fine crumb in a food processor. Add the butter and salt and pulse together until combined. Transfer to a 9-inch (23 cm) pie pan and press against the bottom and sides to form an even layer.

2. Place in the oven and bake for 15 minutes. Set aside and allow to cool completely.

3. Combine the egg yolks, cornstarch, and ¼ cup (59 g) of milk in a medium bowl and set aside. Place the remaining milk, heavy cream, sweetened condensed milk, sugar, salt, espresso powder, and chocolate in a large saucepan. Heat over medium-high heat and bring to a simmer.

4. When the cream mixture comes to a simmer, begin to temper the yolks. Scoop ½ cup (118 ml) of the cream mixture into the bowl with the egg yolks. Whisk together to make sure the yolks do not cook. Repeat this until you have mixed half of the heated mixture into the bowl. Return everything to the saucepan. Whisk the mixture in the saucepan until it thickens, about 5 minutes.

5. Add the butter and the vanilla extract. Pour the cream pudding into the pie crust and let it cool. Once cool, place in the refrigerator for at least 4 hours.

6. Place all the ingredients for whipped cream into a bowl of a stand mixer. Mix until it forms stiff peaks. Top the pie with the whipped cream.

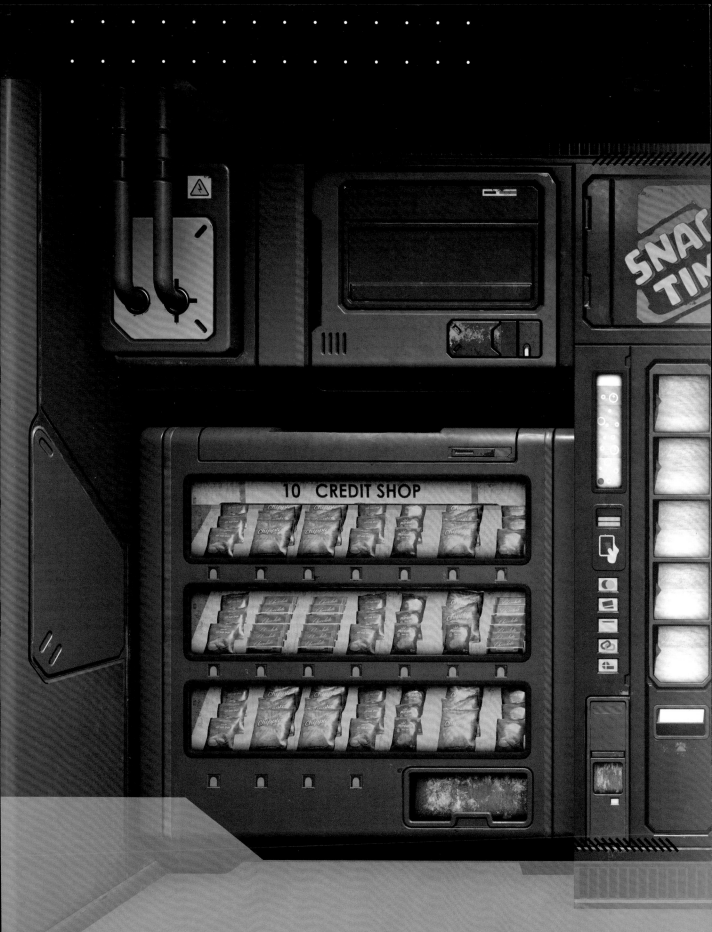

10 CREDIT SHOP

# VENDING
# MACHINES

This is going to sound a bit weird, but I'm going to try to explain myself anyway. Just don't say I didn't warn you. I had one of those long workdays, sitting in meetings and going over proposals and talking with clients and blah blah—you know the drill. Or you don't and should consider yourself lucky. I made it to the end of this particularly terrible day only to realize it was late, really late, and I was smack dab in the middle of a lifeless business district. Every restaurant and food stall had closed. I couldn't believe it at first, but after walking a few blocks to my hotel, I realized there really was nothing open. I assumed I was going hungry for the night, but I turned the corner and found myself face to face with what would normally be completely off-limits for someone such as myself: a vending machine.

But I was desperate, and my stomach demanded something, so I threw in some credit chips and got a few drinks and snacks in return. It was probably just my relief that I found anything at all, but that meal was absolutely divine. I've never had soda so delicious or nonperishable moa wings so fresh. I woke up the next day still thinking about it, so I double-checked on the vending machine to figure out what I had bought. I retraced my steps, but the savior from the night before? It was nowhere to be found.

OK, OK, I kid—it was there. This isn't a ghost story. But that morning, nothing looked all that appealing to me. I couldn't figure out how I had such a feast the night before from such humble origins. The question sat in the back of my mind for the rest of that trip, so when I got home, I decided to try to recreate what I had. These recipes are undoubtedly better than whatever slop I actually ate that night, but I tried to do my own memory justice. Look, I told you it was a weird story.

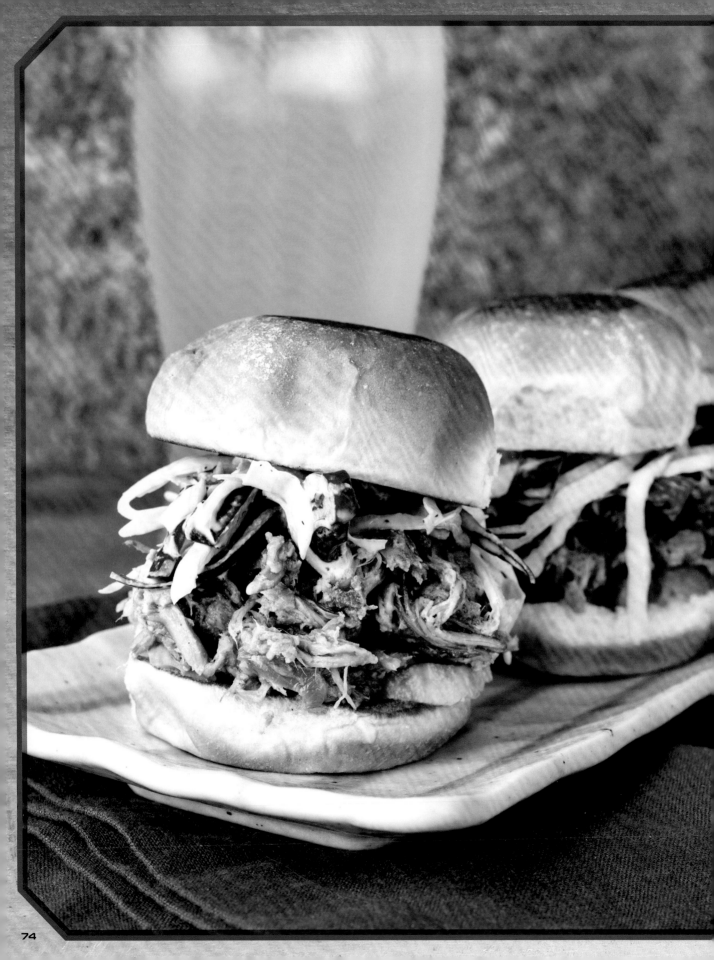

# BUFFAGOAT BUTTOCKS

**Difficulty**: Easy
**Prep Time**: 1 hour
**Cook Time**: 8 hours
**Yield**: 24 sliders
**Dietary Notes**: N/A

*With a name like Buffagoat Buttocks, it was always a mystery exactly what I was eating when this came out of those vending machines you see everywhere. There's almost something there, so I made my own version, complete with its own pork butt to fit the name. And yes, smart reader, I know pork butt is actually part of the shoulder. Just let me have this one, OK?*

### PULLED PORK

1 tbsp. (12 g) salt
1 tsp. (3 g) fenugreek
2 tsp. (7 g) paprika
2 tsp. (7 g) onion powder
2 tsp. (6 g) ground fennel
1 tbsp. (8 g) ground cumin
2 tbsp. (25 g) garlic powder
¼ cup (55 g) light brown sugar
1½ onions, quartered
3 celery stalks, cut into large pieces
2 cups (473 ml) chicken broth
5 lb. (2¼ kg) pork butt
1 cup (280 g) barbecue sauce

### SLAW

½ green cabbage, cored and thinly sliced
½ red cabbage, cored and thinly sliced
2 carrots, julienned
½ onion, thinly sliced
Juice and zest of 1 lemon
¼ cup (59 ml) buttermilk
1 tbsp. (15 g) Dijon mustard
1 tbsp. (15 ml) apple cider vinegar
1 tbsp. (12 g) sugar
½ cup (114 g) mayonnaise
Salt
Ground black pepper

### ASSEMBLY

24 slider buns
Pickle slices

## PULLED PORK

1. Preheat the oven to 350°F (177°C). Combine the salt, fenugreek, paprika, onion powder, fennel, cumin, garlic powder, and brown sugar in a small bowl. Rub the spice mixture all over the pork butt and set aside.

2. Place a Dutch oven over medium-high heat. Add the quartered onions and celery. Cook until the onions are lightly charred. Add the chicken broth and place the prepared pork butt on top. Cover the Dutch oven and place in the oven. Cook for 8 hours, or until the pork is tender.

3. Shred the pork into a large bowl. Slice the onion quarters thin, adding them to the bowl with the pork. Top with barbecue sauce and toss together until combined. Season with salt and pepper to taste.

## SLAW

1. For the slaw, combine the cabbages, carrots, and sliced ½ onion in a large bowl. Whisk together the lemon juice and zest, buttermilk, Dijon mustard, apple cider vinegar, and sugar. Add the dressing to the large bowl, toss, and fully coat the vegetables. Cover and place in a refrigerator overnight.

2. To assemble: Lightly toast the slider buns. Top with a pickle slice, a generous portion of pulled pork, and the slaw.

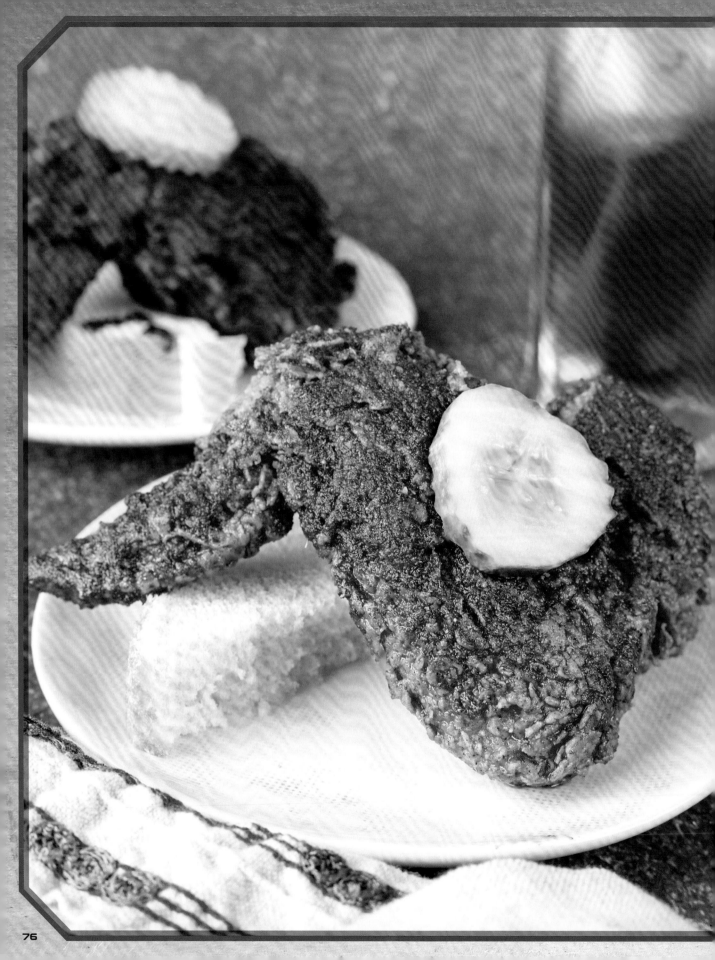

# MOA WINGS

**Difficulty**: Hard
**Prep Time**: 30 minutes
**Rest Time**: 4 hours
**Cook Time**: 8 to 12 minutes per batch
**Yield**: 4 servings
**Dietary Notes**: Very spicy

### DRY BRINE

1 tbsp. (12 g) salt
½ tsp. (2 g) monosodium glutamate
1 tsp. (2 g) ground black pepper
2 lb. (907 g) whole chicken wings

### DREDGE

Peanut oil for deep-frying
2½ cups (313 g) all-purpose flour
1 tbsp. (12 g) salt
2 tsp. (5 g) paprika
2 tsp. (4 g) cayenne pepper
2 tsp. (4 g) ground black pepper

### WET MIXTURE

2 cups (473 ml) buttermilk
3 tbsp. (45 ml) hot sauce
2 tbsp. (30 ml) pickle juice
2 eggs

### SPICY OIL

3 tbsp. (11 g) cayenne pepper
1 tbsp. (10 g) garlic powder
1 tsp. (2 g) ground black pepper
1 tsp. (3 g) paprika
1 tsp. (4 g) salt
1½ tbsp. (21 g) brown sugar
½ cup (118 ml) hot oil

### ASSEMBLY

White bread slices
Pickle slices

*These wings are hot. And I mean hot. Not "wow, perhaps a drink will cool me down" hot. I'm talking "tingling lips, sweaty brow, and perhaps some regret later" hot. But it's a good heat if you're prepared for it.*

1. Combine the salt, monosodium glutamate, and black pepper in a small bowl. Place the chicken wings on a wire rack over a baking sheet. Generously season the wings with the salt mixture. Place the chicken in the refrigerator and let the chicken rest, uncovered, for 4 hours.

2. Pour 2 inches (5 cm) of oil in a deep pot and heat to 325°F (163°C). Combine the ingredients for the dredging mixture in a medium bowl. Whisk together until well combined and set aside. In another medium bowl, whisk together all the ingredients for the wet mixture and set aside.

3. Remove the chicken from the refrigerator and pat dry. Place the chicken in the flour mixture and rub in the flour until fully covered. Transfer the chicken to the wet mixture and cover. Return the chicken to the flour mixture and coat well.

4. Carefully place the chicken in the heated oil. Repeat with multiple pieces of chicken, but do not crowd the pot. Allow the chicken to cook for about 8 to 12 minutes, or until it reaches an internal temperature of 165°F (74°C).

5. Transfer to a plate covered with paper towels. Repeat with the remaining chicken. Make sure to allow the oil to return to 325°F (163°C) between each batch.

6. After the chicken has been cooked, prepare the spicy oil by combining cayenne pepper, garlic powder, black pepper, paprika, salt, and brown sugar in a small bowl. Carefully pour in the hot oil and whisk together until combined. Brush each of the chicken wings with the spicy mixture. Serve the wings with white bread slices and pickle slices.

**NOTE** This oil can be grabbed after you are done frying all the chicken wings. Once you are done frying, pour a half cup of the hot oil carefully in a metal bowl with the spices.

# SPADEHORN BITS

**Difficulty**: Easy
**Prep Time**: 15 minutes
**Cook Time**: 30 minutes
**Yield**: 24 to 32 meatballs
**Dietary Notes**: Dairy-free

*If you weren't aware, spadehorns are a domesticated farm animal indigenous to Reach before Reach became, well, undomesticated. Spadehorns were widely exported to other colonies, but the taste isn't quite the same. That said, I'm frankly not sure where the meat is sourced from these days. But those vending machines keep selling products, so I got as close as I could. That's one mystery that'll have to remain unsolved.*

### MEATBALLS

1 lb. (454 g) ground turkey
1 carrot, finely grated
¼ onion, diced
2 garlic cloves, minced
1 tbsp. (6 g) ginger paste
2 tbsp. (40 g) tonkatsu sauce
¼ cup (40 g) potato starch
1 tsp. (2 g) ground black pepper
1 tsp. (4 g) salt
Canola oil for browning

### SAUCE

1 cup (235 g) ketchup
3 tbsp. (60 g) tonkatsu sauce
½ cup (110 g) light brown sugar
2 tbsp. (30 ml) apple cider vinegar
1 tsp. (5 ml) Worcestershire sauce
3 tbsp. (45 ml) soy sauce
¼ cup (78 g) fig jam

1. Combine all the ingredients for the meatballs in a large bowl. Stir together until just combined. Split into 1-inch (2½ cm) meatballs, ending up with about 24 to 32 meatballs.

2. Heat a large frying pan with canola oil over medium-high heat. Add the meatballs and brown each side and cook through. Transfer to a plate.

3. Combine all the ingredients for the sauce in a medium saucepan. Heat over medium-high heat until the sauce is heated through. Add the meatballs and simmer for 5 minutes.

# THE PURPLE CONCOCTION

**Difficulty**: Easy
**Prep Time**: 10 minutes
**Cook Time**: 25 minutes
**Rest Time**: 12 hours
**Yield**: 8 drinks
**Dietary Notes**: Vegan

## GRAPE LAVENDER SYRUP

1 cup (200 g) sugar
1 cup (237 ml) Concord grape juice
Juice of 1 lemon
2 tsp. (1 g) dried lavender
1 drop purple food dye (optional)

## PER SERVING

¼ cup (59 ml) grape lavender syrup
Ice
1¼ cup (296 ml) club soda

*I don't usually order purple drinks—just not a fan of grape stuff—but I bought a Purple Concoction from a vending machine once and it wasn't all that bad. I figure they've got more than just grape in here, so I threw something together to match with my own little twist. Lavender is purple, right? It'll fit right in.*

1. Combine the sugar, grape juice, and lemon juice in a small saucepan over medium-high heat. Whisk together until the sugar has dissolved and bring to a boil. Reduce the heat and simmer for 10 minutes. Remove from the heat and add the lavender. Cover and let steep for 15 minutes.

2. Strain into a small airtight container. Mix in the food dye. Allow to cool. Store in the refrigerator for at least 12 hours and up to 2 weeks.

3. To make a serving, combine the syrup and ice in a cup. Pour in the club soda and stir.

# GAUSS ORANGE SODA

**Difficulty**: Easy
**Prep Time**: 30 minutes
**Cook Time**: 30 minutes
**Rest Time**: 12 hours
**Yield**: 8 drinks
**Dietary Notes**: Vegan

### ORANGE SYRUP

Zest and juice of 3 large oranges
1 cup (200 g) sugar
1 tsp. (7 g) citric acid
2 drops orange food dye (optional)

### PER SERVING

5 tbsp. (74 ml) orange syrup
Ice
1¼ cup (296 ml) club soda

*In my youth, my mamá would always serve breakfast with a glass of fresh orange juice. I eventually learned the ways of the world, including just how much sugar is in a single glass of orange juice. At that point, I may as well throw in some carbonation and have a good orange soda instead, right? It's got more fizzy goodness, with the same orange taste.*

1. Combine the orange zest and juice, sugar, and citric acid in a small saucepan over medium-high heat. Whisk together until the sugar dissolves. Bring to a boil, then reduce the heat and simmer for 20 minutes.

2. Remove from the heat and transfer to a small airtight container. If using the orange food dye, add to the mixture and mix together. Once cooled, cover and store in the refrigerator for at least 12 hours and up to 2 weeks.

3. To make a serving, combine the syrup and ice in a cup. Pour in the club soda and stir.

**NOTE** You'll end up with about 1 cup (237 ml) of orange juice from this.

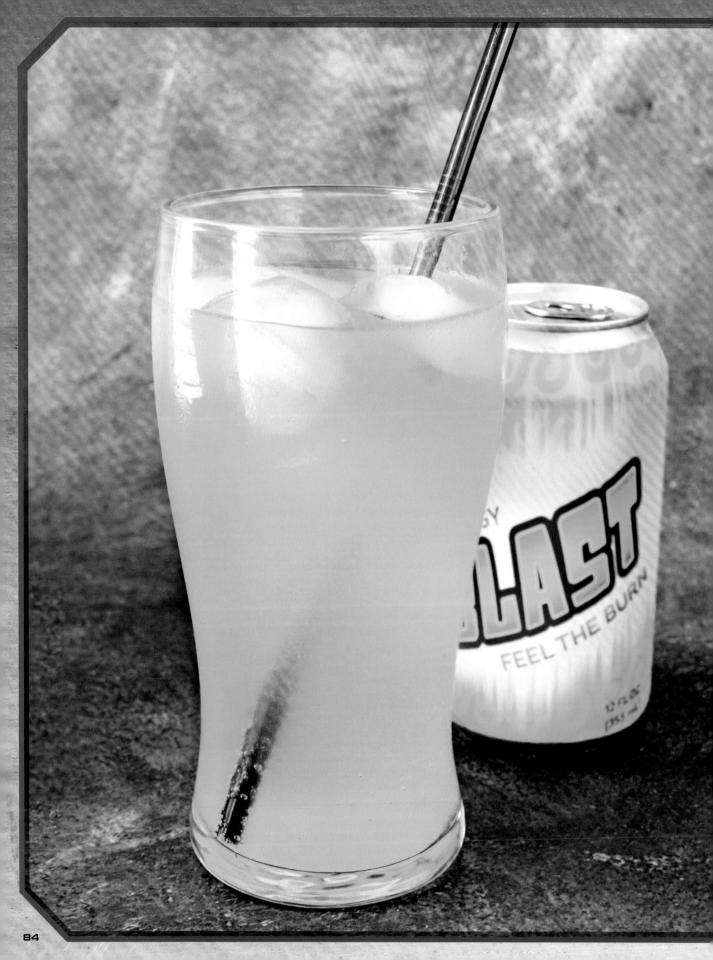

# BLAST SODA

**Difficulty**: Easy
**Prep Time**: 15 minutes
**Cook Time**: 30 minutes
**Rest Time**: 12 hours
**Yield**: 8 drinks
**Dietary Notes**: Vegan

## CITRUS SYRUP

1 cup (200 g) sugar

3 lemons, juiced (½ cup/118 ml) and 3 peels

5 limes, juiced (½ cup/118 ml) and 5 peels

½ orange, juiced (¼ cup/59 ml) and 1 peel

1 slice of ginger

2 drops neon-green food dye

## PER SERVING

¼ cup (59 ml) citrus syrup

½ to 1 tsp. (2.5 to 5 g) citric acid

Ice

1¼ cup (296 ml) club soda

*I've seen that BLAST soda junk in so many vending machines and empty cans littering the streets that I had to make my own attempt. It hurts me, both nutritionally and spiritually, to see just how much sugar I put into this, and it's still not as sweet as the actual canned drink. If you really need your sugar fix, you're better off making it yourself.*

1. Combine the sugar, lemon peels and juice, lime peels and juice, orange peel and juice, and ginger in a medium saucepan over medium-high heat. Whisk together until the sugar has dissolved and bring to a boil.

2. Reduce the heat and simmer for 20 minutes. Remove from the heat and strain into a medium airtight container. Mix in the food dye. Allow to cool. Store in the refrigerator for at least 12 hours and up to 2 weeks.

3. To make a serving, combine the syrup, citric acid, and ice in a cup. Pour in the club soda and stir.

## NOTE

To make this as close to the stuff in the vending machines, I recommend adding the full teaspoon of citric acid. If you don't want it to be too sour, just reduce the amount.

# HAVE S'MOA

Ah yes, the moa. A beautiful, if not a little awkward, flightless bird that us humans love to consume. If you are old enough, you may remember a time when moas were a common sight on menus across the Inner Colonies. But moas had the unfortunate luck of growing up on Reach, a planet doomed to catastrophe from a Covenant invasion, and shared the planet's fate. Fortunately, moas were popular enough that there were small populations across other planets, most notably at the Have S'Moa restaurant and the petting zoo on Gannick 22. But because of the sudden drop in supply, moas went from a kid's delight to a precious commodity.

Fortunately, the populations have bounced back over the years, but moa meat is still hard to come by. But do not lose hope, because I'm here to tell you that you're not missing all that much. Moa meat is good, but it's barely differentiable from beef. All those fancy dignitaries and oligarchs dining with napkins tucked in their collars and their pinkies held up may have convinced themselves that moa is a delicacy, but I promise you that you can have the same meal with some easy substitutions. Spring for the fancy stuff if you'd like—I can't stop you. But if you can't afford the visit to Wiljax Brantley's establishment, these recipes are the next-best thing.

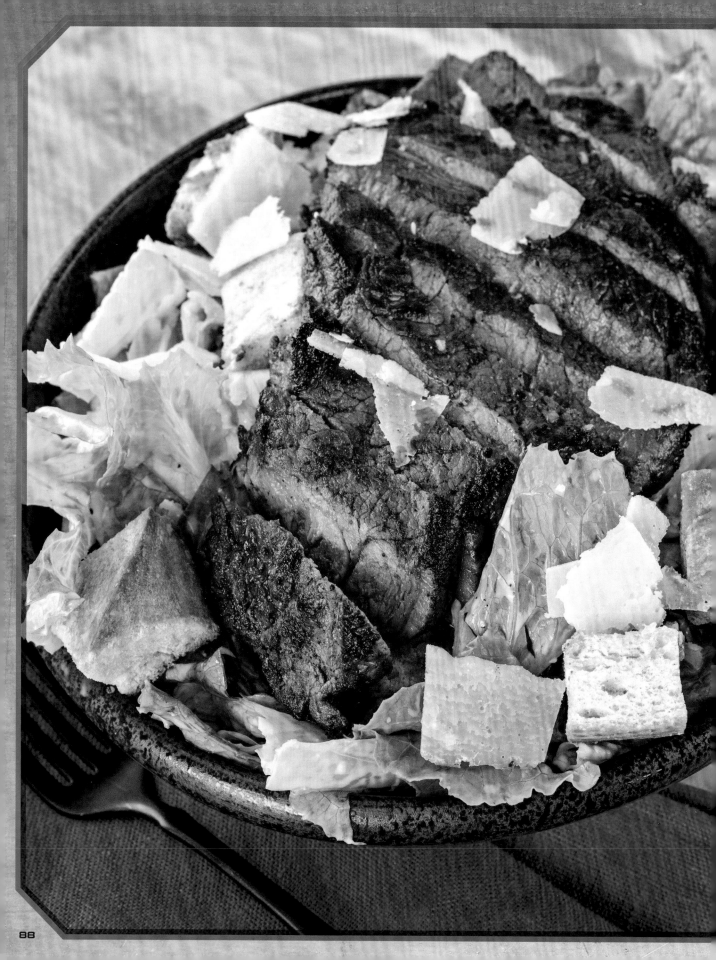

# MOA CAESAR SALAD

**Difficulty**: Easy
**Prep Time**: 30 minutes
**Rest Time**: 20 minutes
**Cook Time**: 30 minutes
**Yield**: 2 to 4 servings
**Dietary Notes**: N/A

### CROUTONS

1 baguette, cut into 1-in.
(2½ cm) cubes
¼ cup (59 ml) olive oil
3 garlic cloves, minced
1 tsp. (2 g) garlic powder
½ tsp. (2 g) salt

### STEAK

1½ tbsp. (22 ml) soy sauce
1 tbsp. (15 ml) olive oil
juice of 1 lime
1 tsp. (3 g) chile powder
½ tsp. (1 g) ground cumin
½ tsp. (1 g) ground coriander
1 tsp. (4 g) garlic powder
1 tsp. (4 g) salt
2 tbsp. (30 ml) canola oil
2 New York strips

### SALAD

2 romaine lettuces, cut into
large chunks
½ cup Parmesan cheese, shaved
Caesar salad dressing

*I used to get the moa Caesar salad when I tried convincing myself I had to order healthier options, but honestly, I've grown to love the combination. And when you make this at home instead of at a restaurant, you can take your time and really prepare the meat beautifully.*

### CROUTONS

1. Preheat the oven to 350°F (177°C). Combine all the crouton ingredients in a bowl and toss until combined. Transfer to a baking sheet covered with parchment paper in a single layer. Bake for 15 to 20 minutes, tossing them halfway through, until the croutons are golden brown.

2. The croutons can be stored in a large airtight container at room temperature for up to 1 week.

### STEAK

1. Whisk together the soy sauce, olive oil, lime juice, chile powder, cumin, coriander, garlic powder, and salt in a medium bowl. Add the steak and toss to coat. Let rest for 20 minutes.

2. Heat a medium stainless steel frying pan with 2 tablespoons (30 ml) of canola oil over high heat. Sear the steak to your desired doneness. Transfer to a plate and cover in aluminum foil. Allow the meat to rest for 10 minutes. Slice into bite-size pieces.

### SALAD

1. Toss together the romaine lettuce and Parmesan cheese in a large bowl. Add as much Caesar salad dressing as you would like and toss until coated. Add as many croutons as you would like and toss until just mixed. Transfer to 2 to 4 serving bowls. Top with the cooked steak.

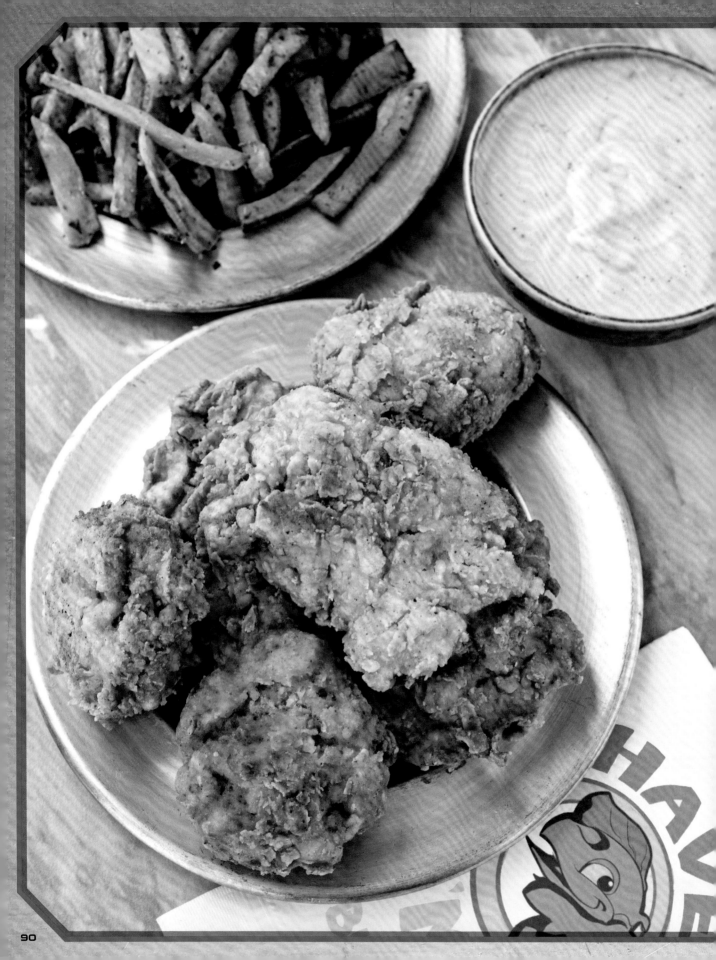

# MOA NUGGETS

**Difficulty**: Medium
**Prep Time**: 30 minutes
**Rest Time**: 10 minutes
**Cook Time**: 20 minutes
**Yield**: 4 to 6 servings
**Dietary Notes**: N/A

*You know how those lacking in culinary experience love saying something "tastes like chicken" when it's new to them? Somehow, these large, flightless birds escape that comparison, as they have far more in common with the flavors found in beef, which is good news for you and me, since beef is far easier to find on grocery shelves and in ship galleys than moa meat. You're not getting the pure, 100-percent authentic moa-nugget experience here, but I promise you that it's close enough.*

## NUGGETS

2 cups (250 g) all-purpose flour
3 tbsp. (30 g) cornstarch
1 tbsp. (12 g) baking powder
2 tsp. (7 g) garlic powder
¼ tsp. (½ g) cayenne pepper
2 tsp. (8 g) salt
1 tsp. (2 g) ground black pepper
2 eggs
1¾ cups (414 ml) buttermilk
2 lb. (907 g) cube steak, cut into cubes
Peanut oil for deep-frying

## GRAVY DIPPING SAUCE

¼ cup (59 ml) oil from frying
¼ cup (32 g) flour
1½ cups (355 ml) milk
Salt
Ground black pepper

### NUGGETS

1. Combine the flour, cornstarch, baking powder, garlic powder, cayenne pepper, salt, and pepper in a medium bowl. Whisk together the eggs and buttermilk in another medium bowl.

2. Generously season all the steak nuggets with salt and pepper. Place 1 of the nuggets in the flour and toss to coat. Place in the egg mixture and let the excess drip off. Place in the flour mixture again to coat. Place in the egg mixture again and then finally back into the flour mixture. Shake off any excess flour and place on a wire rack. Repeat with the remaining portions. Let the steaks rest for 10 minutes.

3. Place 1 inch (2½ cm) of peanut oil in a deep-frying pan. Heat the oil to about 325°F (163°C). Carefully fry the prepared steaks for 1 to 2 minutes on each side. Transfer to a plate with paper towels.

### GRAVY DIPPING SAUCE

1. Heat the oil in a cast-iron skillet over medium heat. Add the flour and whisk it in and stir constantly for about 1 minute, until it thickens. If it is still too loose, add extra flour.

2. Reduce the heat to medium low. Add the milk slowly while whisking until thickened, about 5 minutes. Season with salt and pepper.

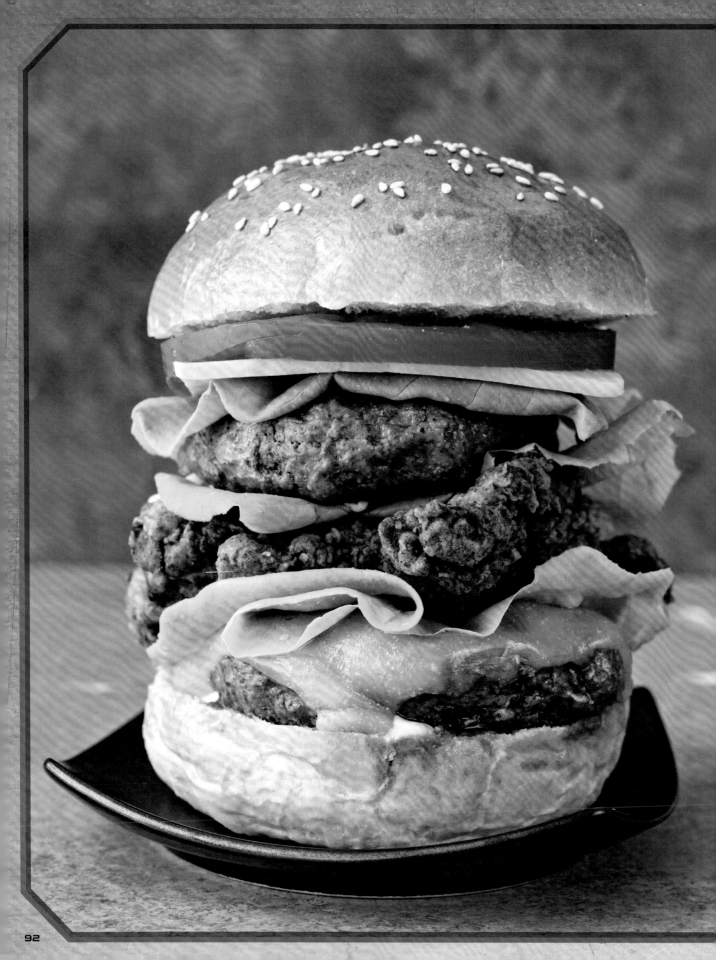

# FULL-STACK GROUND POUNDER

**Difficulty**: Legendary
**Prep Time**: 1 hour
**Rest Time**: 8 hours
**Cook Time**: 45 minutes
**Yield**: 6 Burgers
**Dietary Notes**: N/A

*Oh, man, here it is. The full-stack ground pounder, a marvel of culinary engineering and a near-impossible task for one person. I've attempted it (and failed miserably) a few times in the past, but nowadays I mostly make this when I'm having friends over to show off. You're probably better just ordering one from Have S'Moa, but I can't stop you from attempting to make one for yourself.*

## BUNS
### TANGZHONG
3 tbsp. (24 g) bread flour
⅓ cup (79 ml) milk

### DOUGH
1 tbsp. (10 g) instant yeast
⅔ cup (158 ml) milk, heated to 100°F to 110°F (38°C to 43°C)
2½ cups (340 g) bread flour
1½ tsp. (6 g) salt
1 tbsp. (16 g) granulated sugar
1 egg
¼ cup (56 g) unsalted butter, softened

### EGG WASH
1 egg
2 tbsp. (30 ml) milk

1 tbsp. (9 g) white sesame seeds

## FRIED CHICKEN THIGHS
### MARINADE
6 boneless skinless chicken thighs
1½ cups (356 g) buttermilk
½ cup (118 ml) pickle juice
1 tbsp. (15 g) black peppercorns
2 bay leaves
1 tbsp. (12 g) salt
1 tsp. (5 ml) hot sauce
Peanut oil for deep-frying

## FLOUR MIXTURE
2 cups (250 g) all-purpose flour
1 tbsp. (12 g) kosher salt
1 tbsp. (12 g) garlic powder
1 tsp. (4 g) onion powder
1 tbsp. (8 g) paprika
1 tsp. (2 g) ground black pepper
1 tsp. (2 g) cayenne pepper

Peanut oil for deep-frying

## BURGER
2 lb. (907 g) ground beef
1 lb. (454 g) ground lamb
2 tsp. (10 ml) fish sauce
1 tsp. (4 g) garlic powder
1 tsp. (4 g) ground fennel
Salt
Ground black pepper
2 tsp. (10 ml) canola oil
6 slices of cheddar cheese

## ASSEMBLY PER SANDWICH
1 bun
1 burger patty with cheese
1 burger patty without cheese
3 slices butter lettuce
Japanese mayonnaise
1 slice cheddar
2 slices tomato
2 pieces bacon, cooked
1 fried chicken thigh

*Continued on the next page*

# FULL-STACK GROUND POUNDER

## BUNS

1. Combine the 3 tbsp. (24 g) of bread flour and ⅓ cup (79 ml) of milk in a small saucepan. Heat over medium-high heat and whisk until it comes together, about 1 minute. Set aside and allow to cool.

2. Combine the yeast and ⅔ cup (158 ml) of milk in a small bowl and let it rest for 5 minutes, allowing the yeast to become active. Combine 2½ cups (410 g) of bread flour and the salt and sugar in a large bowl of a stand mixer.

3. Add the tangzhong, milk with yeast, and egg to the mixer bowl and mix until it just comes together. While the dough begins to knead, add the butter 1 tablespoon (14 grams) at a time. Knead the dough for 5 minutes. If the dough is too sticky, add 1 tablespoon (8 g) of flour at a time. If it is too dry, add 1 tablespoon of milk at a time.

4. Transfer to a large, oiled bowl, cover, and let rest for 1 hour or until it has doubled in size. Once doubled, punch down and knead. Prepare a baking sheet with parchment paper.

5. Divide the dough into 6 equal portions. Shape into round balls, place on the baking sheet, and lightly press down to widen. Cover with plastic wrap and let rest for 30 to 60 minutes, or until doubled in size.

6. Preheat the oven to 375°F (191°C). Whisk together an egg and 2 tablespoons (30 ml) of milk in a small bowl. Remove the plastic wrap from the baking sheet and brush each of the buns with egg wash. Top with white sesame seeds. Place in the oven and bake for 16 to 19 minutes or until golden brown.

## FRIED CHICKEN

1. Combine the chicken thighs, buttermilk, pickle juice, peppercorns, bay leaves, salt, and hot sauce in a large sealable bag. Shake together, seal, and refrigerate for at least 8 hours and up to 24 hours.

2. Remove the chicken from the brine and pat dry. Fill a deep, heavy pot with 2 inches (5 cm) of peanut oil and heat to 350°F (177°C) over medium-high heat.

3. Combine the flour, salt, garlic powder, onion powder, paprika, pepper, and cayenne pepper in a medium bowl. When the oil has reached the target temperature, dredge a piece of chicken in the spiced flour mixture until fully covered.

4. Carefully place in the heated oil. Cook until the chicken reaches an internal temperature of 165°F (74°C), about 6 to 10 minutes. Transfer to a plate covered with paper towels. Repeat with the remaining chicken.

## BURGER

1. Place the beef, lamb, fish sauce, garlic powder, and ground fennel in a large bowl. Mix together until the spices are blended with the meat, but do not overwork. Divide into 12 equal portions and shape into patties slightly wider than the buns you are using. Generously season the patties with salt and pepper.

2. Heat a large frying pan over medium-high heat. Add canola oil (or nonstick spray). Place the patties in the pan and cook each side for 4 minutes, or until cooked to your desired doneness. On half of the patties, add cheese, cover, and cook until it melts.

## ASSEMBLY

1. Cut open 1 of the buns. Place a burger patty with cheese on top. Top with lettuce, 1 piece of chicken, and another piece of lettuce. Put a bit of Japanese mayonnaise on top of the lettuce. Begin layering again with a burger patty, lettuce, slice of cheese, tomato, and finally the 2 slices of bacon. Top with the burger bun top.

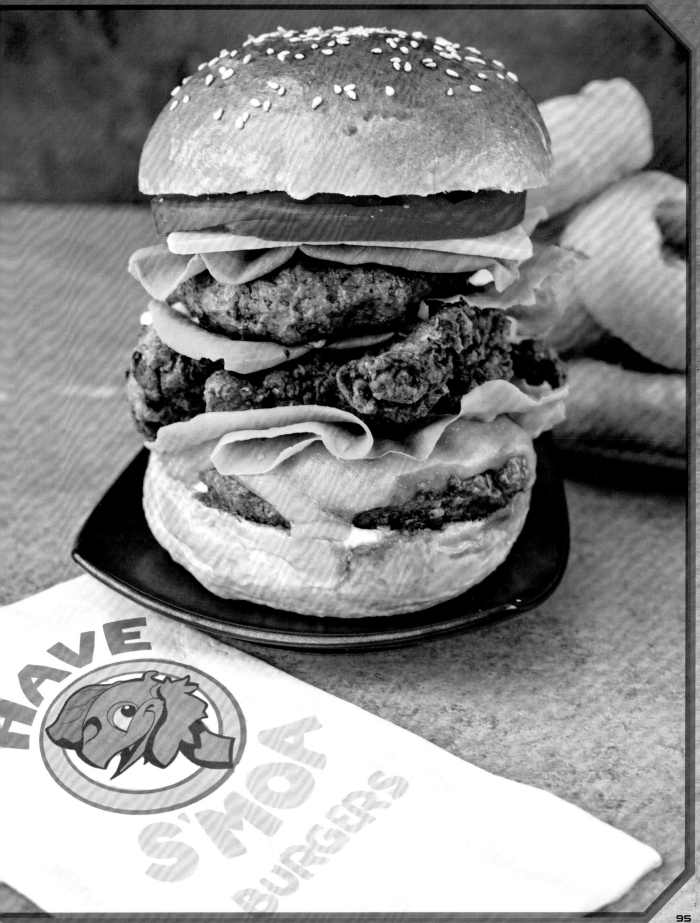

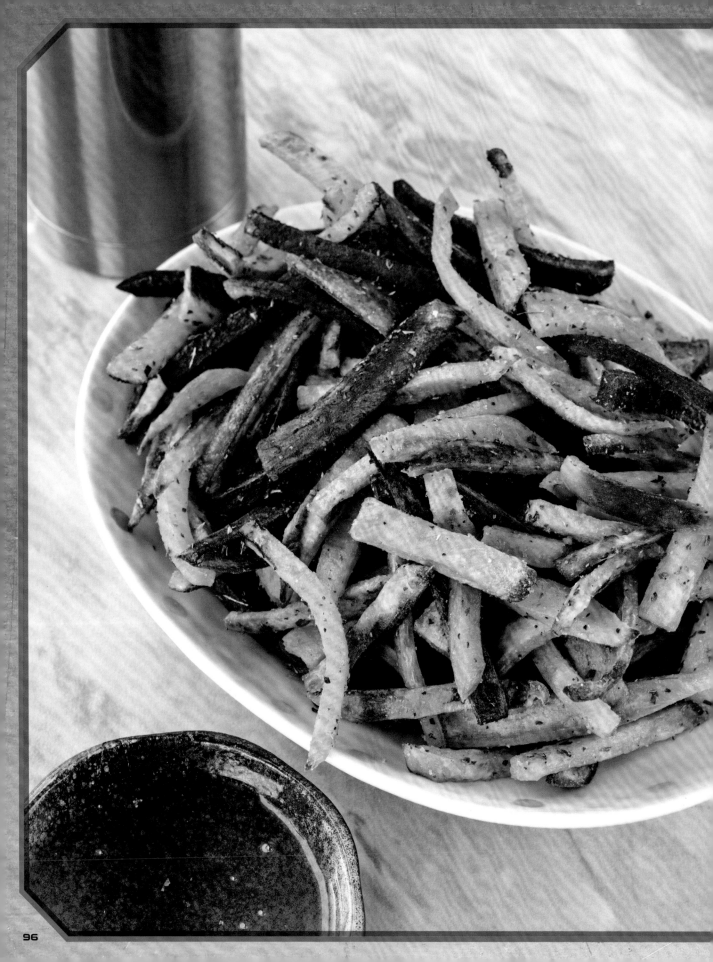

# SWEET POTATO FRIES

**Difficulty**: Easy
**Prep Time**: 15 minutes
**Cook Time**: 40 minutes
**Yield**: 4 to 6 servings
**Dietary Notes**: Vegetarian

¼ cup (59 ml) olive oil
1 tsp. (5 g) garlic powder
1 tsp. (4 g) onion powder
1 tbsp. (3 g) oregano
½ tsp. (1 g) pepper
2 tsp. (8 g) salt
3 sweet potatoes (any color), cut into fry portions
Honey, for serving

*Anyone can warm up some oven-ready fries, but you throw in some sweet potato slices and do it yourself? Toss in all those good spices and add some honey at the end, and suddenly, you're learning to elevate even the most basic parts of a dish.*

1. Preheat the oven to 425°F (218°C). Combine olive oil, garlic powder, onion powder, oregano, pepper, and salt in a large bowl. Toss the potatoes in the mixture.

2. Prepare a baking sheet with aluminum foil and nonstick spray. Transfer the seasoned potatoes onto the sheet in a single layer and place in the oven. Bake for 20 minutes. Toss and bake for another 15 minutes. Turn on the broiler and cook the fries until they are crispy, about 4 to 5 minutes. Serve with honey.

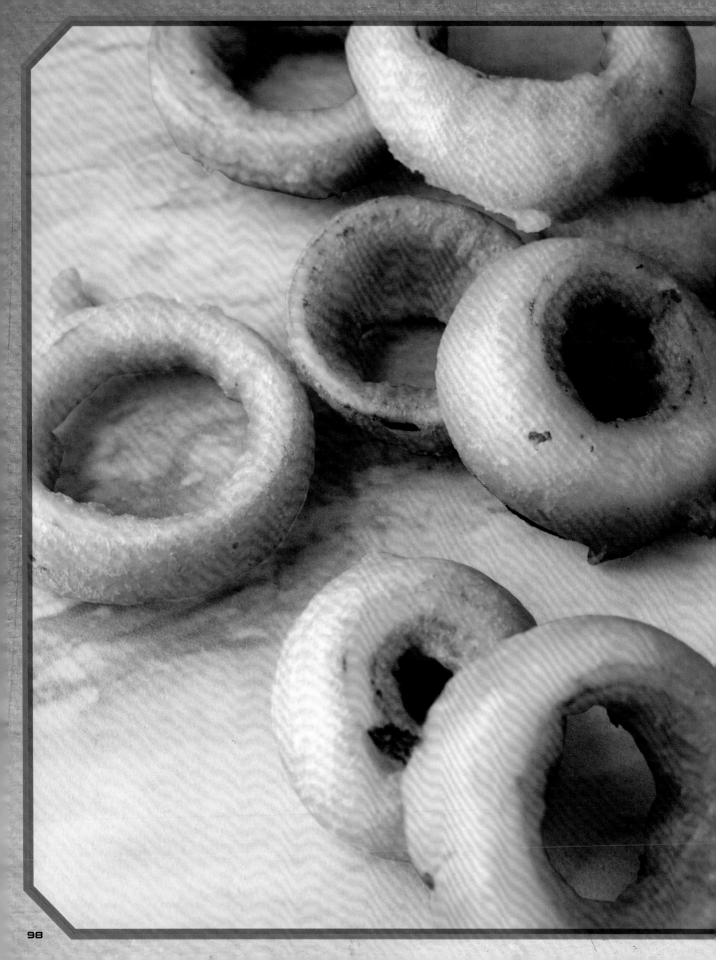

# ONION RINGS

**Difficulty**: Medium
**Prep Time**: 30 minutes
**Cook Time**: 5 minutes per batch
**Yield**: 6 servings
**Dietary Notes**: Vegetarian

Peanut oil for deep-frying
2 cups (250 g) all-purpose flour
⅓ cup (43 g) cornstarch
1 tsp. (4 g) garlic powder
1 tsp. (4 g) onion powder
2 tsp. (8 g) salt
½ tsp. (1 g) ground black pepper
1 tsp. (4 g) baking powder
12 oz. (341 ml) amber ale, cold
2 large onions, cut into ¾-in.-thick
(2 cm thick) slices and separated
into individual rings

*I remember when Have S'Moa ran all those commercials for their "onion rings the size of Halos!" All that news about new discoveries in space was going around, and they wanted to cash in on the craze. But their Halo onion rings are crispy and incredible, so I had to try making them myself.*

1. Pour 1½ inch (4 cm) of peanut oil in a deep pot and preheat to 365°F (185°C).

2. Place ½ cup (63 g) of flour on a plate and set aside. Combine remaining flour, cornstarch, garlic powder, onion powder, salt, pepper, and baking powder in a medium bowl. Wait until the oil is nearly heated before adding the amber ale to the bowl. Whisk in the beer until you have a smooth batter.

3. Cover the onion rings in flour. Once your oil has heated, dip the flour-covered onion rings into the batter. Make sure to let any excess batter drip off the onion rings before placing them in the oil.

4. Place the battered onion rings into the hot oil and fry each side for about 2 minutes, or until golden brown. Transfer onto a plate lined with paper towels to remove any excess oil. Repeat with the remaining onion rings.

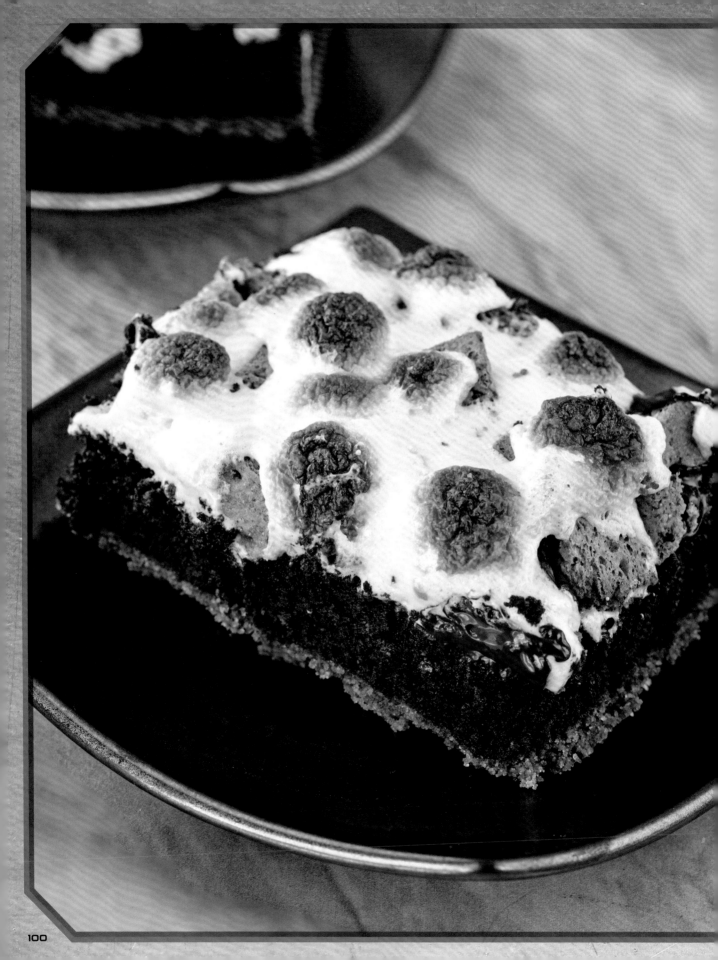

# S'MOA BROWNIES

**Difficulty**: Medium
**Prep Time**: 30 minutes
**Cook Time**: 40 minutes
**Yield**: 9 servings
**Dietary Notes**: N/A

## CRUST

5 oz. (142 g) graham crackers
¼ cup (59 g) sugar
6 tbsp. (84 g) unsalted butter, melted

## BROWNIE BATTER

1 cup (226 g) unsalted butter
¾ cup (150 g) sugar
2 tbsp. (28 g) light brown sugar
3 oz. (85 g) bittersweet chocolate chips
¼ cup (30 g) cocoa powder
½ tsp. (2 g) salt
½ tsp. (2 g) baking powder
½ tsp. (2½ ml) vanilla extract
2 eggs
¾ cup (94 g) all-purpose flour

## TOPPINGS

2 oz. (56 g) chocolate chips
5 oz. (142 g) mini marshmallows
1 oz. (28 g) graham crackers

*I'm not normally a fan of food puns. I want my food to be delicious, not funny. These brownies are good enough that, just this one time, I'll make an exception.*

1. Prepare a 10-by-10-by-2-inch (25½-cm-by-25½-cm-by-4-cm) baking pan with parchment paper and set aside. Place the graham crackers in a food processor and pulse until smooth. Add the sugar and melted butter and mix until well combined.

2. Transfer to the prepared baking pan. Press the crust down until flat and even. Cover and place in the refrigerator until the brownie batter is ready to bake.

3. Preheat the oven to 350°F (177°C). Start preparing the brownie batter. Place the butter in a medium saucepan over medium-high heat. Heat until the butter has just melted. Add the sugars and chocolate chips and mix until well combined.

4. Remove from the heat, transfer to a large bowl, and allow to cool slightly. Once cooled, whisk in the cocoa powder, salt, and baking powder. Add the eggs 1 at a time to the batter. Add the vanilla extract. Fold in the flour until it is just combined.

5. Remove the prepared pan from the refrigerator and uncover. Top the graham cracker with the brownie batter. Spread the batter into 1 even layer. Place in the oven and bake for 30 to 35 minutes, or until the brownie batter is cooked through.

6. Remove from the oven and turn on the broiler. Top with the graham crackers, marshmallows, and chocolate chips for the topping. Place under a broiler for 1 to 2 minutes, or until the marshmallows are golden. Allow to cool completely before cutting into 9 portions.

# ENZO'S CHURRASCARIA

When I make planetfall on Andesia, I make sure to visit the sprawling city of Promesa, a hub of business, fancy research, and elaborate shopping. You can't shop on an empty stomach, of course, and a few smart entrepreneurs found it a perfect place for delicious restaurant concepts. One such restauranteur had quite a few distinct restaurants, but the most popular were Enzo's Churrascaria and Thai Game. In most of their locations, the restaurants were separate and distinct, but in some of Promesa's larger food courts, they found it more economical to combine the two menus and utilize both kitchens to churn out delicious chow when the shoppers demanded it. I always thought two places with the same menu was confusing, but eh. It worked for them. And it wasn't my job to tell them their idea was bad, so I kept my mouth quiet about it.

What I'm not quiet about is how delicious the food is. We're talking greats like curry puffs, curries, fried rice, stir-fry—you name it. And who can forget their iconic dessert to top it all off? You couldn't leave Enzo's hungry if you wanted to. And with all these recipes I've assembled from my many visits, you won't even have to set foot in an Enzo's to see what all the fuss is about.

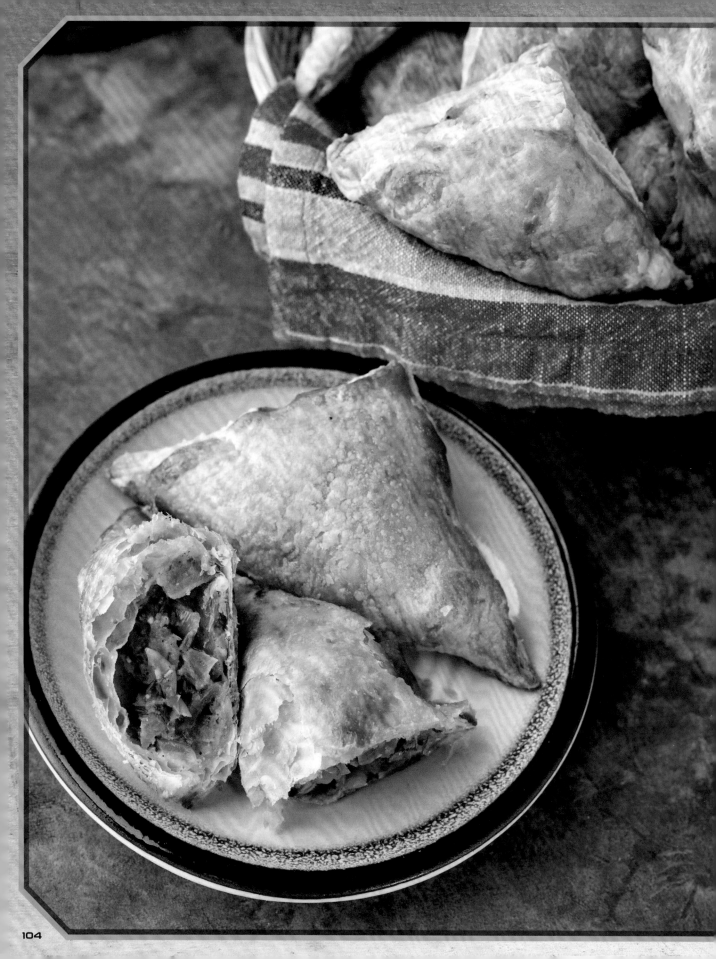

# CURRY PUFFS

**Difficulty**: Medium
**Prep Time**: 1 hour
**Rest Time**: 10 minutes
**Cook Time**: 45 minutes
**Yield**: 27 puffs
**Dietary Notes**: Vegetarian

1 russet potato, peeled and chopped
1 tbsp. (15 ml) olive oil
1 large onion, diced
5 garlic cloves, minced
2 tsp. (8 g) salt
1 tbsp. (6 g) ginger paste
1 tbsp. (10 g) cumin seeds
2 tbsp. (10 g) coriander seeds
1 tsp. (2 g) ground turmeric
1 tsp. (2 g) garam masala
½ tsp. (1 g) ground ginger
½ tsp. (1 g) amchur powder
¼ tsp. (½ g) ground cinnamon
¼ tsp. (½ g) ground cardamom
1 carrot, peeled and chopped
½ cup (80 g) peas
½ cup (118 ml) plus 1 tbsp.
(15 ml) water
3 scallions, chopped
½ bunch of cilantro, chopped
3 sheets puff pastry, thawed
1 egg

*It always surprises me just how many flavors and ingredients go into these puffs. If you don't have all the spices listed, consider these a delicious excuse to expand your spice rack. And once you do, you might as well make them again!*

1. Heat a large pot with water (enough to just cover potatoes), potatoes, and 1 teaspoon (4 g) salt over high heat. Bring to a boil and then reduce the heat and simmer for 15 to 20 minutes, or until the potatoes are tender. Drain and set aside.

2. Heat a large nonstick frying pan with 1 tablespoon (15 ml) of olive oil over medium-high heat. Add the onions and cook until softened, about 3 to 5 minutes. Add the garlic and ginger paste and stir well. Add the cumin seeds, coriander seed, turmeric, garam masala, ground ginger, amchur powder, cinnamon, cardamom, and salt. Toss until the onion is coated in the spices.

3. Add the carrots and peas and toss together and let cook for 5 minutes. Add the potatoes and lightly mix together. Add ½ cup (118 ml) of water and cover. Allow to cook until the water has evaporated, about 5 minutes.

4. Remove from the heat and mix in the scallions and cilantro. Lightly mash to bring everything together.

> **NOTE** You can leave this chunky, or mash it well. Either way, the result is delicious.

5. Prepare 2 baking sheets with parchment paper. To prepare the puffs, split a sheet of puff pastry into 9 squares. Add 2 to 3 tablespoons of filling in the center of a square. Fold on a diagonal to form a triangle. Press the edges together and crimp shut with a fork. Place on a prepared baking sheet. Repeat until you have 27 filled curry puffs. Transfer the baking sheets to the freezer and let rest for 10 minutes.

6. Preheat the oven to 350°F (177°C). Whisk together the egg and 1 tablespoon (15 ml) of water. Brush each of the curry puffs with the egg wash. Place in the oven and bake for 20 to 25 minutes, or until the puff pastry is golden brown.

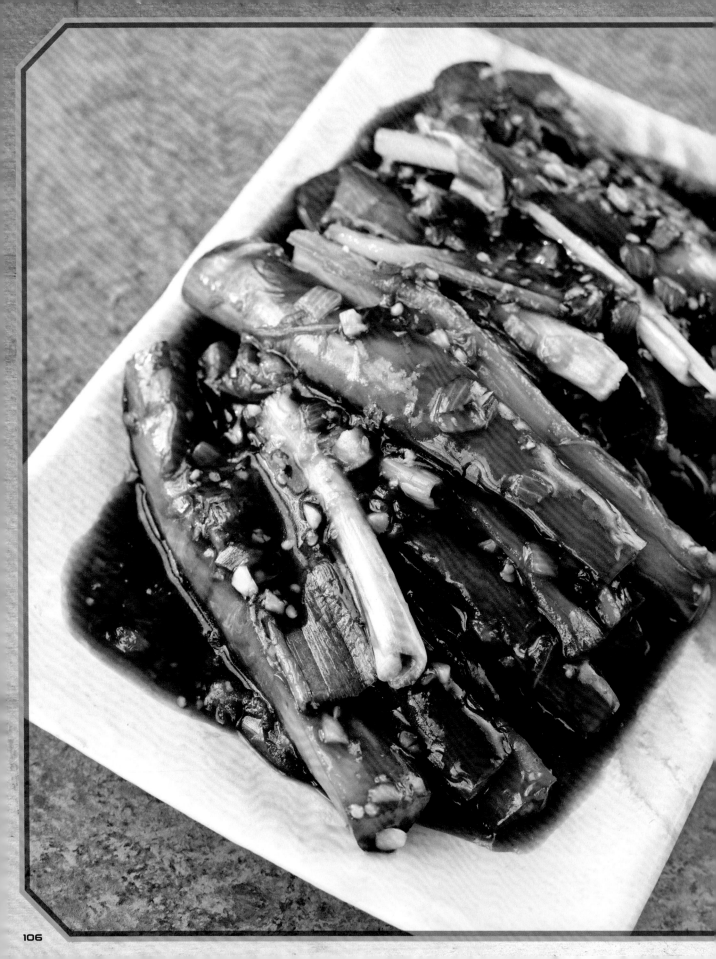

# GARLIC STIR-FRY

**Difficulty**: Easy
**Prep Time**: 15 minutes
**Cook Time**: 20 minutes
**Yield**: 4 to 6 servings
**Dietary Notes**: Vegan

2 Chinese eggplants, cut into
2-in.-long (5-cm-long) pieces
3 tbsp. (45 ml) soy sauce
1 tbsp. (15 ml) hoisin sauce
2 tbsp. (30 ml) Chinkiang vinegar
1 tbsp. (15 ml) Shaoxing wine
3 tbsp. (42 g) light brown sugar
¼ cup (59 ml) vegetable broth
2 tsp. (10 g) cornstarch
1 tbsp. (15 ml) canola oil
1 shallot, diced
2 tbsp. (12 g) ginger, grated
3 garlic cloves, diced
2 scallions, cut into bite-size pieces

*This garlic stir-fry recipe is supposed to be a side dish, but I sometimes forget that when I'm lost in this wonderful, garlicky eggplant dish. You know what? The sauce is heavy enough. You can fill up on this if you really want to. I won't judge.*

1. Bring a large pot of water to a boil and place a steaming rack above it. Place the eggplant inside the steaming rack and cover. Allow the eggplant to steam for 13 to 15 minutes or until it has softened.

2. Combine the soy sauce, hoisin, Chinkiang vinegar, Shaoxing wine, light brown sugar, vegetable broth, and cornstarch in a small bowl. Heat a large frying pan over medium-high heat. Add 1 tablespoon (15 ml) canola oil and allow it to heat. Add the shallot, ginger, and garlic. Cook until the shallot has softened about 3 minutes. Add the steamed eggplant.

3. Stir the eggplant until it is mixed well with the shallot, ginger, and garlic. Increase the heat to high and pour the liquids into the pan. Keep cooking until the liquid reduces about halfway. Add the scallions and cook for another 3 minutes.

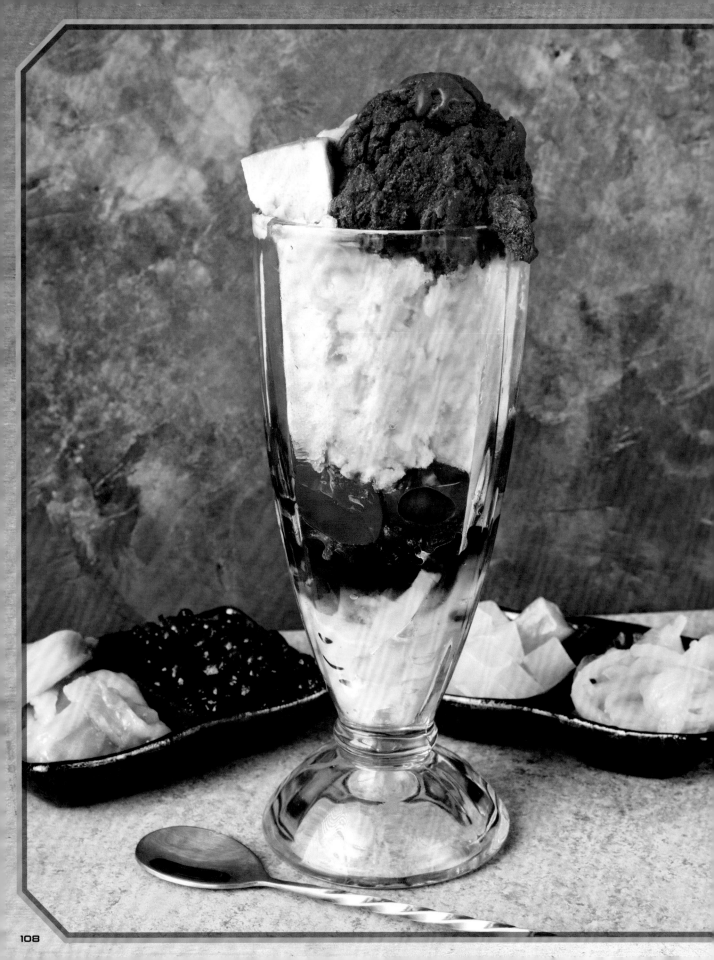

# HALO-HALO

**Difficulty**: Medium
**Prep Time**: 1 hour
**Rest Time**: 8 hours
**Cook Time**: 40 minutes
**Yield**: 6 to 8 servings
**Dietary Notes**: Vegetarian

### UBE ICE CREAM

14 oz. (396 g) sweetened condensed milk
⅔ cup (220 g) ube halaya
1 tsp. (5 ml) ube extract
1 tsp. (5 ml) vanilla extract
Pinch of salt
2 cups (462 g) heavy cream

### FLAN

⅓ cup (67 g) sugar
2 tbsp. (30 ml) water
½ tsp. (2 g) salt
2 eggs
7 oz. (198 g) sweetened condensed milk
6 oz. (177 g) evaporated milk
1 tbsp. (15 ml) vanilla extract

### ASSEMBLY

2 cups shaved ice
Ube ice cream
Flan
Ripe jackfruit
Macapuno
Nata de coco
Ube halaya
Adzuki beans
Palm seeds in syrup
Rice puff cereal
Evaporated milk

*Just to be clear, halo-halo is a marvelously unique Filipino dessert made of shaved ice, ube ice cream, and layers upon layers of goodies. It is not at all related to those giant ancient space hoops that got discovered near the end of the war. Not unless they contain great desserts at least.*

## UBE ICE CREAM

1. Combine the sweetened condensed milk, ube halaya, ube extract, vanilla extract, and salt in a large bowl. Whisk together until well combined.

2. Place the heavy cream into a large bowl of a stand mixer. Mix until the whipped cream forms medium peaks. Transfer to the bowl with everything else. Carefully fold in the whipped cream until it is well combined.

3. Transfer to a large airtight container and spread into a smooth, even layer. Cover and place in the freezer for at least 5 hours before serving.

## FLAN

1. Preheat the oven to 350°F (177°C). Combine sugar and water in a medium saucepan over medium-high heat. Stir until the sugar dissolves. Allow to simmer for 15 minutes, until it turns golden. Immediately add the salt and stir in. Pour the caramel from the saucepan into three 3½-inch (9-cm) ramekins. Quickly rotate the ramekins around to spread it evenly on the bottom.

> **NOTE** The caramel will be extremely hot, so be extremely careful when working with it. It will also set pretty quickly, so make sure to work fast when placing it in the ramekins.

2. Combine the eggs, sweetened condensed milk, evaporated milk, and vanilla extract in a medium bowl until smooth. Pour the mixture in the ramekins.

3. Place the ramekins inside a deep baking dish and fill it about halfway with water. Place in the oven and bake for 35 to 40 minutes.

4. Remove the ramekins from the baking dish and allow them to cool. Once they are completely cooled, place the flan in a refrigerator for at least 3 hours before serving. To remove them from the ramekins, run a knife along the inner rim of each ramekin, place a plate over the ramekin, and flip. Cut into smaller portions to top on the *halo-halo*.

## ASSEMBLY

1. Place the shaved ice at the bottom of a bowl, top with the rest of the toppings to your liking, and pour a few tablespoons of evaporated milk over the ice to flavor, then repeat for each bowl. If using large cups in place of bowls, start layering a few of the toppings on the bottom and place the ice near the top. Immediately add the salt and stir in.

> **NOTE** There really are no rules to setting this up. Have fun and mix-and-match whatever ingredients you like with your shaved ice and ice cream. I've included a list of my favorites.

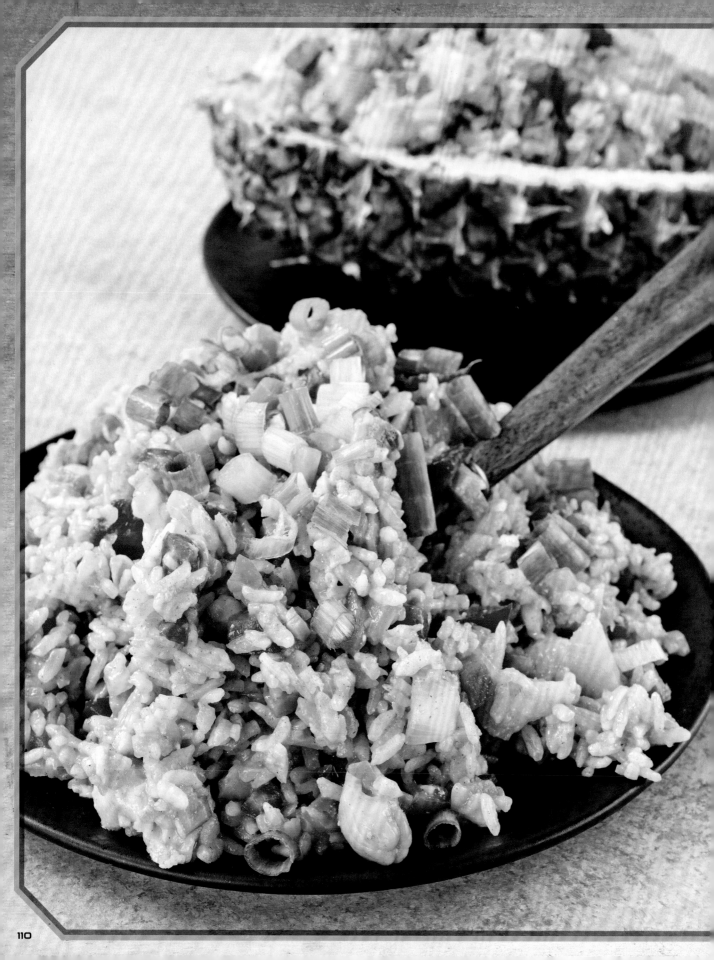

# PINEAPPLE FRIED RICE

**Difficulty**: Medium
**Prep Time**: 30 minutes
**Cook Time**: 20 minutes
**Yield**: 4 to 6 servings
**Dietary Notes**: N/A

## SAUCE

3 tbsp. (45 ml) soy sauce
1 tbsp. (15 ml) fish sauce
2 tsp. (10 ml) oyster sauce
1 tbsp. (20 g) palm sugar
¼ tsp. (1 g) ground coriander
¼ tsp. (1 g) turmeric
⅛ tsp. (½ g) cinnamon

1 tbsp. plus 1 tsp. (20 ml) canola oil
2 eggs, whisked together
½ medium onion, minced
6 garlic cloves, minced
1-in. (2½ cm) piece ginger, minced
1 carrot, diced
1 red bell pepper, diced
¼ cup (38 g) cashews
3 cups (750 g) jasmine rice, cooked
1 whole pineapple, chopped
2 scallions, chopped

*This isn't just your regular old fried rice. This Enzo's classic fried rice has a bite to it, using pineapple to really contrast flavors. It's wonderful, but too much of it does leave the mouth a bit tingly.*

1. Combine all the ingredients for the sauce in a small bowl and set aside. Heat a wok over medium-high heat. Add 1 teaspoon (5 ml) of canola oil and heat for about 30 seconds. Add the whisked eggs and scramble them. Cook until cooked through and fluffy, about 45 seconds to 1 minute. Transfer to a plate.

2. Add 1 tablespoon (15 ml) of canola oil to the pan and increase the heat to high. Add the onion, garlic, ginger, and carrots. Toss and cook for 1 minute. Add the red bell pepper and cashews while tossing constantly. Cook until the bell peppers have softened. Add the rice and mix until combined.

3. Add the combined sauce and cook until the liquid has been fully absorbed by the rice. Add the pineapple and cook to warm the pineapple, about 45 seconds to 1 minute. Finally, add the scallions and cook for 30 more seconds before serving.

## NOTE

I recommend letting the rice sit in a large airtight container in the refrigerator for a day before cooking with it. This really lets the rice absorb the sauce.

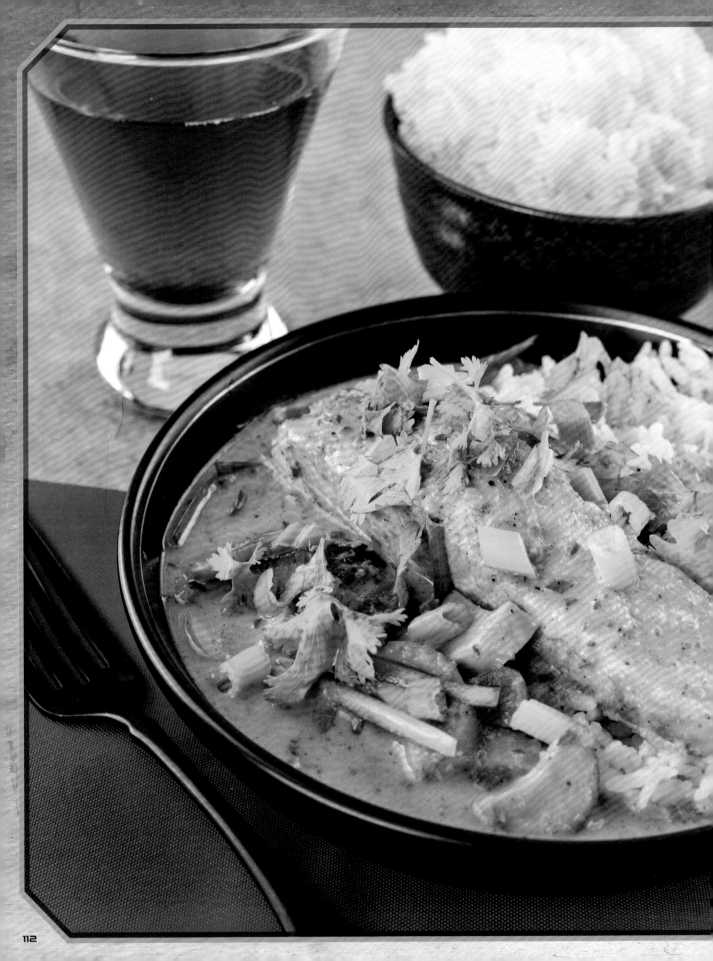

# RED MOON SALMON CURRY

**Difficulty**: Easy
**Prep Time**: 45 minutes
**Cook Time**: 20 minutes
**Yield**: 4 servings
**Dietary Notes**: Dairy-free

### CHILE PASTE

½ red bell pepper, chopped
1 lemongrass, chopped
3 Thai chiles
1-in. (2½-cm) piece of ginger, peeled and sliced
1-in. (2½-cm) piece of galangal, peeled and sliced
5 garlic cloves
1 shallot, halved
1 tsp. (5 g) black peppercorns
2 tsp. (5 g) red pepper flakes
1 tsp. (2 g) coriander seeds
1 star anise
1 tsp. (4 g) salt
1 tbsp. (20 g) palm sugar
3 tbsp. (45 ml) lime juice

### SALMON

1 lb. (454 g) salmon, skin on and cut into 4 portions
Salt
Ground black pepper
2 tsp. (10 ml) canola oil
2 king oyster mushrooms, sliced
3 shiitake mushrooms, sliced
1 shallot, diced
5 garlic chives, cut into 2-in. (5 cm) pieces
½ cup (118 ml) chicken broth
2½ cups (591 ml) coconut milk
1 tbsp. (15 ml) fish sauce
1 tbsp. (15 ml) lime zest
2 tbsp. (30 ml) lime juice

### FOR SERVING

2 cups (500 g) rice, cooked
Cilantro
Scallions, minced

*This is one of my favorite dishes from Enzo's. I usually like to let the salmon in my dishes do the talking, but the curry they pair it with at Enzo's is just superb. It doesn't smother the salmon, either. It takes everything to an even more delicious level*

1. Place all the ingredients for the chile paste in a food processor. Process until extremely smooth. Can be stored in the refrigerator in a small airtight container for up to 1 week.

2. Generously salt and pepper all sides of the salmon. Heat a large nonstick frying pan with 1 teaspoon of canola oil (5 ml) over medium-high heat. Place the salmon skin side down and cook until the skin crisps up, about 5 minutes. Flip and allow the top to lightly brown. Transfer to a plate and set aside.

3. In the same pan, add oyster mushrooms and shiitake mushrooms. Cook until the mushrooms start to crisp up. Remove the mushrooms and set aside.

4. In the same pan, add another teaspoon (5 ml) of canola oil. Add the shallot and cook until softened, about 3 minutes. Add the chile paste, chicken broth, and coconut milk. Bring to a simmer and reduce the heat to medium. Add the salmon and cover. Cook for 8 minutes, or until the salmon registers an internal temperature of 145°F (63°C).

5. Remove the salmon. Add the the mushrooms and garlic chives. Allow the mushrooms to warm back up, about 2 minutes. Add the fish sauce, lime zest, and lime juice.

6. To serve, place a portion of rice in a bowl. Add a portion of the curry sauce. Top with a piece of salmon, cilantro, and scallions.

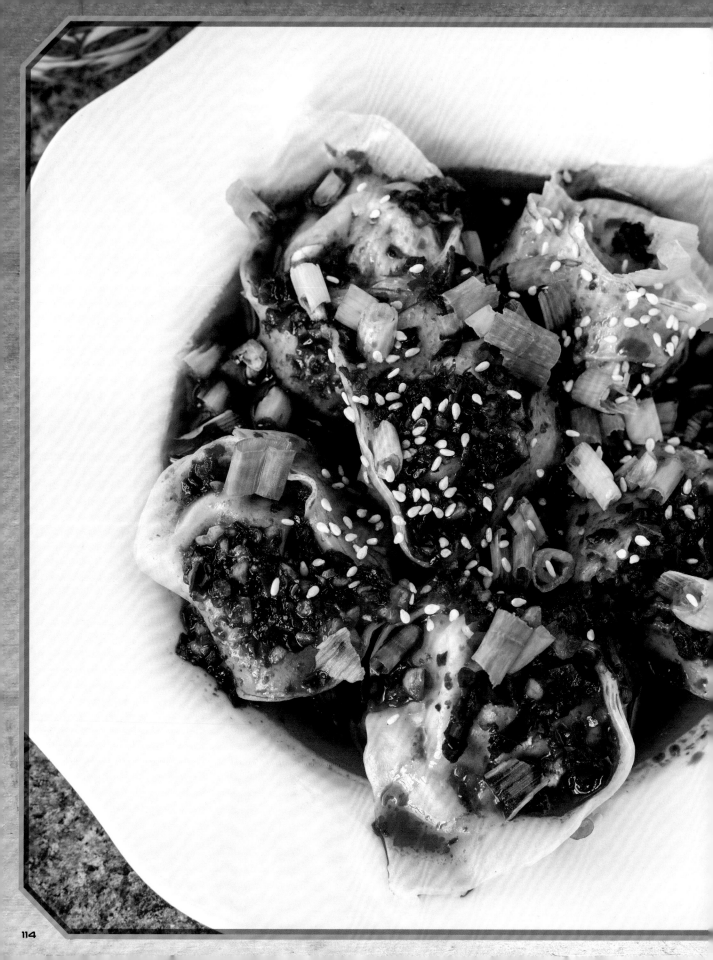

# WON-TONS

**Difficulty**: Hard
**Prep Time**: 1 hour
**Cook Time**: 30 minutes
**Yield**: 28 to 36 dumplings
**Dietary Notes**: Vegan

## WON-TONS

1 tsp. (15 ml) canola oil
5 garlic cloves, minced
1-in. (2½-cm) piece of ginger, minced
5 shiitake mushrooms, chopped
1 carrot, peeled and finely chopped
½ Napa cabbage, chopped
6 oz. (170 g) extra-firm tofu
2 scallions, chopped
1 tsp. (5 ml) soy sauce
1 tsp. (5 ml) Shaoxing wine
1 tsp. (4 g) sugar
1 tsp. (4 g) salt
½ tsp. (2½ ml) Chinkiang vinegar
28 to 36 wonton wrappers

## SAUCE

¼ cup (55 g) Chinese chile oil
2 tsp. (10 g) sugar
1 tbsp. (15 ml) Chinkiang vinegar
4 garlic cloves, minced
2 scallions, thinly sliced
1 tbsp. (9 g) white sesame seeds

*Every food scene has figured out that carefully placing dumplings in a blazing-hot pan makes for a wonderful time, but these wontons are one of my favorite results of this shared experience. They take a little bit of work to get formed, but you'll be thanking yourself once you're done.*

1. Heat a medium nonstick frying pan over medium-high heat. Add 1 tablespoon (15 ml) of canola oil and allow to heat up. Add the garlic and ginger and cook for 3 minutes. Add the mushrooms and carrots, stir, and let cook until softened, about 5 to 8 minutes. Add the cabbage and cook until it has wilted, about 3 minutes.

2. Remove from the heat and allow to cool. Once cooled, transfer to a food processor. Add the tofu and scallions. Pulse a few times until it all comes together. Transfer to a medium bowl. Add the soy sauce, Shaoxing wine, sugar, salt, and Chinkiang vinegar. Mix together. Taste and season with additional salt if needed.

3. To assemble the wontons, place about 1 tablespoon of filling in the center of a wonton wrapper. Lightly wet the edges of the wrapper. Fold on a diagonal to form a triangle. Press the edges together to seal, removing any air bubbles. Repeat this step until you have used all the filling.

> **NOTE** If you want to get extra fancy with your shaped wontons, lightly wet 1 of the bottom corners and pull the edges together to shape into little hats.

4. Combine all the ingredients for the sauce in a small bowl. Set aside.

5. Heat a medium pot filled with water over high heat. Bring to a boil. Add the wontons, being careful not to crowd, and allow them to cook until they float, about 1 to 2 minutes. Remove them from the water and set aside. Repeat with the remaining wontons.

6. Plate the wontons and top with a generous helping of the sauce.

# MAEYAMAS NOODLE BAR

More often than not, restaurants tell a story. Their menu and their dishes paint a picture of the person behind the scenes. The chefs and cooks bring their roots and their upbringing onto a plate or into a bowl and serve it to anyone willing to listen. In this age of space exploration and homes away from home, bringing these stories with you is even more important. But Maeyamas handled it just a little bit differently than usual. The chefs involved with coming up with the concept wanted to intermingle all their experiences at once and make a dining concept as complex as they are.

The entirety of the Maeyamas menu explores how versatile noodle dishes have been for so many. From appetizers to entrees to even desserts, they managed to pull from different cuisines all over Earth and find something delicious that noodles bring to the table. I was pretty skeptical about the idea when I first heard about it but eating here has made me a believer.

You know when you're in a Maeyamas Noodle Bar when there's that magical moment when all the talking among the patrons hits a natural break and you don't hear anything but silverware hitting plates and the sounds of slurping noodles. It's as satisfying as it is a little bit weird, but that's all part of the experience here. And if you're making these recipes at home, you can slurp away without worrying that the nearby table is judging you.

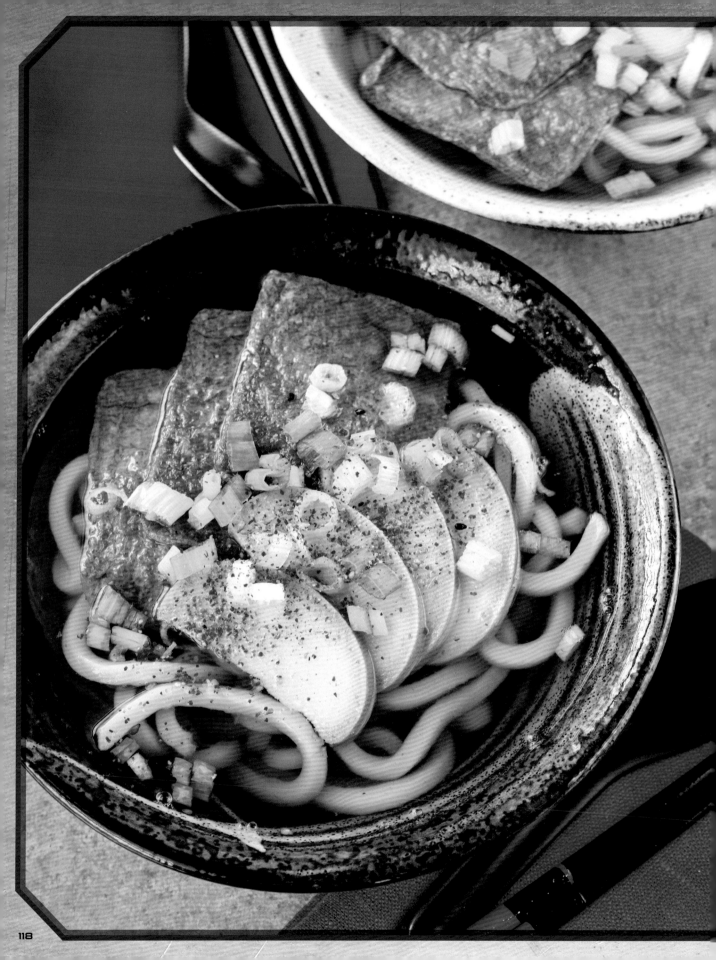

# KITSUNE UDON

**Difficulty**: Easy
**Prep Time**: 15 minutes
**Rest Time**: 1 hour
**Cook Time**: 35 minutes
**Yield**: 2 bowls
**Dietary Notes**: N/A

### SHIITAKE DASHI

4 cups (946 ml) water
4-by-4-in. (10-cm-by-10-cm) piece kombu
1 dried shiitake mushroom
¾ cup (9 g) bonito flakes
1 tbsp. (15 ml) soy sauce
2 tsp. (10 ml) mirin
½ tsp. (3 g) sugar

### SOUP

2 packages frozen udon noodles, cooked
8 pieces inari age
8 ¼-in.-thick (½-cm-thick) slices kamaboko
2 scallions, chopped
Shichimi togarashi

*This soup is so simple yet so perfect for basically any time of the year. It's perfectly balanced in taste and texture, but I sometimes throw in a few extra pieces of inari age for good measure. I really can't get enough of that fried tofu.*

1. Place the kombu and shiitake mushroom in a large pot with the water. Allow it to rest for 4 hours. Place the pot over medium heat. Bring to a boil. Right before the water comes to a boil, remove the kombu.

2. Add the bonito flakes and simmer for 15 minutes. Remove the pot from the heat and let it sit for 5 minutes. Strain through a fine mesh strainer. Can be stored in a small airtight container in the refrigerator for up to 5 days.

3. When ready to set up the soup, split the cooked udon into 2 bowls. Top each bowl with 4 slices of inari age and kamaboko. Heat the dashi stock over medium heat and add the soy sauce, mirin, and sugar. Whisk together until the sugar has dissolved. Split the dashi between the 2 bowls. Serve with shichimi togarashi.

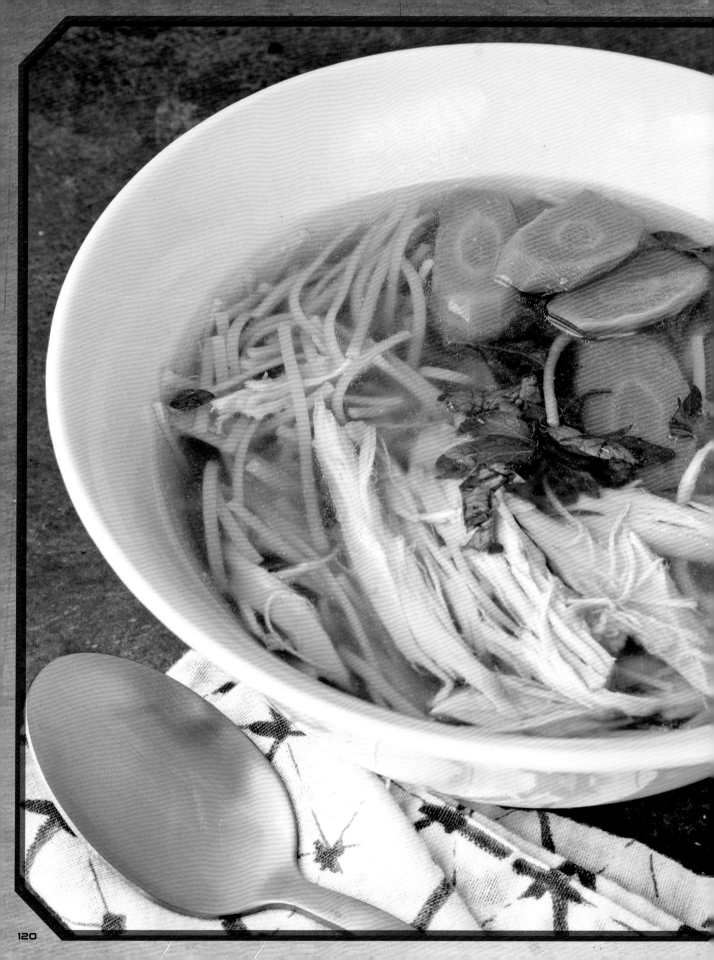

# ROSÓŁ

**Difficulty**: Easy
**Prep Time**: 30 minutes
**Cook Time**: 5 hours
**Yield**: 6 to 8 servings
**Dietary Notes**: Dairy-free

*Chicken soup is a perfect way to fight off cold and feel revitalized, and the Polish dish rosół may be one of the best renditions I know of. You all probably have your family's favorite recipe for this kind of soup, but I guarantee that this one is better. Don't believe me? Quite frankly, it's your loss.*

## BROTH

1 onion, quartered
5 lb. (2¼ kg) whole chicken
2 parsnips, chopped into large chunks
4 carrots, chopped into large chunks
½ celery root, chopped into large chunks
1 leek, chopped
1 tbsp. (15 g) black peppercorns
7 allspice seeds
3 bay leaves
½ bunch parsley
Salt

## PER SERVING

1 to 2 cups (237 to 473 ml) broth
1 oz. (28 g) fine egg noodles
½ carrot, sliced
Chicken meat from whole chicken used in broth (optional)
Ground black pepper
Parsley, chopped

1. Place the onion on a skillet over high heat and allow the outside to char. Remove and place in a large stock pot. Add the whole chicken, parsnips, carrots, celery root, leek, black peppercorns, allspice seeds, and bay leaves.

2. Add water to the stock pot until it just covers everything. Put over high heat and bring to a boil. Remove any foam that forms at the top. Once it boils, reduce heat to low. Allow to simmer for 4 hours.

3. Add the ½ bunch of parsley and simmer for another 30 minutes. After the broth has finished its simmer time, carefully strain the pot into another container to separate the broth from all the ingredients. Taste and season with salt. Can be stored in a large airtight container in the refrigerator for up to 5 days.

4. If you are planning to use the chicken meat in your soup, remove the meat from the whole chicken, shred, and place into a large airtight container. Can be stored in the refrigerator for up to 5 days.

5. To make a serving, place 1 to 2 cups (237 to 473 ml) of the broth in a small pot over medium heat. Add the carrots and shredded chicken meat and cook for 3 minutes. Add the fine egg noodles and cook until the noodles are cooked through. Generously season with black pepper. Transfer to a serving bowl and top with chopped parsley.

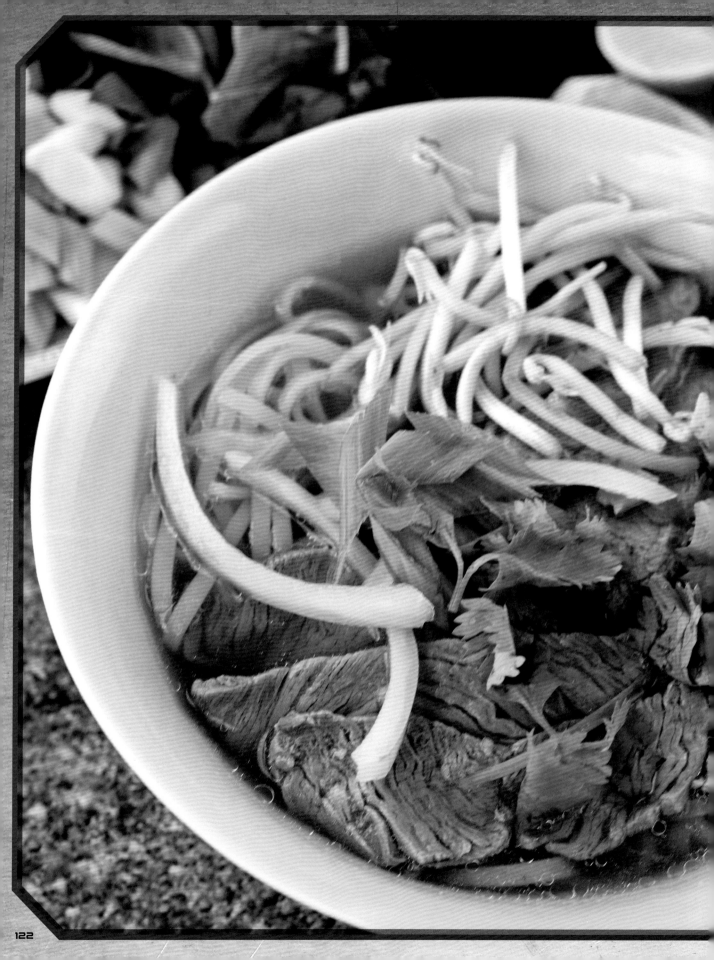

# PHỞ BÒ

**Difficulty**: Medium
**Prep Time**: 1 hour
**Cook Time**: 5 to 6 hours
**Yield**: 4 to 6 servings
**Dietary Notes**: Dairy-free

### BEEF BROTH

2 lb. (907 g) beef bones
1 lb. (454 g) oxtail
1 lb. (454 g) beef brisket
3 qt. (2.8 L) water
3-in. (7½-cm) piece of ginger, halved lengthwise
1 onion, cored and quartered
1 tbsp. (15 g) sugar
2 to 3 tbsp. (30 to 45 ml) fish sauce
1 tsp. (4 g) salt
2 black cardamom pods
1 cinnamon stick
4 star anise
2 cloves
15 coriander seeds

### PER SOUP SERVING

2 oz. (56 g) dried pho noodles, cooked according to directions
3 very thin slices beef sirloin, uncooked
2 slices beef brisket, from above
2 cups (473 ml) beef broth, hot
Onion slices
Scallions
Bean sprouts
Thai basil
Cilantro
1 Thai chile, thinly sliced
2 lime quarters
Hoisin sauce
Sriracha

*I love a good bowl of phở bò, but I never had it specifically until I tried the dish at Maeyamas Noodle Bar. The red meat definitely makes for a different flavor than I'm used to, but it still results in a tasty soup with a great set of flavors. You have to give it a try.*

### BEEF BROTH

1. Place the beef bones, oxtail, and beef brisket in a large bowl. Cover with water and let sit for 15 minutes. Drain and rinse off each of the pieces. Place in a stock pot and fill with enough water to cover the meat. Place over high heat, bring to a boil, and allow to boil for 5 minutes. Strain and rinse all the meat, removing any scum. Transfer to a clean stock pot and set aside.

2. Place the ginger and onions on a baking sheet. Place under a broiler and allow to char, about 5 minutes. Transfer to the stock pot.

3. Add 3 quarts (2.8 L) of water to the stock pot. This should be enough to just cover everything. Place over medium-high heat and bring to a boil. Reduce the heat to low and allow to simmer. Add the sugar, fish sauce, and salt.

4. Allow to simmer for 1 hour, or until the brisket is cooked through. Remove the brisket and set aside. This will be used as a topping later. Allow the broth to keep simmering as you toast your spices.

5. Heat a small stainless steel frying pan over medium heat. Add the black cardamom, cinnamon stick, star anise, cloves, and coriander seeds. Allow to lightly toast for about 3 minutes. Transfer to the stock pot and allow to cook for another 3 to 4 hours.

**NOTE** If you'd like, you can place the spices in a cheesecloth to make them easier to remove later.

6. Taste the broth and add more salt and fish sauce if needed. After the broth has finished its simmer time, carefully strain the pot into another container to separate the broth from all the ingredients. Can be stored in a large airtight container in the refrigerator for up to 5 days.

### PREPARE A SERVING

1. Place the cooked pho noodles in a bowl. Top with the uncooked beef sirloin slices and beef brisket. Ladle on the hot beef broth over the meat to cook the uncooked slice. Top with onion slices, scallions, bean sprouts, Thai basil, cilantro, and Thai chiles to your liking. Serve with limes, hoisin sauce, and sriracha.

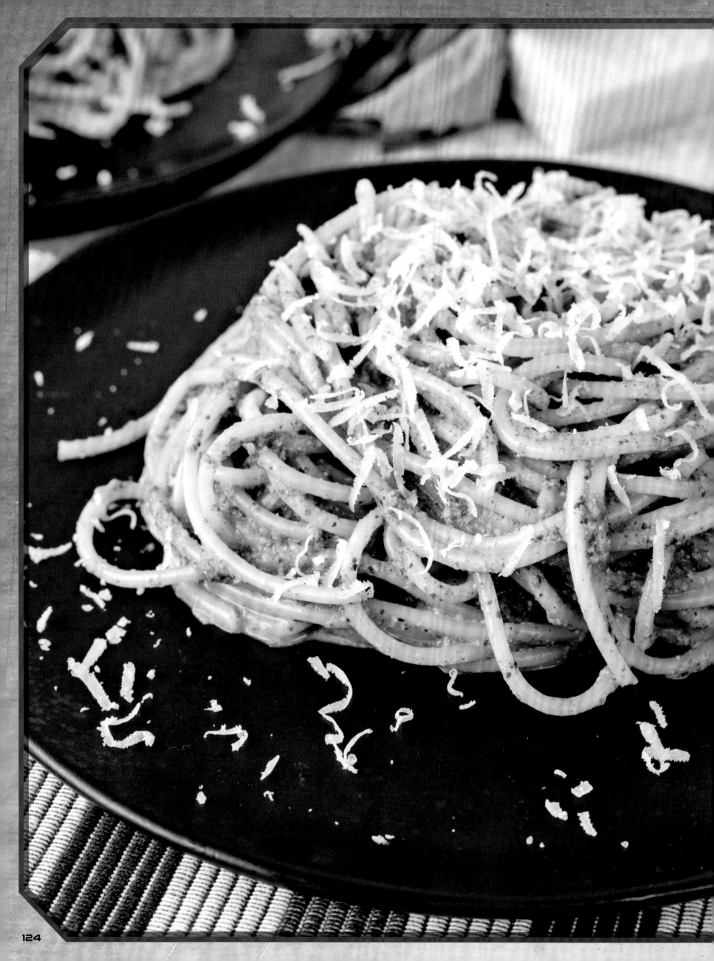

# TALLARINES VERDES

**Difficulty**: Easy
**Prep Time**: 15 minutes
**Cook Time**: 25 minutes
**Yield**: 4 servings
**Dietary Notes**: Vegetarian

2 tbsp. (30 ml) olive oil
1 large onion, chopped
4 garlic cloves, chopped
16 oz. (454 g) spinach
3½ oz. (99 g) basil
¼ cup (46 g) pecans
4 oz. (113 g) queso fresco
¾ cup (177 ml) evaporated milk
1 lb. (454 g) spaghetti,
cooked (save the pasta water)
Salt
Black pepper, ground

*You've probably had a traditional pesto pasta before, but this takes things to a new level. With the power of two great greens—spinach and basil—it's even healthier than regular pesto! At least that's what I tell myself, whether or not it's actually true.*

1. Heat a medium nonstick frying pan with 2 tablespoons (30 ml) of olive oil over medium heat. Add the onion and garlic and cook until softened, about 5 minutes. Add the spinach and basil and cook until just wilted.

2. Transfer to a blender and add the pecans, queso fresco, and evaporated milk. Blend until smooth.

3. Place the cooked spaghetti in a large bowl and toss in the sauce. If the sauce is too thick, add some of the pasta water to loosen. Season with salt and pepper.

# PASTA ALLA NORMA

**Difficulty**: Medium
**Prep Time**: 20 minutes
**Rest Time**: 45 minutes
**Cook Time**: 40 minutes
**Yield**: 4 servings
**Dietary Notes**: Vegetarian

1½ lb. (680 g) small eggplants, cubed
Salt
Olive oil for sautéing
½ large onion, minced
5 garlic cloves, minced
2 tsp. (3 g) dried oregano
1 tsp. (1 g) red pepper flakes
28 oz. (794 g) can whole tomatoes
1 lb. (454 g) penne rigate, cooked
al dente (save the pasta water)
Pepper
1 oz. (28 g) basil leaves, chopped
2 oz. (56 g) ricotta salata

*A Maeyamas classic, their pasta alla Norma is loaded with eggplant and topped with flavor. It may look pretty standard at first, but after a quick taste, you'll soon find there's nothing "norma" about it. (I read that joke back to myself aloud, and I hate it too much to remove it.)*

1. Place the cut eggplant in a strainer and cover generously with salt. Let it sit for 45 minutes. This will remove some of the moisture from the eggplant. Rinse the eggplants and pat dry.

2. Heat a medium nonstick frying pan with 2 tablespoons (30 ml) of olive oil over medium heat. Place the eggplant, in a single layer, in the oil and cook until golden brown. You will likely need to do this in batches. Transfer the cooked eggplant to a plate. Repeat this step until all the eggplant is cooked.

3. In the same pan, add another tablespoon (15 ml) of olive oil if too dry. Add the onion and cook until softened, about 5 minutes. Add the garlic, oregano, and red pepper flakes. Cook until the garlic has softened, about 2 minutes.

4. Add the whole tomatoes and cook until the liquid thickens, about 10 minutes. Toss the eggplant and cooked penne rigate until coated in the tomato. If the sauce is too thick, add some of the pasta water to loosen. Season with salt and pepper. Serve with basil and ricotta salata on top.

# SEVIYAN KHEER

**Difficulty**: Medium
**Prep Time**: 15 minutes
**Cook Time**: 40 minutes
**Yield**: 4 servings
**Dietary Notes**: Vegetarian

1 tbsp. (15 g) ghee
¾ cup (35 g) vermicelli
3½ cups (828 ml) milk
⅔ cup (134 g) sugar
3 saffron strands
1 tsp. (2 g) ground cardamom
2 tbsp. (25 g) golden raisins
1 tbsp. (11 g) almonds, crushed
1 tbsp. (11 g) pistachios, crushed

*I bet I can guess what you're thinking. Noodles? In my dessert? Well, let me ease your concerns, because Maeyamas Noodle Bar wouldn't let you down. You're covering up the noodles with all sorts of dairy, fruity, and nutty goodness that you won't even think is weird after a few bites. You'll be too busy engrossed in the seviyan kheer to notice.*

1. Heat a medium saucepan, with ghee, over medium-low heat. Add the vermicelli and cook until lightly roasted and golden brown, about 3 to 5 minutes.

2. Add the milk and sugar and mix well. Bring to a simmer. Allow to simmer until the liquid reduces by half, about 25 minutes. Stir while it simmers so the vermicelli doesn't stick to the bottom of the pan.

3. Add the saffron and cardamom and mix well. Cook for another 5 minutes. Finally, add the raisins, almonds, and pistachios and mix in well. This can be served either warm or chilled. Serve with additional raisins, almonds, and pistachios.

# THAI GAME

I mentioned previously that Enzo's and Thai Game are run by the same person and are occasionally found in the same food court with a shared menu. More likely than not, you've eaten at one of these fine fusion establishments. The joint menu can be a little daunting, and all those tantalizing options are hard to choose from. But if I were a betting man, which I absolutely am, I'd bet all your favorites are actually Thai Game specials. Enzo's is great and all, but Thai Game has the upper hand when it comes to delights that practically beg you to order them.

It's clear from your first bite how much effort went into making all these dishes traditional and honest with their roots. It isn't a simple thing taking family recipes and regional specialties and translating them into interplanetary fare. You have to worry about some ingredients that don't travel well or sourcing other options from nearby farms. This was the sort of thing I used to do professionally, so I would know. But now, all I do is enjoy the spices and flavors and try to make some at home when I'm feeling up to it. You're not going to find me being a regular at a food court. I have very slightly more dignity than that.

**Thai Game**

# CHICKEN SATAY

**Difficulty**: Medium
**Prep Time**: 30 minutes
**Rest Time**: 4 to 6 hours
**Cook Time**: 15 minutes
**Yield**: 4 to 6 servings
**Dietary Notes**: Dairy-free, gluten-free

## CHICKEN MARINADE

1 cup (237 ml) coconut milk
2 tbsp. (30 ml) soy sauce
1 tbsp. (15 ml) fish sauce
2 tbsp. (30 ml) lime juice
2 tsp. (10 ml) lime zest
3 garlic cloves, minced
1-in. (2½ g) piece ginger, grated
2 tsp. (7 g) coriander
1 tbsp. (6 g) turmeric
½ tsp. (2 g) cumin
1 tbsp. (14 g) light brown sugar
1 tsp. (4 g) salt
2 lb. (907 g) chicken tenders
Wooden skewers

## PEANUT SAUCE

¼ cup coconut milk
¼ cup (78 g) creamy peanut butter
2 tsp. (10 ml) soy sauce
1 tbsp. (15 ml) lime juice
1 tbsp. (14 g) brown sugar
2 tsp. (10 ml) sesame oil
2 tbsp. (30 g) sambal oelek

*Want a delicious, spicy way to start your meal? Look no further than some chicken satay, gorgeous grilled chicken just absolutely drenched in a peanut-based sauce. Take a bite and you'll find a nice, comforting burn that'll keep convincing you to eat another skewerful.*

### CHICKEN MARINADE

1. Combine the coconut milk, soy sauce, fish sauce, lime juice, lime zest, garlic, ginger, coriander, turmeric, cumin, brown sugar, and salt in a large airtight container. Add the chicken and toss to coat. Cover, place in the refrigerator, and marinate for at least 4 hours and up to 6 hours.

2. Allow the wooden skewers to soak in water for 30 minutes prior to grilling. Lightly pat the marinated chicken to remove excess marinade and thread onto a skewer. Repeat until all the chicken tenders are on a skewer.

3. Heat a large grilling pan sprayed with nonstick spray over medium-high heat. Place the chicken on the pan and cook for 4 minutes. Flip and cook for another 2 to 3 minutes, or until the chicken registers at a temperature of 165°F (74°C).

### PEANUT SAUCE

1. Combine all the ingredients in a small bowl. Serve immediately or store in the refrigerator until you are ready to serve. The sauce will thicken in the refrigerator.

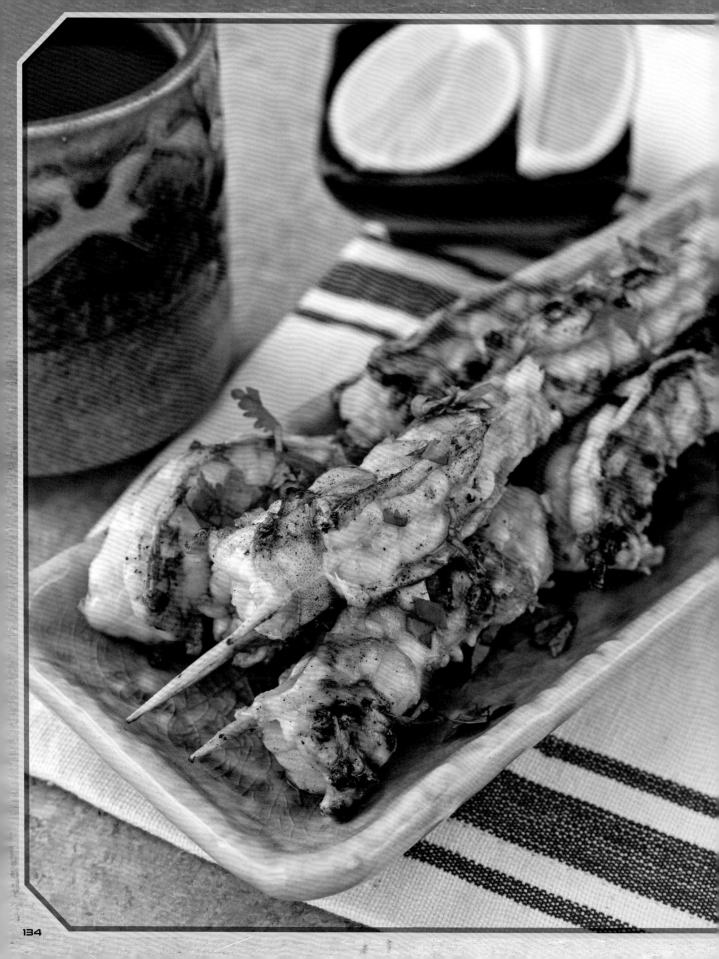

# GRILLED MEGA PRAWNS

**Difficulty**: Easy
**Prep Time**: 15 minutes
**Rest Time**: 30 minutes
**Cook Time**: 10 minutes
**Yield**: 5 to 6 skewers
**Dietary Notes**: Dairy-free

2 tbsp. (30 g) tamarind paste
1 tbsp. (15 ml) soy sauce
2 tsp. (10 ml) fish sauce
Juice of 2 limes
1 tbsp. (20 g) palm sugar, grated
5 garlic cloves, minced
1 Thai chile, minced
1 lb. (454 g) prawns or large shrimp, peeled and deveined
1 tbsp. (4 g) cilantro, chopped

*Prawns are quite difficult to transport and keep fresh, so always be a bit dubious if you find them on a menu at a spaceport or in a ship's mess. But at your own home? You can go out and find prawns as fresh as you need for this amazing dish.*

1. Combine the tamarind paste, soy sauce, fish sauce, lime juice, and palm sugar in a medium bowl. Whisk together until all the palm sugar has dissolved. Add the garlic cloves and Thai chile. Finally, add the prawns or shrimp and mix until they are fully coated. Allow to marinate at room temperature for 30 minutes.

2. Soak 5 wooden skewers in water for 30 minutes prior to grilling. Thread the shrimp onto the skewers, about 2 to 3 per skewer.

3. Cook the skewers on a preheated grill for 2 to 3 minutes per side, or until the shrimp are cooked through.

4. Serve with lime slices and top with cilantro.

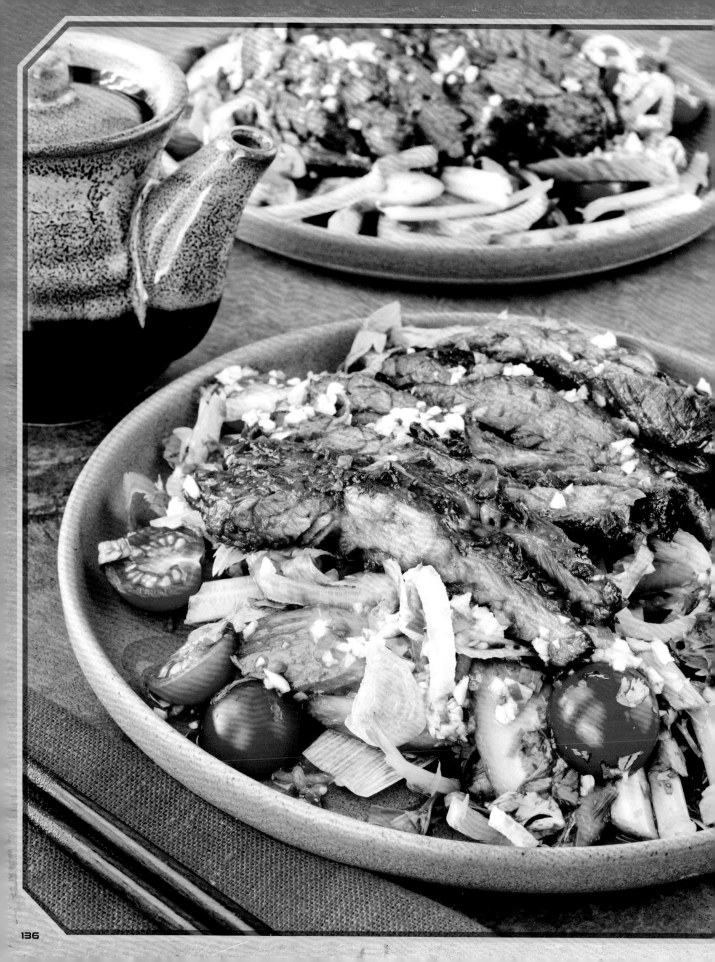

## Thai Game

# YUM NUA

**Difficulty**: Easy
**Prep Time**: 20 minutes
**Rest Time**: 1 hour
**Cook Time**: 15 minutes
**Yield**: 4 servings
**Dietary Notes**: Dairy-free

### GRILLED STEAK

3 tbsp. (45 ml) soy sauce
2 tsp. (10 ml) fish sauce
1 tbsp. (20 g) palm sugar, grated
1 tbsp. (15 ml) lime juice
Pinch of ground black pepper
2 garlic cloves, grated
1 lb. (454 g) skirt steak
1 tbsp. (15 ml) canola oil

### DRESSING

3 tbsp. (45 ml) fish sauce
¼ cup (59 ml) lime juice
1 tbsp. (20 g) palm sugar, grated
3 Thai chiles, finely chopped
3 garlic cloves, minced

### SALAD

1 cucumber, peeled and sliced
3 oz. (87 g) cherry tomatoes, halved
2 shallots, sliced
3 sprigs Chinese celery, cut into
2-in. (5-cm) lengths
1 scallion, chopped
½ bunch cilantro, chopped

*I have a confession to make: I didn't know much about fish sauce for most of my adult life, and it wasn't until I learned how to make yum nua that I learned my utter failure as a cook. If you're reading this and thinking, "I also don't know much about fish sauce," I'm about to improve your life tenfold. Try it, and you'll start finding excuses to put it on everything, within reason, of course.*

### GRILLED STEAK

1. Combine the soy sauce, fish sauce, palm sugar, lime juice, pepper, and garlic in a medium bowl. Whisk together until the palm sugar has dissolved. Add the steak and mix well until fully coated. Let marinate at room temperature for up to 1 hour, tossing a few times during this time to make sure the meat is coated in the marinade.

2. Heat a medium stainless steel frying pan with 1 tablespoon (15 ml) of canola oil over high heat. Sear the steak to your desired temperature. Transfer to a plate and cover in aluminum foil. Allow the meat to rest for 10 minutes.

3. Slice the meat against the grain in order to avoid the pieces being chewy.

### DRESSING AND SALAD

1. Combine ingredients for the dressing in a small bowl. Whisk together until the palm sugar has dissolved.

2. Toss all the ingredients for the salad in a medium bowl. Pour on the dressing and toss to coat. Split between 4 plates. Top each salad with ¼ of the sliced steak.

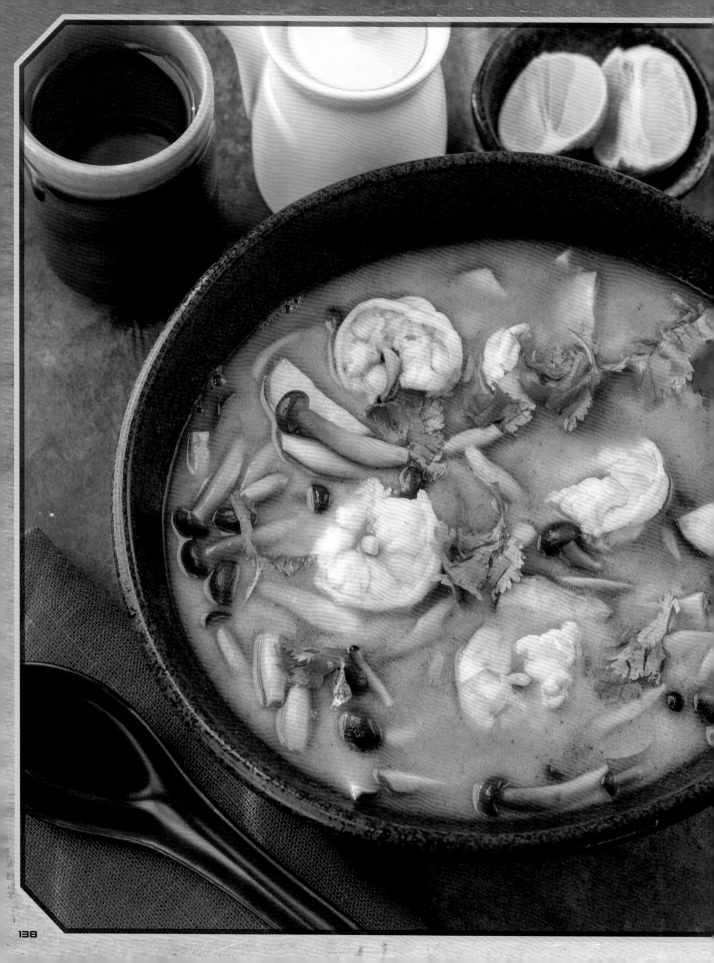

## Thai Game
# TOM YUM

**Difficulty**: Easy
**Prep Time**: 30 minutes
**Cook Time**: 45 minutes
**Yield**: 4 servings
**Dietary Notes**: N/A

½ lb. (226 g) shrimp, head and shell on
Canola oil, for frying
1 lemongrass, crushed
2-in. (5-cm) piece ginger, sliced
3-in. (7½-cm) piece galangal, sliced
3 garlic cloves, crushed
2 Thai chiles, split open
4 kaffir lime leaves, torn
4 cups (946 ml) water
2 tbsp. to ¼ cup (34 to 68 g) nam prik pao
⅓ cup (84 g) evaporated milk
1 oyster mushroom, sliced
1 bunch beech mushrooms
1 tbsp. (30 ml) fish sauce
1 to 2 limes
Cilantro, chopped

*One of my favorites from Thai Game. It took me quite a while to interpret this one to incorporate into a similar recipe. There are a lot of ingredients and flavors to figure out, and although I had a hand in the supply contract for their locations, they don't just give away their secrets if you ask nicely. And, oh, did I ask often.*

1. Remove the heads, shells, and tails from the shrimp and place in a medium pot. Clean and devein the fish and set aside.

2. Place the medium pot over medium-high heat. Sauté the shrimp heads until they turn pink and the liquid from the shrimp head has evaporated. Add the lemongrass, ginger, galangal, garlic, Thai chiles, and kaffir lime leaves. Stir everything together and let cook for another 5 minutes to allow everything to lightly toast. Add the water and scrape the bottom to remove any pieces that may have gotten stuck to the pot. Add the nam prik pao and stir together to combine. Bring to a boil, then reduce the heat to low. Allow to simmer for 30 minutes.

3. After the stock has simmered, carefully remove all the pieces in the broth and discard. Add the evaporated milk and stir in well. Add the mushrooms and cook until cooked through, about 3 to 5 minutes.

4. Add the fish sauce and cook for another 2 minutes. Finally, add the shrimp and cook for another minute, until cooked through. Remove from the heat and let sit for about 3 minutes.

**NOTE** It is important to let this rest for a couple of minutes before adding the lime. Add it too early, and the evaporated milk will curdle.

5. Juice 1 lime in and mix well. Taste and add additional lime juice if needed. Serve with cilantro and extra chopped Thai chile on top.

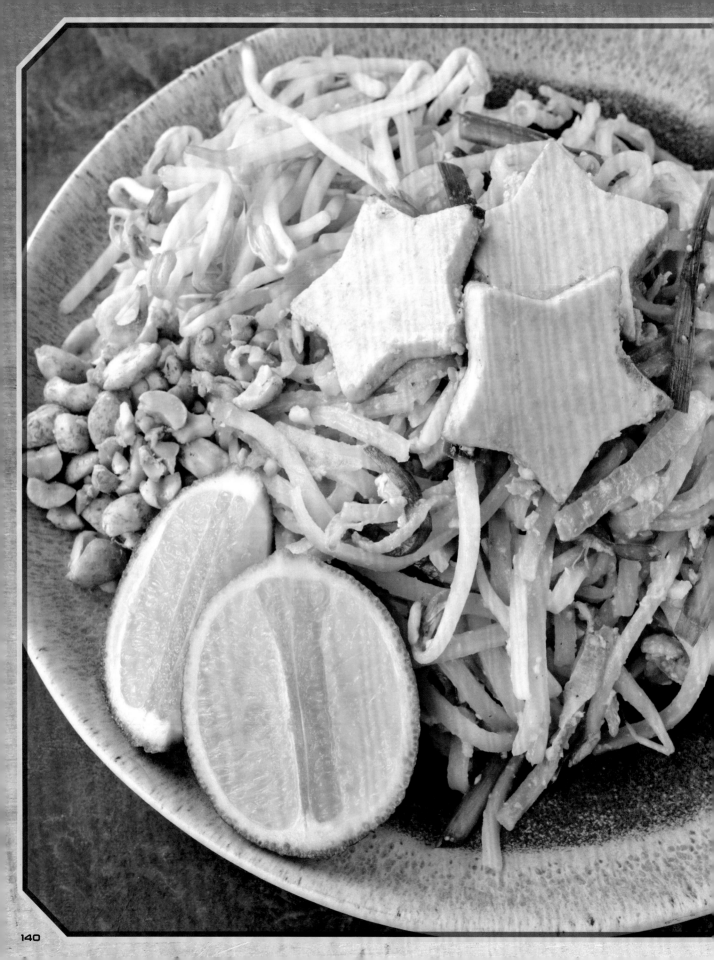

# SPACE PAD THAI

**Difficulty**: Medium
**Prep Time**: 30 minutes
**Cook Time**: 15 minutes
**Yield**: 4 servings
**Dietary Notes**: N/A

8 oz. (226 g) medium rice noodles
2 oz. (56 g) tamarind pulp
2 tbsp. (40 g) palm sugar, grated
½ cup (118 ml) boiling water
1½ tbsp. (22 g) fish sauce
3 shallots, sliced
4 garlic cloves, minced
8 oz. (226 g) pressed tofu, sliced
3 tbsp. (30 g) hua chai po wan (optional)
12 garlic chives, chopped into 1-in. (2½ g) pieces
2 cups mung bean sprouts
3 eggs
Canola oil for sautéing
¼ cup (37 g) roasted peanuts, roughly chopped

### SERVING

Mung bean sprouts
Roasted peanuts
Limes

*I've never understood why they call it space pad Thai. Is it just because of the tofu cut into stars? Why not make all their food space themed? Well, it's a great dish all the same. You can spend the time and make your own star-shaped tofu if you like, but I do it only when I have guests to impress.*

1. Place the rice noodles in a large bowl and cover with warm water. Allow the noodles to soak for 1 hour. After the noodles have rehydrated, drain the water and, using a pair of scissors, cut the noodles in half.

2. Place the tamarind pulp and palm sugar in a medium bowl. Add the boiling water and whisk together until smooth and combined. Carefully pass the mixture through a fine mesh strainer to remove any seeds and large chunks from the tamarind pulp. Add the fish sauce and set aside.

3. Combine the shallots, garlic, tofu, and hua chai po wan in a small bowl. Combine the garlic chives and mung bean sprouts in another bowl. Whisk the eggs.

**NOTE** It is very important that you have everything ready before you start cooking. When cooking with high heat, everything happens very quickly. Be prepared!

4. Heat a wok (or large stainless steel frying pan) over medium-high heat. Once heated, add 1 tablespoon (15 ml) of canola oil and allow to heat for another minute. Add the bowlful of shallots and other ingredients and sauté until the shallots have wilted, about 5 minutes.

5. Turn the heat up to high and add the noodles and sauce, constantly tossing until the noodles absorb the sauce. Once the sauce is completely absorbed, push everything in the pan to one side. Reduce the heat to medium-high heat. Add the eggs into the empty section of the pan. Let sit for 30 seconds over the heat. Scramble the eggs, then toss the eggs with the noodles until mixed together.

6. Add the garlic chives and mung bean sprouts. Toss in until the chives begin to wilt. Remove from the heat and toss in the roasted peanuts. Serve with additional mung bean sprouts, peanuts, and limes.

# KUKU'S CAFÉ

This cookbook has me pulling inspiration from all sorts of eating establishments I've been to over the years, but Kuku's Café is probably the one place you've never heard of before. It's the epitome of a hole in the wall—you could walk past Kuku's while they were busy and not realize it was open for business. But their sandwiches are so delicious that it's criminal it has stayed so under the radar for so long— although if you were to ask the frequent diners, I strongly suspect they wouldn't mind Kuku's staying off the online best-food lists for a bit longer. But look: The owners have been churning out great food for a while now, and they deserve some good press for all their efforts.

Sandwiches, better than most other kinds of food, show off the talent of a restaurant's kitchen. It's a simple concept, but that simplicity just means all the details are up to the chefs to get it just right. Kuku's Café has some really inspired ideas, pulling from a wide array of cultures and cuisines, and brings forth a menu that makes me drool just thinking about it. I'd love to include everything on their menu in this cookbook, but I have to leave at least something to the imagination. If you can find the restaurant in the sprawl of Mombasa, you need to stop by and see it for yourself. And if it eludes you, at least you've got these recipes to make up for it.

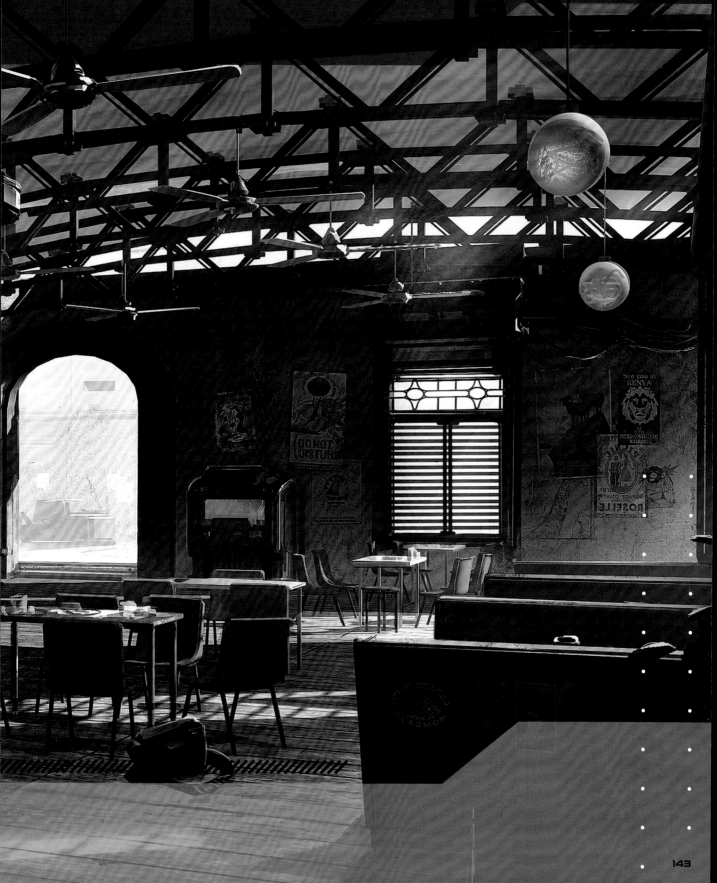

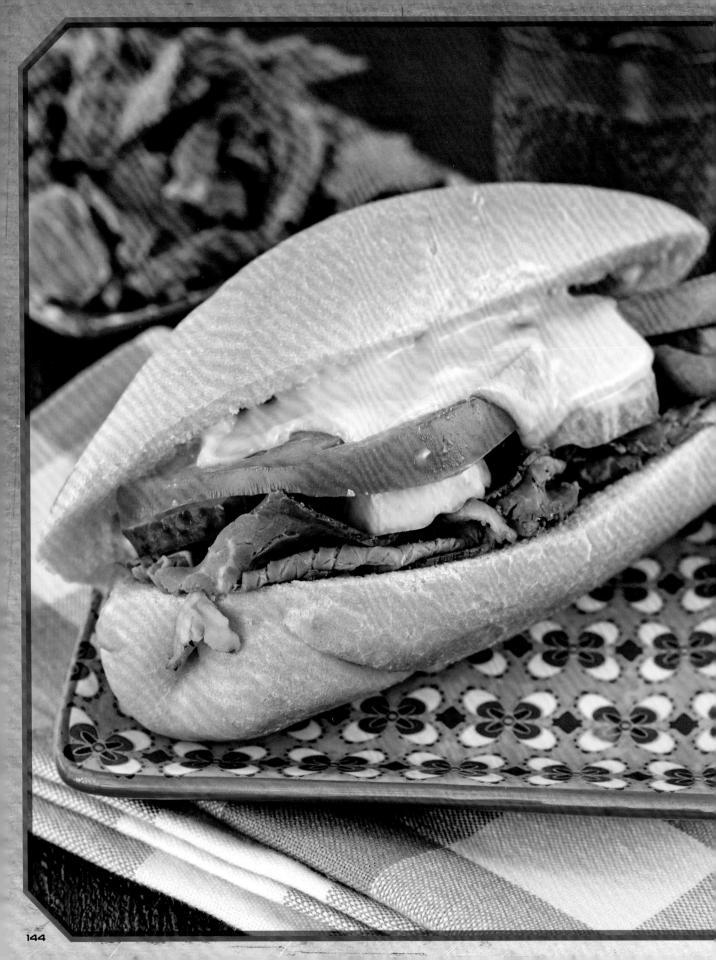

# BAURU SANDWICH

**Difficulty**: Easy
**Prep Time**: 15 minutes
**Cook Time**: 5 minutes
**Yield**: 1 sandwich
**Dietary Notes**: N/A

2 slices of large tomato
Salt
1 bolillo
3 oz. (85 g) roast beef
4 to 5 pickle slices
Water
0.7 oz. (20 g) Edam cheese, shredded
0.7 oz. (20 g) Gouda cheese, shredded
2 oz. (56 g) Swiss cheese, shredded

*The bauru sandwiches at Kuku's Café are not ostentatious or elaborate, but they're full of down-to-earth, cheesy roast beef goodness. First popular in Brazil, these sandwiches are a perfect humble bite for any occasion, but I'm quite partial to these after testing too many drinks for this cookbook.*

1. Generously salt the tomato slices and set aside. Cut open the bolillo. Place the roast beef in the sandwich. Top with the pickle and tomato slices. Set aside.

2. Place 1 inch (2½ cm) of water in a small nonstick frying pan over medium-high heat. Once it comes to a simmer, add the cheese, and cook until the cheese has melted. Strain out the water and pour the melted cheese on top of the tomato slices.

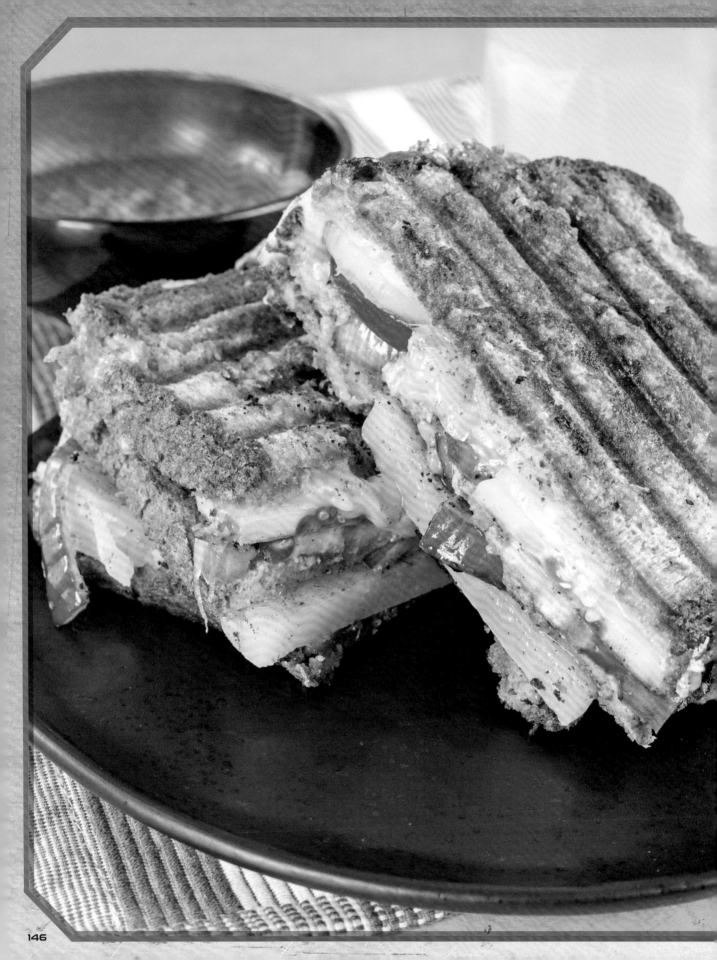

# BOMBAY SANDWICH

**Difficulty**: Medium
**Prep Time**: 45 minutes
**Cook Time**: 30 minutes
**Yield**: 4 sandwiches
**Dietary Notes**: Vegetarian

*This Bombay sandwich can, at first glance, look like a fancier grilled cheese sandwich. But let me educate you—grilled cheese can't hold a candle to this beautiful dish. With the chutney, chaat masala, potato, and onion, it's a complete meal in itself.*

### CHAAT MASALA

1 tbsp. (10 g) cumin seeds
1 tsp. (2 g) coriander seeds
1 tsp. (2 g) fennel seeds
1 tsp. (5 g) black peppercorns
1 green cardamom pod
1 tbsp. (10 g) amchur powder
1 tsp. (3 g) ginger powder
1 tsp. (2 g) Kashmiri chile powder
2 tsp. (14 g) kala namuk
¼ tsp. (½ g) citric acid

### GREEN CHUTNEY

1 bunch cilantro
2 tbsp. (10 g) mint
2 serrano chiles, stemmed
4 garlic cloves
½-in. (12-mm) piece ginger
½ tsp. (2 g) sugar
1 tsp. (4 g) salt
Juice of 1 lime
2 tbsp. (30 ml) water
¼ oz. (7 g) shredded coconut

### SANDWICH AND ASSEMBLY

1 russet potato, peeled and sliced
12 slices white bread

## NOTE

Make sure to not use overly thin slices of bread here. They might tear while cooking, causing the filling to spill out.

Unsalted butter for grilling
2 tomatoes, sliced
½ red onion, sliced
1 cucumber, peeled and sliced
8 oz. (226 g) mozzarella cheese, shredded

### CHAAT MASALA

1. Heat a small stainless steel frying pan over medium heat. Add the cumin, coriander, fennel, black peppercorns, and cardamom pod. Allow to lightly toast for about 3 minutes. Set aside and allow to cool completely.

2. Transfer to a spice grinder and blend until the peppercorns have grinded. Place in an airtight container. Combine with the remaining ingredients.

### GREEN CHUTNEY

1. Place all the ingredients in a food processor and pulse until smooth. If the mixture is too thick, add a small amount of water at a time to loosen it. Can be stored in a small airtight container in the refrigerator for up to 1 week.

### SANDWICH AND ASSEMBLY

1. Bring a large pot of water to a boil. Add the potato and boil until softened, about 12 minutes. Drain, pat dry, and transfer to a plate.

2. To assemble a sandwich, butter one side of 1 piece of white bread, flip it, and spread on a layer of green chutney. Top with a layer of the sliced, cooked potatoes. Sprinkle it with chaat masala. Top with a handful of red onions.

3. Spread a layer of green chutney on another slice of bread. Place the chutney layer on top of the sandwich. Spread another layer of chutney on the side facing upward now. Place a layer of sliced cucumbers and sliced tomatoes on top. Add a layer of mozzarella. Sprinkle it with chaat masala.

4. Spread a layer of green chutney on a third slice of bread. Place the chutney layer on top of the sandwich. Spread a layer of butter on the top part of the bread. Repeat steps 3 and 4 to assemble the remaining sandwiches.

5. Heat a large grilling pan over medium-high heat. Place a prepared sandwich on the pan. Place a heavy, heat-safe item on top to press the sandwich. Cook until the bottom has turned golden brown, about 3 to 5 minutes. Flip, place the weight on again and allow the other side to cook until golden brown, about 3 to 5 minutes.

6. Repeat with the rest of the sandwiches.

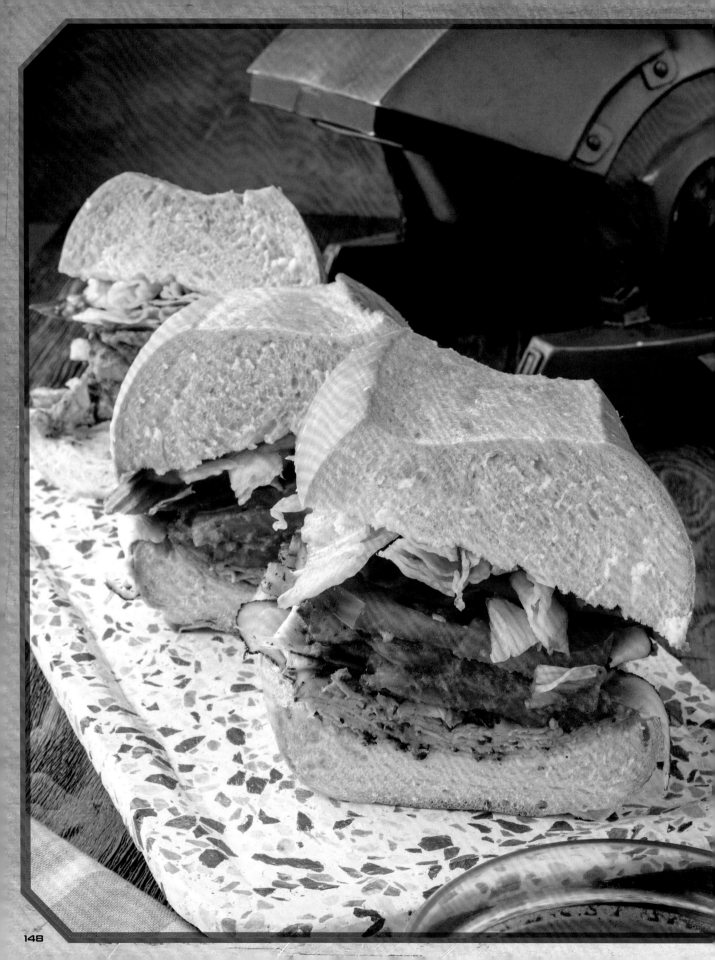

# GATSBY SANDWICH

*Gatsby sandwiches are a South African tradition prepared in various ways, but you can't call it a Gatsby sandwich unless it's on a sandwich roll and packed to the brim with fries. These sandwiches, when served at Kuku's Café, are massive, meant for a table instead of a single patron, but I've seen a few hulking military types on occasion eat an entire order on their own.*

**Difficulty**: Easy
**Prep Time**: 30 minutes
**Cook Time**: 45 minutes
**Yield**: 4 to 6 servings
**Dietary Notes**: Dairy-free

### PERI-PERI SAUCE

1 red bell pepper, stemmed and seeded
½ red onion
4 garlic cloves
3 Thai chiles, stemmed
1 tsp. (4 g) smoked paprika
1 tsp. (2 g) oregano
¼ cup (59 ml) red wine vinegar
1 tsp. (4 g) salt
1 tsp. (5 g) sugar
½ tsp. (1 g) ground black pepper
Juice and zest of 1 lemon
2 tbsp. (30 ml) olive oil

### BAKED POTATO CHIPS

2 russet potatoes, cut into wedges or thick fries
3 tbsp. (45 ml) olive oil
1 tsp. (4 g) garlic powder
1 tsp. (2 g) oregano
½ tsp. (1 g) ground black pepper
1 tsp. (4 g) salt

### ASSEMBLY

1 large loaf French bread
½ lb. (226 g) deli meat of choice
Baked potato chips
Peri-peri sauce
1 large tomato, sliced
1 cucumber, sliced
¼ iceberg lettuce, chopped

## PERI-PERI SAUCE

1. Place the bell pepper, onion, and garlic on a baking sheet. Place under a broiler and allow to char, about 5 minutes. Allow to cool.

2. Place bell pepper, onion, garlic, Thai chiles, smoked paprika, oregano, red wine vinegar, salt, sugar, and black pepper in a blender. Blend until completely smooth. Transfer to a small saucepan. Heat over medium-high heat and bring to a boil. Reduce the heat to low and simmer for 30 minutes, until it has thickened. Remove from the heat and allow to cool slightly.

3. Transfer back to the blender. Add the lemon zest, lemon juice, and olive oil. Blend until smooth. Transfer to a small airtight container. Can be stored in an airtight container in the refrigerator for up to 2 weeks.

## BAKED POTATO CHIPS

1. Preheat the oven to 450°F (232°C). In a bowl, combine the olive oil, garlic powder, oregano, pepper, and salt. Toss the potato wedges in the mixture.

2. Prepare a baking sheet with aluminum foil and nonstick spray. Transfer the seasoned potato wedges onto the sheet and place in the oven. Bake for 15 minutes. Toss and bake for another 15 minutes. Toss once more and bake for another 10 minutes. Turn on the broiler and cook the fries until they are crispy, about 4 to 5 minutes.

## ASSEMBLY

1. Cut open the bread loaf. Top the bottom portion with the deli meat. Top with the baked potato chips and a generous portion of peri-peri sauce. Top with the tomato, cucumber, and lettuce. Place the other half of the loaf on top and cut into 4 to 6 portions.

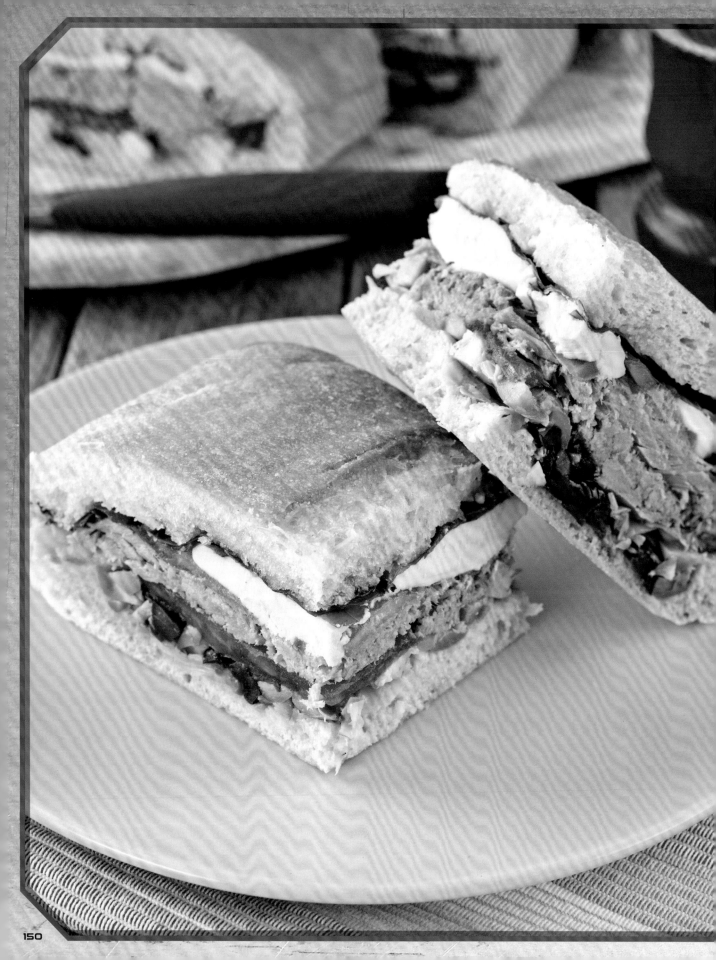

# PAN BAGNAT

**Difficulty**: Easy
**Prep Time**: 45 minutes
**Rest Time**: 12 hours
**Yield**: 4 to 6 portions
**Dietary Notes**: N/A

*The pan bagnat at Kuku's Café is a French sandwich just loaded with tuna, olives, oil, and eggs. It's protein stacked on protein and will fill anyone up, but I love making it at home because it means I have extra olives to snack on afterward.*

¼ red onion, thinly sliced
½ cup (118 ml) red wine vinegar
¼ cup (59 ml) olive oil
4 garlic cloves, crushed
⅓ cup (57 g) Kalamata olives, chopped
⅓ cup (57 g) Castelvetrano olives, chopped
7 oz. (198 g) artichoke hearts, chopped
1 tbsp. (13 g) capers, chopped
1 large ciabatta, day old
3 Roma tomatoes, sliced
13 oz. (369 g) canned tuna in olive oil
2 hard-boiled eggs, sliced
10 large basil leaves

1. Combine the red onion and red wine vinegar in a small bowl. Set aside and allow to sit for at least 30 minutes. Combine the olive oil and crushed garlic in a small bowl. Allow to sit for at least 15 minutes.

2. Combine the Kalamata olives, Castelvetrano olives, artichoke hearts, and capers in a medium bowl. Set aside.

3. Cut the ciabatta lengthwise. Remove some of the interior of the bread to form a cavity.

**NOTE** If you want your sandwich to have a thicker layer of bread, just skip this step of removing some. I personally like mine without it!

4. Brush the interior of the ciabatta with the garlic olive oil, discarding the crushed garlic. Spread the olive mixture over the bottom slice of ciabatta. Top with a single layer of sliced tomatoes.

5. Add the tuna and spread into an even layer across the loaf. Top with the sliced hard-boiled eggs and finally with a layer of basil leaves. Cover with the top slice of ciabatta.

6. Wrap the sandwich tightly with plastic wrap and aluminum foil. Place in the refrigerator and top with a heavy weight (like a cast-iron pan) for at least 12 hours. To serve, remove from the plastic wrap and cut into 4 to 6 portions.

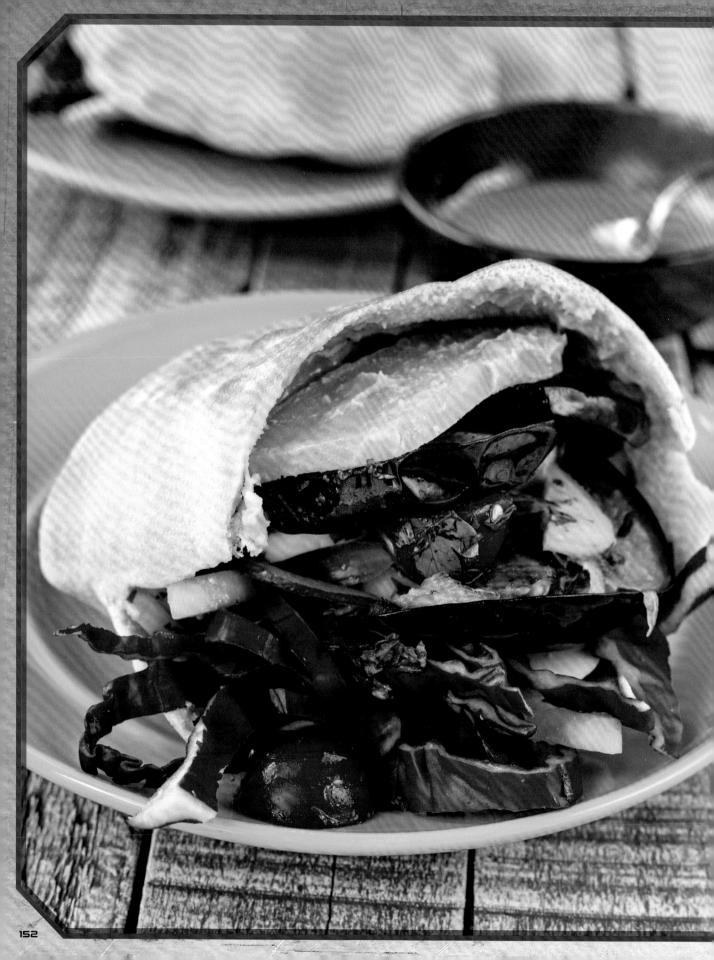

# SABICH

*The hearty sabich: a pita packed with protein and produce, with tahini poured in for good measure. I prefer mine with extra potatoes, but you can put any variety of things in it and get a pretty great product.*

**Difficulty**: Medium
**Prep Time**: 45 minutes
**Rest Time**: 20 minutes
**Cook Time**: 30 minutes
**Yield**: 4 sabich
**Dietary Notes**: Vegetarian

### SALAD

2 tbsp. (4 g) mint
¼ cup (15 g) parsley
¼ cup (15 g) cilantro
2 tbsp. (30 ml) olive oil
Zest and juice of 1 lemon
10 cherry tomatoes, halved
1 cucumber, peeled, halved, and sliced
2 garlic cloves, minced
¼ red onion
Salt
Pepper

1 eggplant
Peanut oil, for frying
1 russet potato, peeled and sliced ½ in. (12 mm) thick
1 cup (246 g) hummus
4 hard-boiled eggs, sliced
¼ red cabbage, cored and thinly sliced
½ cup (112 g) tahini
4 pitas

1. Combine the mint, parsley, cilantro, olive oil, lemon juice, and lemon zest in a large bowl. Whisk together well. Add the tomatoes, cucumber, garlic, and red onion. Toss until well coated with the dressing. Season with salt and pepper. Place in a small airtight container, cover, and place in the refrigerator until ready to use.

2. Place the cut eggplant into a strainer and cover generously with salt. Let sit for 30 minutes to remove the excess moisture. Pat each of the slices to wipe off the released moisture.

3. Heat a large frying pan with ¼ inch of oil over medium-high heat. Bring the oil to 360°F (182°C). Place the eggplant in it (do not crowd), and fry until the first side has turned golden brown, about 3 minutes. Flip and cook until the other side is golden brown, about 2 minutes. Transfer to a plate with paper towels. Pat down with the paper towel to remove excess oil. Repeat with the remaining eggplant.

4. Bring a large pot of water to a boil. Add the potato and boil until softened, about 12 minutes. Drain, pat dry, and transfer to a plate.

5. Assemble the sabich by cutting about ⅛th of the pita off. Brush the inside with hummus. Place a layer of potatoes and top with tahini. Place a few slices of eggplant and egg slices. Add the cabbage and the salad. These will be very full pitas at this point. Serve with additional tahini.

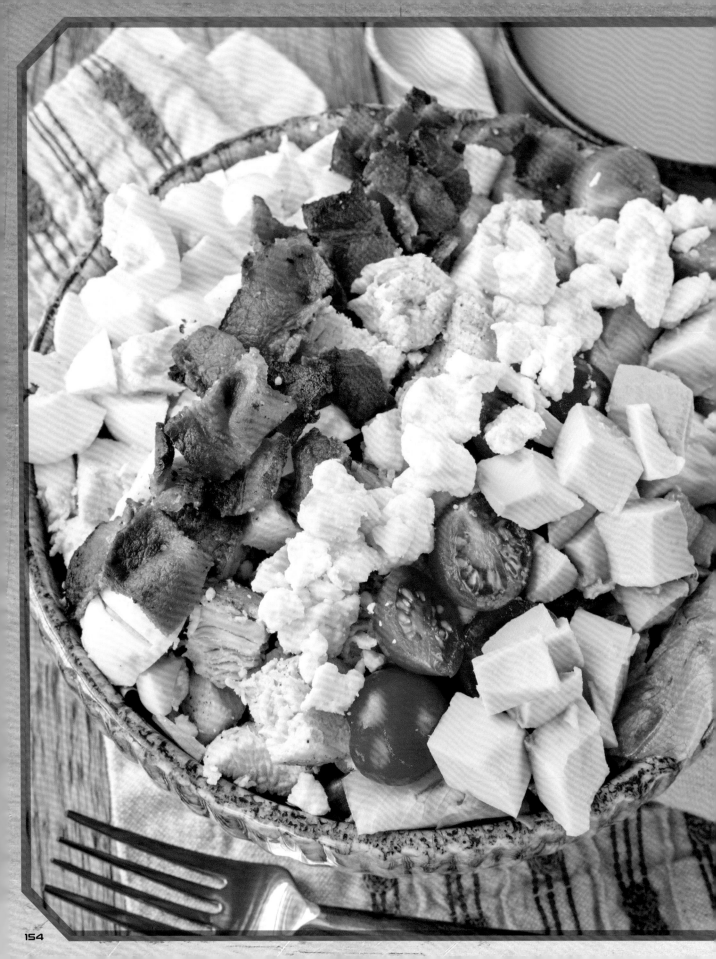

# COBB SALAD

**Difficulty**: Easy
**Prep Time**: 45 minutes
**Cook Time**: 40 minutes
**Yield**: 4 portions
**Dietary Notes**: N/A

*I know I said that Kuku's Café had some of the best sandwiches out there, but the rest of their small menu has some excellent hits as well. I mean, what's a Cobb salad if not a sandwich without the bread? Oh, and now I can already hear people discussing what makes something a sandwich. Just drop it and enjoy the recipe—this is a good one.*

### DRESSING

¼ cup (59 ml) red wine vinegar
1 tbsp. (15 g) Dijon mustard
1 garlic clove, minced
⅓ cup (78 ml) olive oil
1 tsp. (4 g) salt

### CHICKEN

1 boneless, skinless chicken breast
1 tbsp. (15 ml) olive oil
½ tsp. (2 g) salt
½ tsp. (1 g) pepper

### SALAD

3 endives, chopped
1 head romaine lettuce, chopped
1 head butter lettuce, chopped
4 hard-boiled eggs, chopped
8 slices bacon, cooked and chopped
1 large avocado, chopped
20 cherry tomatoes, halved
2 oz. (56 g) bleu cheese

## DRESSING

1. Place all the ingredients in a small airtight container. Shake until mixed together well.

## CHICKEN

1. Cut the chicken breast into 3 portions of equal size and thickness. Place in a bowl with olive oil, salt, and pepper. Toss together until the chicken is coated.

2. Heat a large grilling pan over medium-high heat. Add 1 tablespoon (15 ml) of oil, or nonstick spray. Add the chicken breast and cook the first side until golden brown, about 5 to 6 minutes. Flip the chicken and cook until the other side is golden brown, about 5 to 6 minutes, or until the chicken registers at an internal temperature of 165°F (74°C).

3. Remove from the heat, move to a plate, and let rest for 5 minutes. Transfer to a cutting board and cut into cubes and set aside.

## SALAD

1. Combine the endive, romaine lettuce, and butter lettuce in a large bowl. Split between 4 large bowls.

2. Top with the remaining ingredients. Serve with dressing.

# JIM DANDY

Whenever I found myself dragging through a spaceport for an early flight out of the system, there was no finer sight than the warm neon glow of a Jim Dandy. Take a seat in one of their old-timey and occasionally sticky booths. Why not order a unique breakfast, kick back, and enjoy a delicious cup of coffee? You'll quickly find that a miserable commute can quickly become—well, still pretty miserable. But now you're full and caffeinated, so it can't be completely bad.

I had a fair amount of work organizing contracts with Jim Dandy, so I had a lot of behind-the-scenes looks at the menu and the kitchens at some of their flagship locations. For a pretty commonplace chain, the company put a lot of emphasis on maintaining talented chefs and a fresh array of ingredients. The kitchen knew their stuff and put their heart and soul into the dishes they produced, all of which you wouldn't assume when you saw the veneer of a bland, family-friendly diner with those terrible incandescent lights. But don't be fooled, hungry patrons. The food is worth the stop.

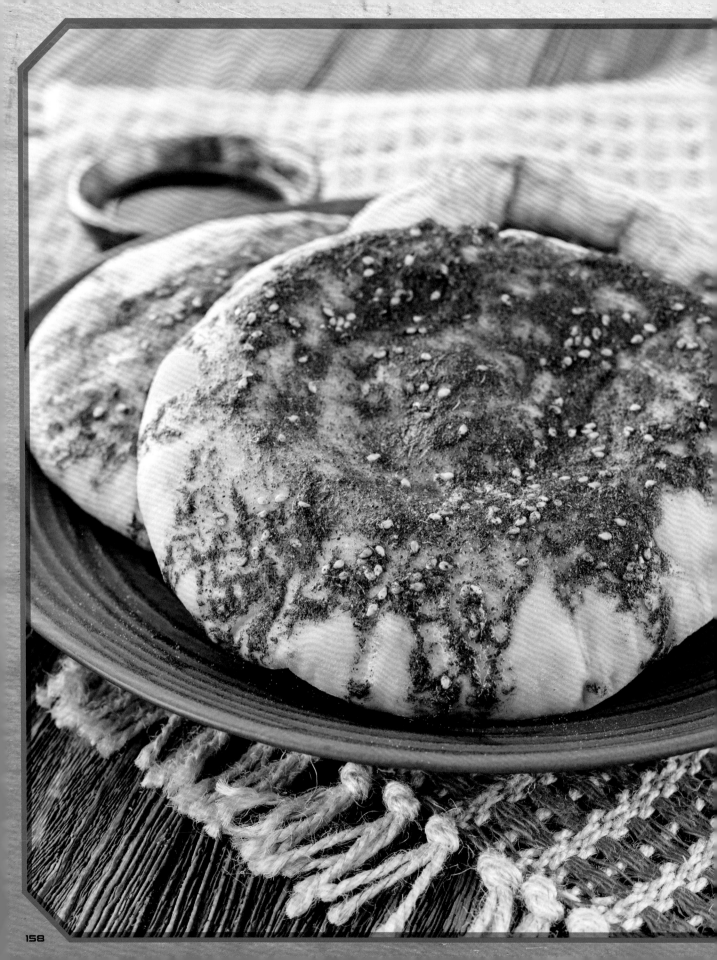

# DAND'OUCHE (ZA'ATAR MAN'OUCHE)

*Sometimes, I like to go simple with my breakfast to start the day. This isn't quite the simplest of recipes to put together, but the result is nice and to the point. A flaky dough with a great-tasting za'atar goes wonderfully with coffee, tea, or maybe even another serving. Why not? It's your day. Gotta start it right.*

**Difficulty**: Medium
**Prep Time**: 20 minutes
**Rest Time**: 2 hours
**Cook Time**: 10 minutes
**Yield**: 4 servings
**Dietary Notes**: Vegetarian, dairy-free

## DOUGH

¾ cup (177 ml) warm water
1½ tbsp. (22 ml) olive oil
1 tsp. (7 g) honey
1 tsp. (3 g) yeast
2 cups (250 g) all-purpose flour
1 tsp. (5 g) salt

## ZA'ATAR MIX

2 tbsp. (18 g) za'atar
⅓ cup (79 ml) olive oil

1. Combine the water, olive oil, honey, and yeast in a medium bowl. Mix well and set aside for 10 minutes to allow the yeast to get frothy. Combine the all-purpose flour and salt in a large bowl.

2. Add the liquid mixture to the large bowl and mix in until it just comes together. If the dough is too sticky, add 1 tablespoon (8 g) of all-purpose flour until it becomes tacky. Transfer to a lightly floured surface and knead for 5 minutes.

3. Transfer the dough ball to a large, oiled bowl and toss the dough in the oil until all sides are covered. Cover the bowl with plastic wrap and let the dough rest until it has doubled in size, about 2 hours.

4. Combine the ingredients for the za'atar mix.

5. Preheat oven, with a large baking sheet flipped upside down in the lower third of the oven, to 500°F (260°C). Lightly flour a countertop and place the dough on the counter. Lightly pat and divide the dough into 4 equal pieces. Tuck in the sides and form each of the pieces into a round ball.

6. Pat down a ball with your hands. With a rolling pin, roll out into a 7-inch (18 cm) disk. Generously sprinkle flour on top of a small piece of parchment paper. Lightly place the rolled-out disk on top. Repeat with the remaining portions.

> **NOTE** Placing each piece on a piece of parchment like this will make it easy to transfer the dough directly onto the baking sheet in the oven. If you have a pizza peel, feel free to use that, and keep that generously floured as well.

7. Once the oven is preheated, carefully slide 1 to 2 of the doughs directly on top of the baking sheet. Bake until golden brown and slightly puffed, about 4 to 5 minutes. Carefully remove from the oven and brush with the za'atar mixture. Return to the oven and bake for another 2 minutes. Remove and transfer to a wire rack to cool. Repeat with the remaining portions.

8. Serve with additional za'atar mix.

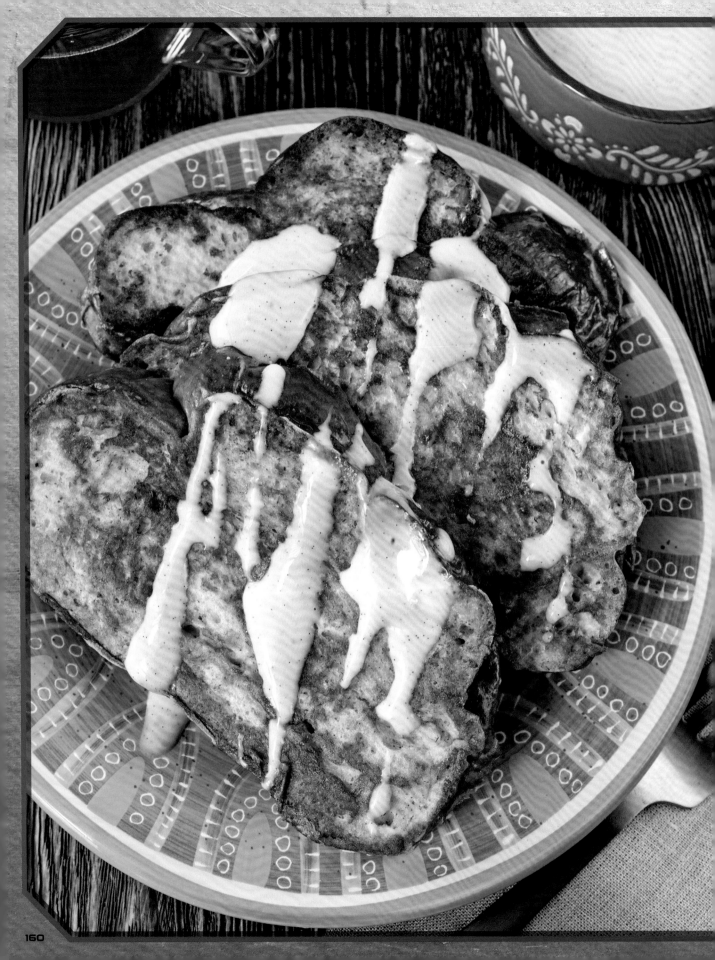

## Jim Dandy

# FRENCH TOAST

**Difficulty**: Medium
**Prep Time**: 30 minutes
**Rest Time**: Overnight
**Cook Time**: 30 minutes
**Yield**: 2 portions
**Dietary Notes**: Vegetarian

### ORANGE CRÈME ANGLAISE

¾ cup (173 g) heavy cream
¼ cup (59 ml) whole milk
½ vanilla bean, seeds scraped
1 tsp. (2 g) orange zest
3 egg yolks
¼ cup (50 g) sugar
½ tsp. (2½ ml) vanilla extract
½ tsp. (2½ ml) orange extract

### FRENCH TOAST

Six ½-in. slices of challah
6 eggs
¾ cup (177 ml) whole milk
¼ cup (58 g) heavy cream
½ tsp. (1 g) ground cinnamon
2 tsp. (11 g) sugar
Pinch of ground nutmeg
Pinch of salt
1 tsp. (5 ml) vanilla extract
Unsalted butter for browning

*You always expect French toast to come with maple syrup, but Jim Dandy threw me for a loop when they served this dish with crème anglaise only—no maple syrup in sight. I was going to get the waiter's attention to see if it was a mistake, but the chef clearly knew what they were doing. It was amazing, and now I can't imagine French toast any other way.*

### ORANGE CRÈME ANGLAISE

1. Heat heavy cream, milk, vanilla bean pod and seeds, and orange zest in a small saucepan over medium heat. Cook until right before it comes to a boil. Remove from the heat, cover, and let sit for 30 minutes.

2. Whisk together the egg yolks and sugar in a medium bowl. Remove the vanilla bean pod from the saucepan. Scoop ½ cup (120 ml) of the heated mixture into the bowl with the egg yolks and whisk until well combined. Add another ½ cup (120 ml) of the hot mixture and whisk thoroughly again. Slowly whisk the egg yolk mixture into the saucepan. Return the saucepan over medium heat and whisk until it thickens into a custard, about 5 minutes.

3. Remove the pan from heat and transfer crème anglaise to a small airtight container through a fine mesh strainer to remove any lumps. Whisk in the vanilla and orange extract. Place the container in an ice water bath to help cool it. Once completely cooled, cover and store in the refrigerator for up to 3 days.

### FRENCH TOAST

1. The night before, let the challah slices sit out to dry out.

2. The next day, whisk together eggs, whole milk, heavy cream, cinnamon, sugar, nutmeg, salt, and vanilla extract in a deep baking dish.

3. Heat a large, flat pan over medium-high heat. Rub the pan with butter.

4. Place a slice of challah in the egg mixture. Let soak for 15 seconds, flip, and allow to soak for another 15 seconds.

5. Remove the bread from the egg mixture and allow any excess liquid to drip off. Place on the heated pan. Cook each side for 4 to 5 minutes, or until golden brown.

6. Repeat steps 4 and 5 with the remaining slices of challah. Serve with butter and orange crème anglaise.

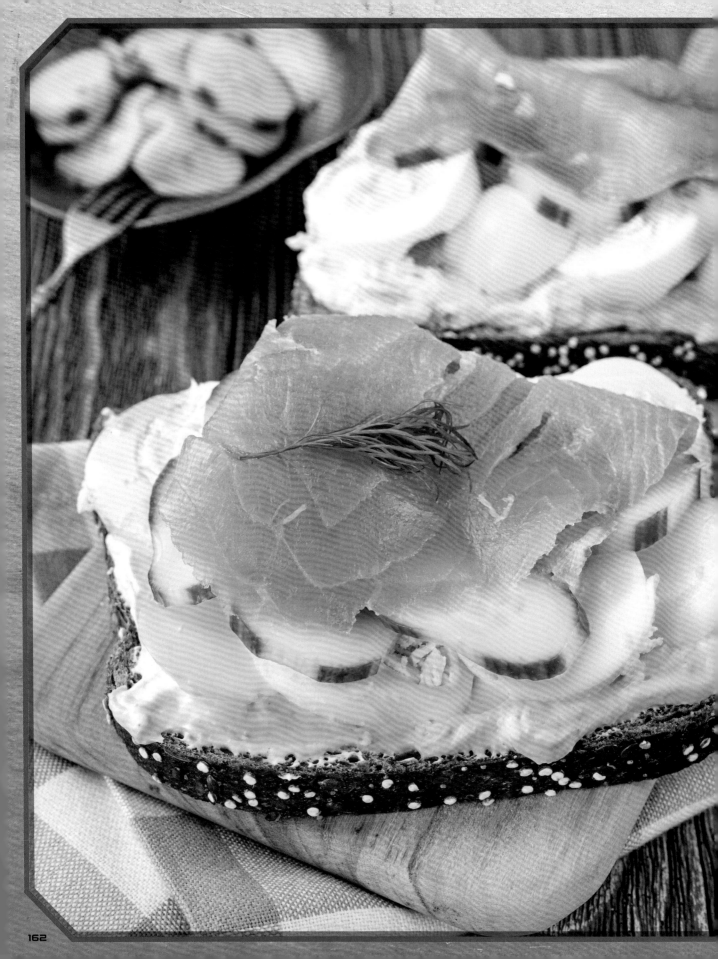

# SMÖRGÅS

**Difficulty**: Easy
**Prep Time**: 20 minutes
**Yield**: 4 servings
**Dietary Notes**: N/A

*The beauty of smörgås is the limitless combinations you can come up with. The Jim Dandy chefs stick to this version, but you should work local ingredients into your meals when you can. But don't skip out on the cream spread—it's too good to pass up.*

## CREAM SPREAD

6 oz. (170 g) cream cheese
¼ cup (56 g) crème fraîche
1 tbsp. (20 g) horseradish
1 tbsp. (15 g) shallot, minced
Zest and juice of 1 lemon
½ tsp. (1 g) fresh dill, chopped
Pinch of ground white pepper
Pinch of salt

## ASSEMBLY

4 slices rye bread
4 hard-boiled eggs, sliced
Pickled cucumber slices
(see page 35)
8 oz. (226 g) smoked salmon
Fresh dill

## CREAM SPREAD

1. Whisk together the cream cheese and crème fraîche in a medium bowl.

2. Add the other ingredients and mix until just combined. Season with additional salt and pepper if needed. Place in a small airtight container. Can be stored in the refrigerator for up to 1 week.

## ASSEMBLY

1. Toast the rye bread to your desired crispness. Spread a generous portion of the cream spread. Top with sliced hard-boiled eggs, pickled cucumber, and smoked salmon. Finally, top with a sprig of fresh dill. Serve as an open-faced sandwich.

# CACHAPAS

**Difficulty**: Easy
**Prep Time**: 15 minutes
**Cook Time**: 15 minutes
**Yield**: 2 servings
**Dietary Notes**: Vegetarian

1 15-oz. (425 g) can sweet corn
2 eggs
¼ cup (57 g) harina de maíz
1 tbsp. (14 g) sugar
1 tsp. (4 g) salt
1 tbsp. (14 g) butter,
room temperature

**SERVING:**

Butter for browning
Queso de mano for filling

## NOTE

You can use fresh corn, but I recommend using canned corn (drain the liquid) because it will be softer and help bring out a smoother texture.

*My mother always made cachapas for me growing up, so I was ecstatic when I saw Jim Dandy has them on their menu. They get—well, close enough, but here's my childhood staple as good as I can remember it for you all to enjoy.*

1. Place the corn, eggs, harina de maíz, sugar, salt, and butter in a blender. Blend until the mixture comes together and is smooth. Let the mixture sit for about 3 minutes before cooking it. This will allow it to thicken. If the mixture becomes too thick, add a few tablespoons of water to loosen it.

2. Heat a medium nonstick frying pan over medium-high heat. Once heated, add 1 tablespoon of butter to the pan. After it has melted, add half of the corn mixture, and spread into a circle. Allow to cook until the bottom has browned lightly, about 4 to 5 minutes.

3. Cook on the other side until that is also golden brown, about 3 to 4 minutes. Flip the cachapa once more. Place the queso de mano over half the cachapa. Fold the other half of the cachapa over the cheese. Cover the pan with a lid and allow the cheese to melt. Transfer to a plate, spread extra butter on the top, and serve immediately.

4. Repeat steps 2 and 3 for the other half of the mixture.

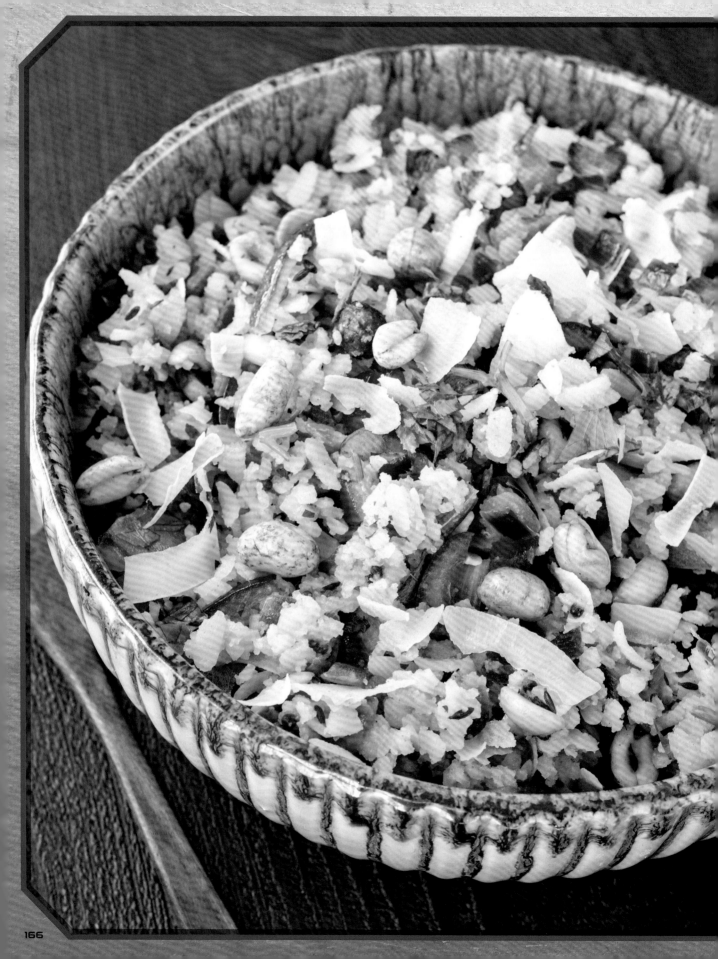

# KANDE POHE

**Difficulty**: Easy
**Prep Time**: 30 minutes
**Cook Time**: 15 minutes
**Yield**: 4 servings
**Dietary Notes**: Vegan

1½ cup (222 g) poha, thick variety
½ cup (73 g) peanuts
2 tbsp. (30 ml) canola oil
¾ tsp. (3 g) mustard seeds
1 tsp. (4 g) cumin seeds
1 red onion, chopped
6 curry leaves
2 serrano peppers, chopped
½ tsp. (1 g) turmeric
½ tsp. (2 g) sugar
Salt
Juice of ½ lemon
⅓ cup (1.5 g) cilantro, finely chopped
¼ cup (19 g) grated coconut

*Another fantastic breakfast from Jim Dandy, kande pohe hits a savory note that's a nice change of pace from my usual breakfast plans. It's bright and complex and a welcome addition to anyone's early morning culinary repertoire.*

1. Place the poha in a fine mesh strainer and rinse it in cold water until it softens. Allow the water to drain, cover with a wet towel, and set aside.

2. Heat a large nonstick frying pan on medium-high heat. Add the peanuts, tossing constantly, and slightly toast, about 5 minutes. Remove them from the pan and set aside.

3. Add 2 tablespoons (30 ml) canola oil to the pan and let it heat up. Add the mustard seeds and cumin seeds and toast until the seeds begin to pop, about 1 to 2 minutes. Add the onions and cook until softened and slightly browned, about 6 to 8 minutes. Add the curry leaves and serrano peppers and cook until the peppers have softened slightly, about 2 minutes.

4. Add the turmeric, sugar, peanuts, and poha. Toss until well mixed and everything is heated through. Season with salt. Cover and cook for another 2 minutes.

> **NOTE** If your poha becomes too dry while it is set aside, simply give it a quick rinse before tossing it in the pan.

5. Add the lemon juice, cilantro, and grated coconut. Serve warm.

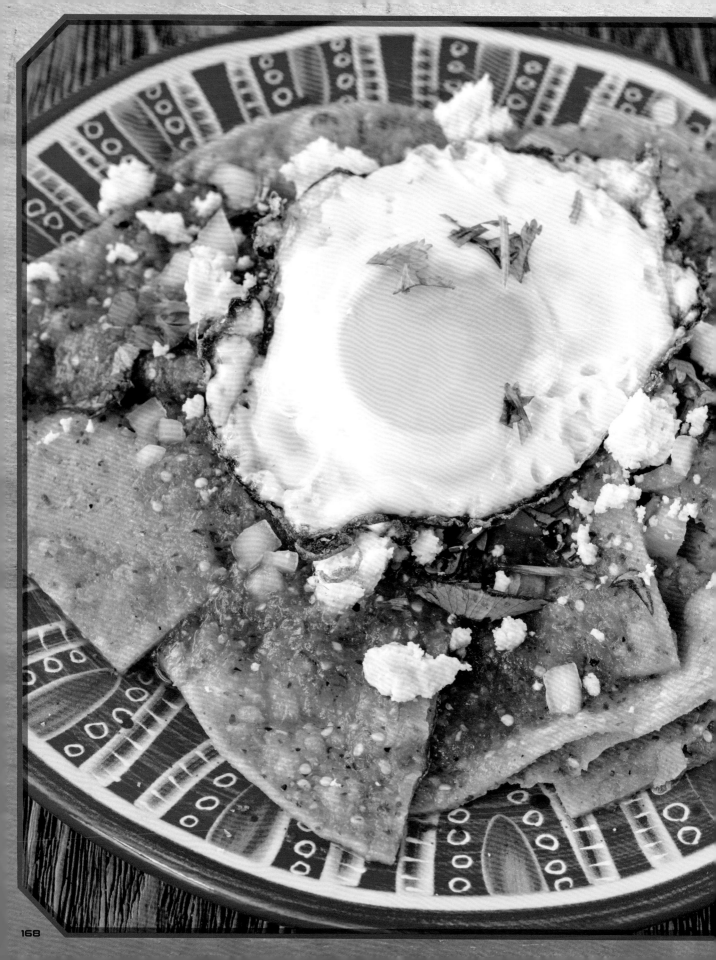

# CHILAQUILES

Jim Dandy —

# CHILAQUILES

*A lot of mornings, I can get by with just a cup of black coffee and toast to start my day. Other mornings, I need a real heavy hitter of a breakfast. This is my go-to. Jim Dandy's has been making these chilaquiles since I started going to this joint. The recipe has never changed, but why would they, when this is just perfection on a plate.*

**Difficulty**: Easy
**Prep Time**: 30 minutes
**Cook Time**: 30 minutes
**Yield**: 4 servings
**Dietary Notes**: Vegetarian

## SALSA VERDE

1 lb. (454 g) tomatillos, husked and rinsed
8 garlic cloves, crushed
2 jalapeños, stemmed and halved
1 serrano, stemmed and halved
1 poblano, stemmed and halved
½ large onion, quartered
½ bunch cilantro
3 tbsp. (45 ml) lime juice
1 tsp. (4 g) salt

## TORTILLA CHIPS

Peanut oil for browning
15 corn tortillas, each cut into 4 triangles
Salt

## PER SERVING

¼ of the salsa verde
¼ of the tortilla chips
1 to 2 fried eggs
Queso fresco for topping
Crema Mexicana for topping
Onion, chopped, for topping
Cilantro

## SALSA VERDE

1. Place the tomatillos, garlic cloves, jalapeños, serrano, poblano, and onion on a large baking sheet. Put under a broiler and cook until everything has slightly charred, about 5 to 8 minutes. Check this frequently; if the garlic chars too quickly, remove it from the pan and let the rest finish charring.

2. Once charred, transfer the poblano onto a sheet of aluminum foil and seal closed. Let rest for 5 minutes. After the time has passed, open the aluminum foil and remove and discard the skin from the poblano peppers. Allow all the charred vegetables to cool.

3. Transfer all the charred items and cilantro to a food processor. Pulse until the ingredients are coarsely chopped. Add the lime juice and salt. Pulse a few more times until blended. Taste and season.

4. Transfer to a small airtight container and place in the refrigerator until you need it. Can be stored for up to 2 weeks.

## TORTILLA CHIPS

1. Fill a deep pot with 2 inches (5 cm) of peanut oil and heat over medium heat to 350°F (177°C).

2. Place a few of the tortilla triangles, making sure to not crowd the pot. Cook until the tortillas turn golden brown. Once cooked, transfer to a plate with paper towels and lightly sprinkle with salt. Repeat with the remaining portions of corn tortillas

## TO PREPARE A PORTION

1. Heat the salsa verde in a small nonstick frying pan over medium-high heat until heated through. Turn off the heat, add the tortilla chips, and toss until coated with the salsa, making sure to not make them mushy.

2. Transfer to a plate and top with the fried egg, queso fresco, crema Mexicana, onions, and cilantro.

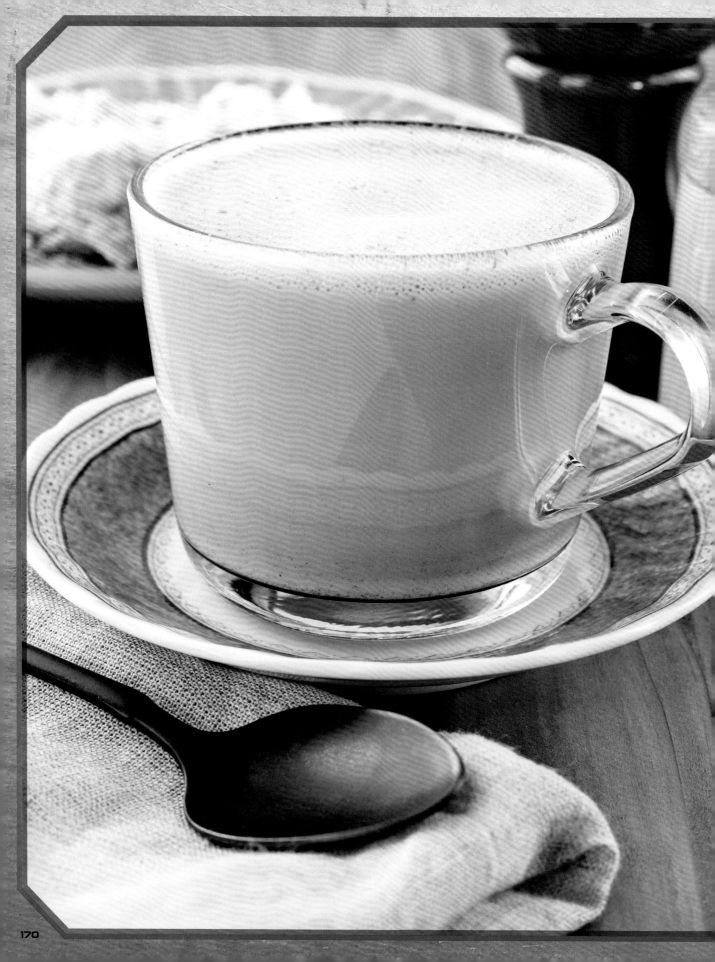

# CAFÉ CON LECHE

**Difficulty**: Easy
**Prep Time**: 10 minutes
**Cook Time**: 10 minutes
**Yield**: 2 cups
**Dietary Notes**: Vegetarian, gluten-free

1¼ cup (296 ml) whole milk
1 tbsp. (12 g) sugar
¼ tsp. (½ g) ground cinnamon
Pinch of salt
1 cup (237 ml) coffee

*Jim Dandy prides itself on its coffee, both in quality and variety. I'm normally a black-coffee guy, but I like all the drinks they serve and sometimes treat myself to a tasty, creamy café con leche. It should really be called leche con café, but I'm not complaining.*

1. Heat the milk, sugar, cinnamon, and salt in a small saucepan over medium heat. Bring to a simmer for 10 minutes, whisking to make sure the milk does not burn on the bottom of the pan.

2. Prepare 1 cup (237 ml) of coffee with your preferred method. Split the coffee between 2 large mugs. Top each with the simmered milk.

# FULL MOON

Of all the work I care to remember, one of my stranger assignments was to set up supply contracts for a gigantic supercarrier that I didn't even know the name of when I started. It had some very important mission that was going to take it away from the Sol system for a redacted amount of time, doing redacted activities, with a redacted crew size to support. Military contracts really were the worst arrangements to be assigned to. I was told I was on the contract because of my experience, but it felt an awful lot like punishment to me.

Anyway, I eventually learned from some helpful drunks at the ship's cozy bar that I was on the *Infinity*, a real technological marvel. I heard all sorts of tales in that bar, but I couldn't tell you what was confidential military secrets and what was drunken ramblings. And honestly, even years after the work was done, I don't feel comfortable sharing anything I heard. I don't need any UNSC folks paying me a visit after this book gets published. I'd much rather talk about all the great drinks I had in the Full Moon bar to complement the extraordinarily frustrating workdays I had there. This wasn't the whole drink list, but let's just say I don't remember everything there all that clearly.

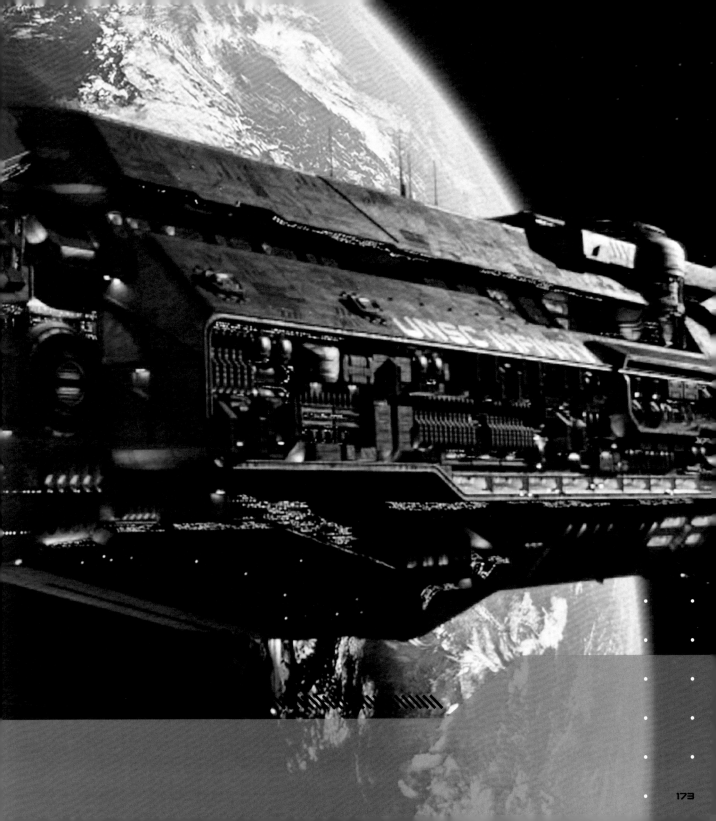

# GROOB

**Difficulty**: Easy
**Prep Time**: 5 minutes
**Yield**: 2
**Dietary Notes**: Vegetarian

½ grapefruit
6 oz. (94 g) raspberries
½ orange
¼ cup oat milk
2 bananas
6 ice cubes
8 oz. (227 g) frozen yogurt

*Lots of places have their own way to make groob, but the only rules are in the name. You need something for each letter, and the Full Moon had a great rendition I still make on my own.*

1. Place the ingredients in a blender. Blend until smooth. If the mixture is too thick, add additional oat milk. Split and serve in two tall glasses

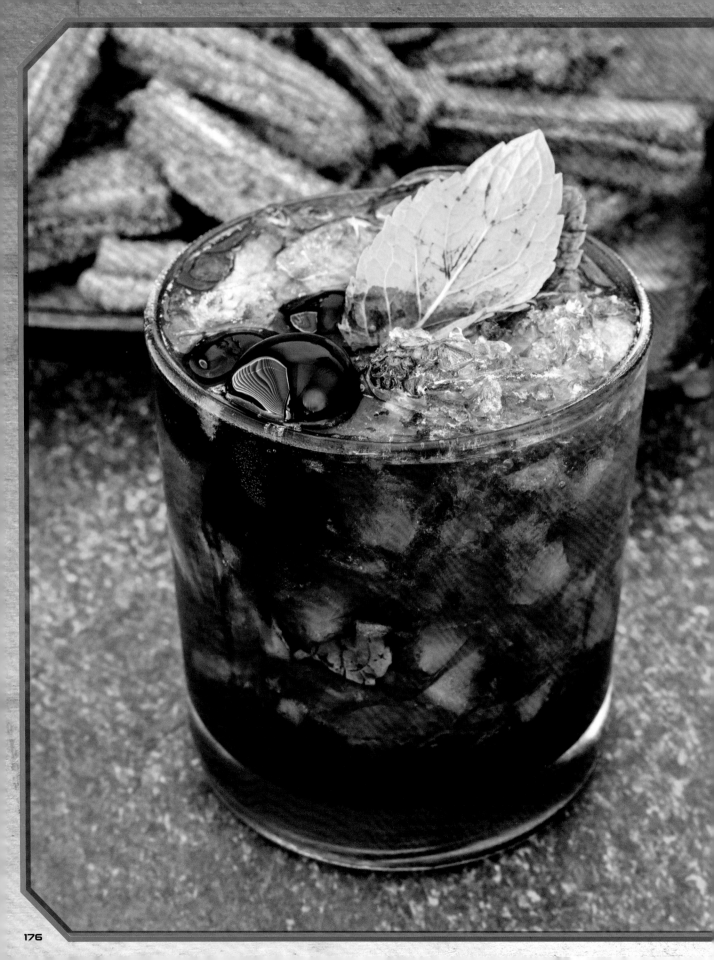

# MINT JULEP

**Difficulty**: Easy
**Prep Time**: 15 minutes
**Yield**: 1 drink
**Dietary Notes**: Vegan

10 mint leaves
½ oz. (14 ml) cherry syrup
2½ oz. (74 ml) bourbon
½ oz. (14 ml) cherry liqueur
½ oz. (14 ml) lemon juice
1 cup crushed ice

### GARNISH
Crushed ice
4 mint leaves
3 maraschino cherries

*Cherries, like all fruit, can be difficult to transport across space. That's why I love maraschino cherries so much; they let you have a great cherry garnish in your drinks no matter which planet or freighter you're stuck on.*

1. Muddle the mint and cherry syrup in an old-fashioned glass. Add the bourbon, cherry liqueur, and lemon juice. Fill with crushed ice and stir. Garnish with additional crushed ice, mint leaves, and maraschino cherries.

# TWO-TAILED COMET

**Difficulty**: Easy
**Prep Time**: 15 minutes
**Yield**: 2 drinks
**Dietary Notes**: Vegan

### BLUE COMET

2 ice cubes
1 oz. (28 ml) vodka
1 oz. (28 ml) blue curaçao
1 oz. (28 ml) sambuca
½ oz. (14 ml) orange liqueur
3 oz. (85 ml) club soda

### RED COMET

2 ice cubes
1 oz. (28 ml) vodka
½ oz. (14 ml) grenadine
1 oz. (28 ml) sambuca
½ oz. (14 ml) cherry liqueur
3 oz. (85 ml) club soda

*When I was doing work with the Infinity, I shared a drink with all sorts of people, from cleaning and support crew to the high-ranking folks. Someone important enjoyed the company and got me this tasty drink, the first time I've ever had it. He also gave me a flag of some old alma mater he attended, and for some reason I can't bring myself to throw it away. I must be getting sentimental as I get older.*

### BLUE COMET

1. Place two ice cubes in a cocktail shaker. Add the vodka, blue curaçao, sambuca, and orange liqueur. Shake thoroughly. Strain into a glass and add club soda.

### RED COMET

1. Place two ice cubes in a cocktail shaker. Add the vodka, grenadine, sambuca, and cherry liqueur. Shake thoroughly. Strain into a glass and add club soda.

# WOTHA

**Difficulty**: Easy
**Prep Time**: 15 minutes
**Rest Time**: 1 hour
**Yield**: 6 servings
**Dietary Notes**: Vegetarian

1 750-ml bottle nero d'avola
¼ cup (59 ml) orange liqueur
¼ cup (59 ml) Aperol
1 cup (237 ml) pomegranate juice
2 tbsp. (42 g) honey
1 orange, sliced
2 lemons, sliced
Arils of 1 pomegranate

*My doctor always tells me I need a more balanced diet—you know, that I should cover more food groups. Well, I very clearly explained how one of my favorite drinks from the Full Moon has all kinds of fruit, but I don't think he appreciated the humor.*

1. Combine all the ingredients in a pitcher and stir together. Refrigerate for at least 1 hour. Serve with extra fruit if desired.

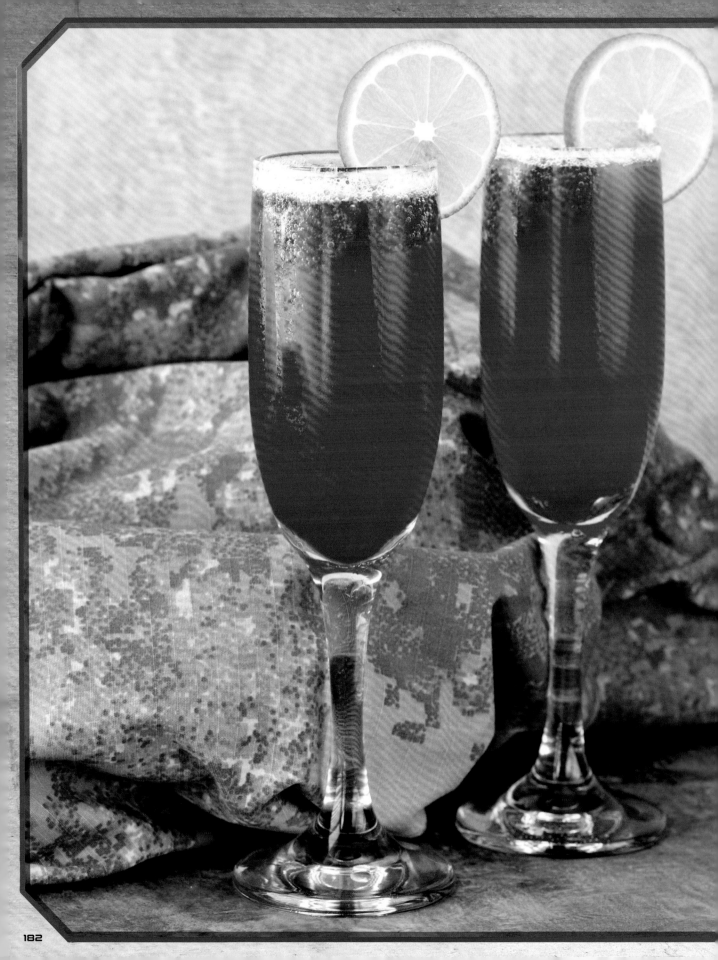

# ZANTELLE

**Difficulty**: Easy
**Prep Time**: 10 minutes
**Cook Time**: 30 minutes
**Rest Time**: 12 hours
**Yield**: 6 drinks
**Dietary Notes**: Vegan

## LIME RASPBERRY SYRUP

¼ cup (56 g) sugar
¾ cup (177 ml) lime juice
6 oz (170 g) raspberries

## PER DRINK

2 ice cubes
½ oz. (14 ml) gin
½ oz. (14 ml) raspberry liqueur
1 oz. (28 ml) elderflower liqueur
1 oz. (14 ml) lime raspberry syrup
¾ cup (177 ml) prosecco
3 fresh raspberries
1 lime slice

*You have to be a bit careful with this drink. It goes down smooth, has a great flavor, and can quickly catch you by surprise. I sometimes load it up with extra raspberries if I have them, but you gotta make the drink your own.*

1. Combine the sugar, lime juice, and raspberries in a small saucepan over medium-high heat. Whisk together until the sugar has dissolved and bring to a boil.

2. Reduce the heat and simmer for 15 minutes. Remove from the heat and strain into a small airtight container. Allow to cool. Store in the refrigerator for at least 12 hours and up to 2 weeks.

3. To make a serving, place two ice cubes in a cocktail shaker. Add the gin, raspberry liqueur, elderflower liqueur, and lime raspberry syrup. Shake thoroughly. Strain into a glass and add prosecco. Garnish with raspberries and a lime slice.

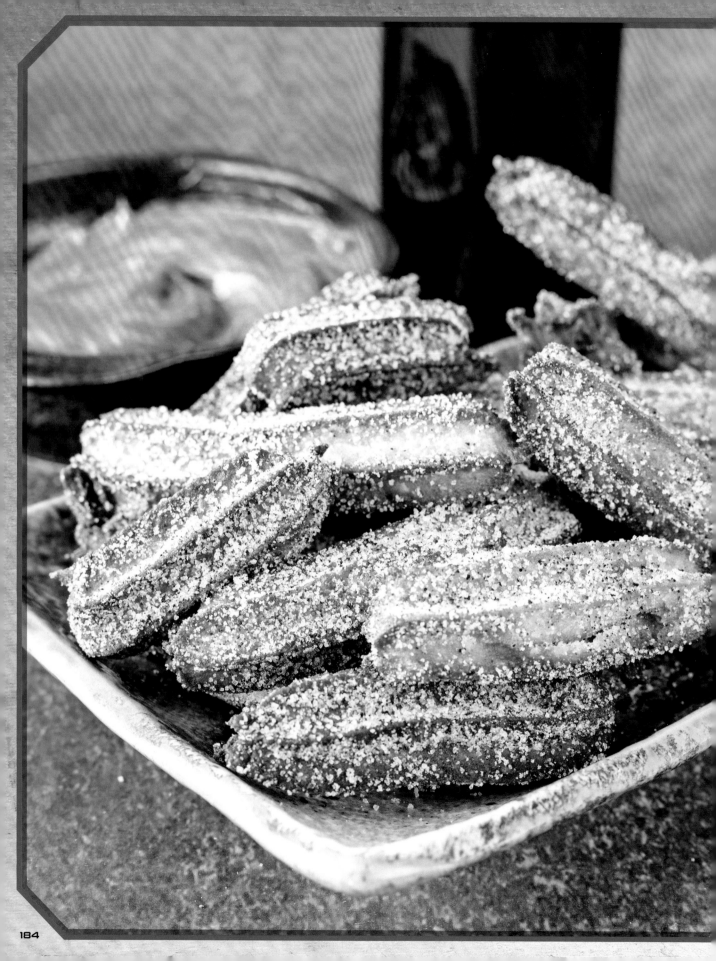

# CHURROS

*You can't just sit in a bar and down drinks on an empty stomach. And there's nothing better to accompany a strong drink than something fried. Oh, why not make it sugary and bitter, too? These churros are a great drink companion, and they don't talk your ear off.*

**Difficulty**: Medium
**Prep Time**: 45 minutes
**Cook Time**: 2 minutes per batch
**Yield**: 35 to 45 small churros
**Dietary Notes**: Vegetarian

### CHURROS

2 cups (250 g) all-purpose flour
1½ tsp. (3 g) espresso powder
1½ cups (355 ml) milk
6 tbsp. (84 g) butter
1 tsp. (4 g) salt
1 tbsp. (15 g) sugar
Peanut oil for deep-frying
2 eggs

### SPICE TOPPING

½ cup (100 g) sugar
2 tsp. (4 g) espresso powder
½ tsp. (1 g) cardamom
¼ tsp. (1 g) salt

1. Combine the flour and espresso powder in a small bowl. Heat the milk, butter, salt, and sugar in a medium saucepan over medium-high heat. Bring to a boil, then reduce the heat and simmer for 3 minutes.

2. Turn off the heat. Add the flour mixture and mix with a spatula until it forms a smooth dough with no raw flour clumps. Keep mixing until the dough is cool to touch. Set aside and allow to cool completely.

3. While the dough is cooling, pour 1½ inches of peanut oil in a deep pot. Begin to heat up to 350°F (177°C). On a plate, combine the sugar, espresso powder, cardamom, and salt. Set aside.

4. Once the dough has cooled, mix in the eggs 1 at a time until completely smooth. Transfer the dough in a pastry bag with a large star tip.

5. After the oil has heated, squeeze a 2- to 3-inch-long (50- to 75-mm-long) strip of dough into the hot oil. Use either scissors or a knife to cut the dough from the pastry tip. Fry the churros for about 45 seconds, flip, and fry for another 30 seconds or until they are golden brown.

6. Transfer the fried churros onto a plate lined with paper towels to remove any excess oil. Once the churros are cool enough to handle, toss in the sugar mixture. Repeat steps 5 and 6 until all the dough is fried. You can keep the churros warm in an oven at 200°F (93°C) for up to 1 hour. These are best enjoyed the day they are made.

7. Serve the churros with dulce de leche.

# DIETARY CONSIDERATIONS

| | Gluten-Free | Dairy-Free | Vegan | Vegetarian |
|---|---|---|---|---|
| **World Cuisine** | | | | |
| Patty Melt | | | | |
| Hainanese Chicken | | X | | |
| Sushi | | X | | |
| Salmon Burger | | X | | |
| Barbacoa Tacos | | X | | |
| Harira | | X | | |
| **UNSC High Fleet Dining** | | | | |
| Hot Dog Dinner | | | | |
| Turkey Dinner | | | | |
| Chef's Special | | | | |
| Hot Chocolate | | | | X |
| Iced Tea | | | X | |
| Cookie's Surprise | | | | X |
| **Havadi Goodwan** | | | | |
| Chocolate Chip Scones | | | | X |
| Cheese Danish | | | | X |
| Custard Pie | | | | X |
| Freya's Tea | | | X | |
| Spiced Coffee | | X | X | |
| **Fronk's** | | | | |
| Kebabs | | X | | |
| Fronk's Fish Nuggets | | X | | |
| Fronk's Fishtacular Tacos | | | | |
| Tuna Gyros | | | | |
| Lobster-Loaded Baked Potato | | | | |
| Chocolate Cream Pie | | | | X |
| **Vending Machines** | | | | |
| Buffagoat Buttocks | | | | |
| Moa Wings | | | | |
| Spadehorn Bits | | X | | |
| The Purple Concoction | | | X | |
| GAUSS Orange Soda | | | X | |
| BLAST | | | X | |
| **Have S'Moa** | | | | |
| Moa Caesar Salad | | | | |
| Moa Nuggets | | | | |
| Full-Stack Ground Pounder | | | | |
| Sweet Potato Fries | | | | X |
| Onion Rings | | | | X |
| S'moa Brownies | | | | |

| | Gluten-Free | Dairy-Free | Vegan | Vegetarian |
|---|---|---|---|---|
| **Enzo's Churrascaria** | | | | |
| Curry Puffs | | | | X |
| Garlic Stir-Fry | | | X | |
| Halo-Halo | | | | X |
| Pineapple Fried Rice | | | | |
| Red Moon Salmon Curry | | X | | |
| Won-Tons | | | X | |
| **Maeyamas Noodle Bar** | | | | |
| Kitsune Udon | | | | |
| Rosół | | X | | |
| Phở Bò | | X | | |
| Tallarines Verdes | | | | X |
| Pasta alla Norma | | | | X |
| Seviyan Kheer | | | | X |
| **Thai Game** | | | | |
| Chicken Satay | X | X | | |
| Grilled Mega Prawns | | X | | |
| Yum Nua | | X | | |
| Tom Yum | | | | |
| Space Pad Thai | | | | |
| **Kuku's Café** | | | | |
| Bauru Sandwich | | | | |
| Bombay Sandwich | | | | X |
| Gatsby Sandwich | | X | | |
| Pan Bagnat | | | | |
| Sabich | | | | X |
| Cobb Salad | | | | |
| **Jim Dandy** | | | | |
| Dand'ouche (Za'atar Man'ouche) | | X | | X |
| French Toast | | | | X |
| Smörgås | | | | |
| Cachapas | | | | X |
| Kande Pohe | | | X | |
| Chilaquiles | | | | X |
| Café con Leche | X | | | X |
| **Full Moon** | | | | |
| Groob | | | | X |
| Mint Julep* | | | X | |
| Two-Tailed Comet* | | | X | |
| Wotha* | | | | X |
| Zantelle* | | | X | |
| Churros | | | | X |

**\*CONTAINS ALCOHOL**

# ACKNOWLEDGMENTS

Thanks Jeff Rosenthal, Kanji, Matt Thomas, and Kate McKean for joining me on this campaign. Thanks to Rene Rodriguez, Nick Esparaz, Kevin Giesler, Kevin Stich, Irvin Chavira, Harry Readinger, Nina Freeman, Jake Jefferies, Elaine Gray, Will Baker, Forrest Porter, Saam Pahlavan, Brock Wright, my family, and the Pixelated Provisions' community for all the support as I worked through a flood of recipes.

# ABOUT THE AUTHOR

Victoria Rosenthal launched her blog, Pixelated Provisions, in 2012 to combine her lifelong passions for video games and food by recreating consumables found in many of her favorite games. When she isn't experimenting in the kitchen and dreaming up new recipes, she spends time with her husband and corgi hiking, playing video games, and enjoying the latest new restaurants. Victoria is also the author of *Fallout: The Vault Dweller's Official Cookbook*, *Destiny: The Official Cookbook*, *Street Fighter: The Official Street Food Cookbook*, and *The Ultimate FINAL FANTASY XIV Cookbook*. Feel free to say hello on Twitter, Twitch, or Instagram at PixelatedVicka.

## 343 ACKNOWLEDGMENTS

Rick Blanco, Creative Director of Halo Consumer Products

Nicolas "Sparth" Bouvier, Senior Art Director

Jeff Easterling, Franchise Narrative Writer

Chelsea Faso, Licensing Manager

John Friend, Senior Director of Consumer Products

Scott Jobe, Product Development Manager

Tiffany O'Brien, Consumer Products Category Manager

Kenneth Peters, Senior Halo Franchise Writer

Corrinne Robinson, Senior Halo Franchise Manager

Kiki Wolfkill, Head of Halo Transmedia

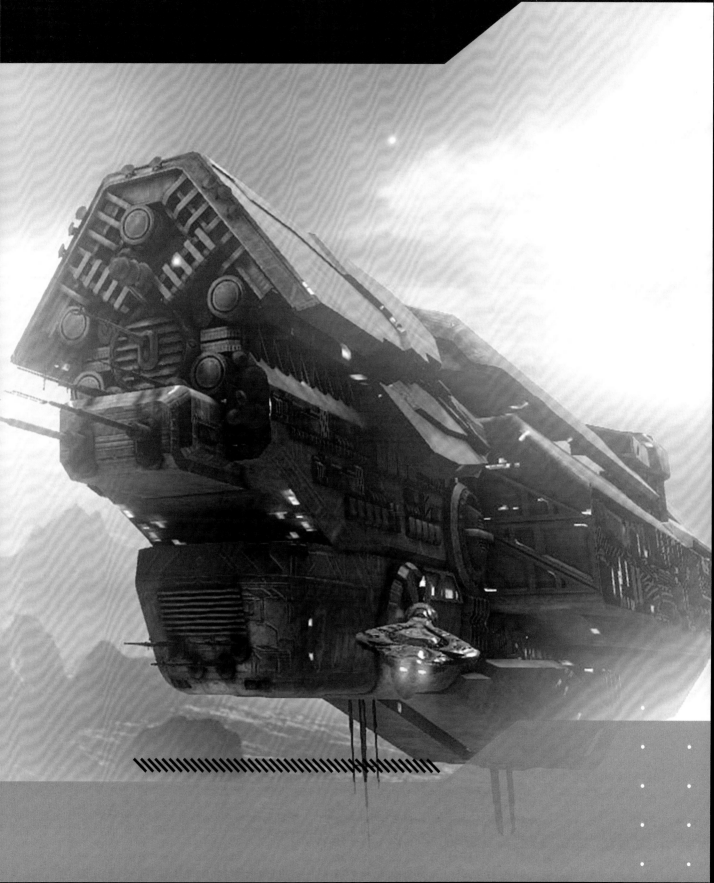

PO Box 3088
San Rafael, CA 94912
www.insighteditions.com

 Find us on Facebook: www.facebook.com/InsightEditions

 Follow us on Twitter: @insighteditions

© 2022 Microsoft Corporation. All Rights Reserved. Microsoft, 343 Industries, the 343 Industries logo, Halo, and the Halo logo are trademarks of the Microsoft group of companies.

All rights reserved. Published by Insight Editions, San Rafael, California, in 2021.

No part of this book may be reproduced in any form without written permission from the publisher.

Library of Congress Cataloging-in-Publication Data available.

ISBN: 978-1-64772-671-8

Publisher: Raoul Goff
VP of Licensing and Partnerships: Vanessa Lopez
VP of Creative: Chrissy Kwasnik
VP of Manufacturing: Alix Nicholaeff
Editorial Director: Vicki Jaeger
Senior Designer: Monique Narboneta Zosa
Senior Editor: Jennifer Sims
Associate Editor: Anna Wostenberg
Senior Production Editor: Jan Neal
Sr. Prod-Mgr Subsidiary Rights: Lina s Palma-Temena
Production Associate: Deena Hashem

Insight Editions, in association with Roots of Peace, will plant two trees for each tree used in the manufacturing of this book. Roots of Peace is an internationally renowned humanitarian organization dedicated to eradicating land mines worldwide and converting war-torn lands into productive farms and wildlife habitats. Roots of Peace will plant two million fruit and nut trees in Afghanistan and provide farmers there with the skills and support necessary for sustainable land use.

Manufactured in China by Insight Editions

10 9 8 7 6 5 4 3 2 1